THE REENCHANTMENT OF ART

THE REENCHANTMENT OF ART

Suzi Gablik

Thames and Hudson

*For my teacher Joan Halifax,
and my friend Lorna Roberts*

CONTENTS

CHAPTER 1
INTRODUCTION
Changing Paradigms, Breaking the Cultural Trance

We cannot bear connection. That is our malady. We must break away, and be isolate. We call that being freed, being individual. Beyond a certain point, which we have reached, it is suicide.

D. H. Lawrence

It is not impractical to consider seriously changing the rules of the game when the game is clearly killing you.

M. Scott Peck

This book is a sustained meditation on how we might restore to our culture its sense of aliveness, possibility and magic. It is not an academic, scholarly work, but has a distinctly visionary bias grounded in what one of my colleagues, the ecofeminist writer Gloria Fenam Orenstein, calls "the methodology of the marvelous"—inexplicable synchronistic processes by which one attracts, as if by magnetism, the next piece of vital information. Most of what is

1

written here is a record of my own psychic journey and reflects the changes in my thinking as it has emerged from the collective beliefs and opinions that are centrally entrenched in our society. Since the issues discussed are deeply personal as well as aesthetic and social, the book does not fit comfortably into any of the categories that are normally used to classify art books. It attempts to engage the whole being—not just the intellect but the emotional, psychological, ethical and spiritual parts of us as well. Although it challenges many of our axiomatic assumptions about art, the book will, I hope, be relevant for people in other disciplines who are concerned about the future of our planet. I see it as a collective project, giving voice to what many people already believe and feel; ideas are expressed and woven together that are very much "in the air," seeking their proper articulation in the community.

The discussions of art are focused around one essential theme: what does it mean to be a "successful" artist working in the world today? Much of what follows is devoted to considering this question. It is something that is not usually asked, since it immediately implicates us in a value analysis of our whole culture. The idea of self-directed professionalism has conditioned, if not totally determined, our way of thinking about art, to the point where we have become incredibly addicted to certain kinds of experience at the expense of others, such as community, for example, or ritual. We live in a culture that has little capacity or appreciation for meaningful ritual. Not only does the particular way of life for which we have been programmed lack any cosmic, or transpersonal dimension, but its underlying principles of manic production and consumption, maximum energy flow, mindless waste and greed, are now threatening the entire ecosystem in which we live.

The prevailing attitude of mind of a culture, its world view or mind-set, is commonly called a paradigm. A paradigm is very powerful in the life of a society, since it influences the way we think, how problems are solved, what goals we pursue and what we value. The socially dominant paradigm is seldom, if ever, stated explicitly, but it uncon-

sciously defines reality for most people, whose view of the world does not normally transcend the limits imposed by this cultural conditioning. For this reason, it is important to come to grips with our cultural model, in order to understand how it affects the way we think and determines what we want. Many of the difficulties and conflicts we experience as personal in this regard are related to the framework of beliefs and standards of behavior provided by our culture to serve as guidelines for individual lives. We tend to pattern ourselves and our world view after our culture, taking as self-evident certain beliefs, values and behaviors; thus, if our model of culture is faulty or disordered, then we ourselves are disordered in precisely the same way. Since cultural conditioning strongly influences individual behavior and thought, to begin to move toward a different framework of assumptions that would change the basis of our experience is extremely difficult.

Is there any way, then, not to let the dominant paradigm in which we currently exist define who we are? And on which level, then, the personal or the cultural, can the problem be resolved? This was the situation uncovered by my last book, *Has Modernism Failed?*, but not really resolved—a widely shared disenchantment over the compulsive and oppressive consumeristic framework in which we do our work, and from which, it would seem, there is no escape. My aim in this book is to go beyond that framework. As a culture, we seem to be approaching a certain awareness that things must change, and not just superficially. Rather, the most basic assumptions underlying modern society are in flux; and, as these assumptions shift, the need for a new philosophical framework is being felt by many people. In arguing for the necessity of moving beyond the whole world view of an epoch, this book looks to the possibility that individuals can reject certain prevailing cultural attitudes and embrace new myths. The question is no longer how did we get here, and why? but, where can we possibly go, and how? We live in a society that has drastically narrowed our sensitivity to moral and spiritual issues; the problem we face is how to deal with a belief structure that has blocked both psycholog-

ical and spiritual development. If there is a new agenda, a new vision now emerging within our society, how might one help put it into practice? This book represents my own attempt to look at what changes are necessary or desirable, how we might achieve them, and what the role of art and artists might be in accelerating this process.

The new questions that are being raised are no longer issues of style or content, but issues of social and environmental responsibility, and of multiculturalism, or "parallel" cultures, rather than a dominant monoculturalism. The subject of multiculturalism is not really touched on in this book, but is explored by Lucy Lippard in her newly published *Mixed Blessings: New Art in a Multicultural America*, whereas I have chosen to limit my focus to social and environmental issues. In January 1990, I participated in a one-day invitational forum in New York, organized by the Rockefeller Foundation, for the purpose of discussing a possible new funding program for environmental and socially concerned art. Some of the questions put to us for consideration were: Are political and social concerns in the arts informing a new aesthetic? Are artists becoming more engaged in work that addresses social issues? Is there a new relevance to this art? Are artists actively invoking nature and issues of the environment in new ways? What is the relationship of their work to environmental activism?

My own answers to the above questions, which raise issues about the *use* of art in our world, are to be found in the pages that follow. I suspect we are at the end of something—a hypermasculinized modern culture whose social projects have become increasingly unecological and nonsustainable. In *Personal Mythology*, David Feinstein writes: "We need new myths; we need them urgently and desperately. . . . Times are changing so fast that we cannot afford to stay set in our ways. We need to become exquisitely skilled engineers of change in our mythologies." If modern aesthetics was inherently isolationist, aimed at disengagement and purity, my sense is that what we will be seeing over the next few decades is art that is essentially social and purposeful, art that rejects the myths of neutrality and autonomy. The sub-

4

text of social responsibility is missing in our aesthetic models, and the challenge of the future will be to transcend the disconnectedness and separation of the aesthetic from the social that existed within modernism.

Until the present time, remaining aloof has always been a possible alternative, but it is quickly becoming a dangerous approach to our current difficulties. Modernism above all exalted the complete autonomy of art, and the gesture of severing bonds with society. This sovereign specialness and apartness was symbolized by the romantic exile of the artist, and was lived out in modes of rebellion, withdrawal and antagonism. Talk about harmony, or fitting in, was anathema to the alienated self. Artists from Gustave Flaubert to Francis Bacon proclaimed their alienation from and antipathy toward society. "Life is so horrible," Flaubert wrote, "that one can only bear it by avoiding it. And that can be done by living in the world of art." When he was seventeen, the painter Francis Bacon recounts, he remembers looking at a dog shit on the pavement and suddenly realizing, "There it is—this is what life is like." For Jean-Paul Sartre, the basic truth of the human situation was its contingency, man's sense that he does not belong—is not necessary—to the universe. Since life was arbitrary, meaningless and without intrinsic value, Sartre advised that we must all learn to live without hope. The English critic Cyril Connolly wrote these legendary comments: "It is closing time in the gardens of the West. From now on an artist will be judged only by the resonance of his solitude and the quality of his despair." Colin Wilson, in *The New Existentialism*, refers to all this as the "futility hypothesis" of life—the nothingness, estrangement and alienation that have formed a considerable part of the picture we have of ourselves.

Today, remaining aloof has dangerous implications. We are all together in the same global amphitheater. There are no longer any sidelines. The psychic and social structures in which we live have become too profoundly antiecological, unhealthy and destructive. There is a need for new forms emphasizing our essential interconnectedness rather than our separateness, forms evoking the feeling of belonging

5

to a larger whole rather than expressing the isolated, alienated self. The old assumptions about a nuclear ego separating itself off from everything else are increasingly difficult to sustain in the face of our changed circumstances. Exalted individualism, for example, is hardly a creative response to the needs of the planet at this time, which demand complex and sensitive forms of interaction and linking. Individualism, freedom and self-expression are the great modernist buzz words. To highly individualistic artists, trained to think in this way, the idea that creative activity might be directed toward answering a collective cultural need rather than a personal desire for self-expression is likely to appear irrelevant, or even presumptuous. But I believe there is a new, evolving relationship between personal creativity and social responsibility, as old modernist patterns of alienation and confrontation give way to new ones of mutualism and the development of an active and practical dialogue with the environment.

In her book *The Aquarian Conspiracy*, Marilyn Ferguson describes how many people, in spheres of life as diverse as psychology, economics, politics, science and medicine, have been responding to the imperatives of the new paradigm by examining the shared goals of our society and subjecting them to critical reappraisal—assumptions about who we are, what kind of universe we are in, and what is ultimately important to us. These people have been finding the will to break the patterns into which we have crystallized, realizing that if we are to avoid destroying the integrity of the ecosystem, we must redesign our fundamental priorities. The world has about forty years, according to a report issued early in 1990 by the Worldwatch Institute, an independent Washington-based, environmental research group, to achieve an environmentally sustainable economy or descend into a long economic and physical decline. Dr. Noel J. Brown, director of the New York office of the United Nations Environmental Program, talks about a ten-year window to turn the tide against our environmental abuse. But none of these changes can take place, the Worldwatch report said, without a transformation of individual priorities and values—mate-

rialism simply cannot survive the transition to a sustainable world. In this sense the new paradigm is definitely more than just a conceptual challenge; it requires that we personally leave behind certain things that have been central parts of our individual and cultural self-definitions.

This book, then, is about reframing. The need for a reframing of the modern world-view and its assumptions in order to forecast the next step for society has been recognized in many professional spheres; within the art world, however, it has, as yet, no established correlative. The necessity for art to transform its goals and become accountable in the planetary whole is incompatible with aesthetic attitudes still predicated on the late-modernist assumption that art has no "useful" role to play in the larger sphere of things. But the fact is that many artists now conceive their roles with a different sense of purpose than current aesthetic models sanction, even though there is as yet no comprehensive theory or framework to encompass what they are doing. I see the task of this book as encouraging the emergence of a more participatory, socially interactive framework for art, and supporting the transition from the art-for-art's-sake assumptions of late modernism, which kept art as a specialized pursuit devoid of practical aims and goals.

The philosophies of the Cartesian era carried us away from a sense of wholeness by focusing only on individual experience. Ultimately this individualistic focus narrowed our aesthetic perspectives as well, due to its noninteractive, nonrelational and nonparticipatory orientation. Most artists still see art as an arena in which to pursue individual freedom and expression. Under modernism this often meant freedom from community, freedom from obligation to the world and freedom from relatedness. The emerging new paradigm reflects a will to *participate* socially: a central aspect of new paradigm thinking involves a significant shift from *objects* to *relationships*. It is what the philosopher David Michael Levin describes as "the rooting of vision in the ground of our needs; the need for openness, the need for contact, the need for wholeness." Whereas the aesthetic perspective oriented us to the making of objects, the ecolog-

ical perspective connects art to its integrative role in the larger whole and the web of relationships in which art exists. A new emphasis falls on community and the environment rather than on individual achievement and accomplishment. The ecological perspective does not replace the aesthetic, but gives a deeper account of what art is doing, reformulating its meaning and purpose beyond the gallery system, in order to redress the lack of concern, within the aesthetic model, for issues of context or social responsibility.

Redefining art and culture in terms implied by the new paradigm has been my most persistent interest for the last few years. The ideas I shall be putting forward are not necessarily all that new, or especially original to me, but they do demand a qualitative change in the way we think about art, and the prospect of these changes can be very unsettling. Some artists have taken offense at what I write because it doesn't appear to validate what they are doing; but a paradigm shift can't occur without consequences to the way we see and do things, and the uprooting of accustomed habits of thinking often has uncomfortable personal consequences. Condemnation of the ways that our society, as currently structured, fails to provide any context for a socially or morally sensitive art is easier, and less likely to demand a change of consciousness, than the more formidable effort of trying to construct a new vision and put it into practice. It is not part of our legacy to view ourselves as powerful agents of change; however, we are being confronted with the necessity of transforming our old modes of understanding if we are to survive the predicaments that are our collective fate right now. To create today is to create with responsibility. "I believe it is better to calmly admit," Albert Camus wrote prophetically in 1960, "that the period of the revered master, of the artist with a camellia in his buttonhole, of the armchair genius is over."

The way to prepare the ground for a new paradigm is to make changes in one's own life. Although my examples here are far from exhaustive (particularly in the second half of the book), they represent a small sample of many people who are beginning to reject the subjective indi-

vidualism of modernity and to work in an expanded context that gives value to social and environmental factors, and who are trying to express in their work some sense of service to the whole. It would seem that a single philosophy no longer accurately represents our culture, which is more accurately revealed right now in the interplay of its opposing tendencies; this means dancing through some of the most conspicuous contradictions in the present scene and considering opposite points of view.

To start with, I shall argue the case for both sides, two radically different pathways of thought, without pitting one side against the other, in order to draw the whole picture. Even though my own identification is strongly with one direction, I believe that the most fruitful developments are likely to take place where these opposing lines of thought meet. The arguments I shall put forward do not present "positions" to be held so much as standpoints from which one may challenge one's own beliefs; my aim is to enlist the reader's participation in rethinking the structure of values he or she has in place at this time, for they are the very essence of both politics and art.

These ideas are not a fully realized framework, but represent my own attempt to think about a new connective, participatory aesthetics, and to speak for a value-based art that is able to transcend the modernist opposition between the aesthetic and the social. As with my previous book, there are many quotes and no footnotes, in order to maintain the flow of narrative and commentary, and in the interest of greater liveliness and accessibility. The form of the text is not linear but cyclical, progressing more like a spiral that circles around and keeps joining up with itself again at new levels each time. What I have written has been inspired and enriched by the contributions of many contemporary authors in several different spheres, and I should like to formally acknowledge my debt here to all those individuals who have changed my way of seeing the world, and whose ideas I have "embroidered" with so unreservedly. The need for "reenchanting" our whole culture was first pointed out by cultural historian Morris Berman in his ground-breaking book, *The*

Reenchantment of the World. Particularly I also wish to single out the books of David Michael Levin, professor of philosophy at Northwestern University in Illinois, whose writing about the opening of vision and the cultivation of the listening self, as principles for a new and more feminine mode of Being based on interdependence and the intertwining of self and other, has been deeply provocative. Equally important are the ground-breaking books of Marion Woodman, a Jungian analyst in private practice in Toronto, whose exploration of the psychological impact of patriarchy and reconceptualizing of the feminine principle have, along with the work of other writers such as Riane Eisler, Carol Gilligan and Catherine Keller, seriously influenced the course of this book, and helped my own view of the creative potential inherent in partnership as a new model for the practice of art to emerge. I have also found certain ideas of psychologists David Feinstein and Stanley Krippner regarding the dynamics of transforming personal and cultural myths extremely useful to the process of reframing our culture. Lastly, the need for a new cultural coding more resonant with the emerging ecological age has been urgently called for by eco-philosophers Thomas Berry, Henryk Skolimowski and Joanna Macy, a call this book tries to answer. All these references, as well as countless others, are to be found in the bibliography at the end of the book. The inclusion of so many other voices in the text weaves a much richer tapestry of ideas than I could ever have produced alone.

Wherever possible, I have also let artists speak for themselves, and I am grateful to the many friends who shared their intentions and visions with me. I could have included many more artists, but I have tried to limit my choices to specific and hopefully well-chosen examples, rather than presenting an extensive compendium of all that is going on. There is also less personal information about individual artists and their career development than is customary in our ego-conscious milieu; discussions of individuals tend to merge into the whole. Indeed, the focus of inquiry is not on individuals, nor even on individual works of art, so much as on the aesthetic assumptions and the critical theories that hold our

view of art in place. Since my reality is not the same as anyone else's, and since most of the examples have been chosen out of my own experience rather than as an objective observer surveying the field, nobody else's choices are likely to be the same as mine. I have chosen only material that was personally resonant for me, that helped to build certain themes and to provide the threads to tie the various issues together. There are bound to be disagreements, but I hope the message and intention of the book will not be obscured by endless debates about who has been included and who hasn't.

The collective task of "reenchanting" our whole culture is, as I see it, one of the crucial tasks of our time, and I should like to offer what I have written as one more contribution to a collective project, a vision that I perceive is shared by many others. If it is accurate to trace many of our present dilemmas to what has been called the "disenchantment of the world," then the solution, presumably, must somehow involve a process that breaks the spell and circle of routines built up by modern culture and begins the transition into a different stream of experience. "Is a rendezvous between world and soul possible," asks Catherine Keller, "precisely where there reigns a multiply institutionalized politic of disconnection? In the Western mainstream, world has been scraped out of soul as surely as soul has been ground out of world." Dualistic metaphysics, Keller states, never completely captured the life-and-death energies of soul. Reenchantment, as I understand it, means stepping beyond the modern traditions of mechanism, positivism, empiricism, rationalism, materialism, secularism and scientism—the whole objectifying consciousness of the Enlightenment—in a way that allows for a return of soul. Reenchantment implies a release from the affliction of nihilism, which David Michael Levin has called "our culture's cancer of the spirit." It also refers to that change in the general social mood toward a new pragmatic idealism and a more integrated value system that brings head and heart together in an ethic of care, as part of the healing of the world.

Overcoming the crisis of disenchantment has become the greatest need of our culture at this time. As M.

11

Scott Peck demonstrates in *The Different Drum,* we cannot save our skins without saving our souls. We cannot heal the mess we have made of the world without undergoing some kind of spiritual healing. Before proceeding to tackle the "arguments," however, it might be useful to pause for a moment and consider what your concept of a "successful" artist is. What qualities does she have? What sort of "stance" in the world? Is the image that forms in your mind one that you can believe in? Is there anything about it that you would like to change?

CHAPTER 2
THE POST-AVANT-GARDE
Endgame Art, Hover Culture, Rearguard Action

It seems to me that the great question that our culture faces now is whether it's going to have the resilience to redefine itself and take off again.

Thomas McEvilley

At times inactivity is preferable to mindless functioning.

Jenny Holzer

I will act as if what I do makes a difference.

William James

I think the operative question today is, how useful would a confrontational culture, an avant-garde, be now?" The question was posed by deconstructive artist and critic Ronald Jones when I interviewed him in New York some time ago. It tracks a dilemma experienced by many younger

13

artists in the postmodern era, who find themselves in an "endgame" situation. As the great juggernaut of modernism, ruled for a century by the notion of perpetual innovation and the creation of new styles, reaches its fateful closure, the idea of participating comfortably in the old discourse of "originality" and change no longer seems possible. Jones claims that the idea of an oppositional or transgressive avant-garde—a counterculture that possesses the deftness to rearrange the terms of our culture or inspire fundamental reform—could only exist now like a sideshow. The avant-garde, which used to be the cultural "cutting edge," has been defeated and rendered impotent by its absorption into the mainstream. If art actually had the capacity to create revolutionary change, according to Jones, it would be excused from view; at this point, change only exists by permission of the culture industry, which likes to create the illusion that the culture is transforming itself, but which has not been engaged in turning itself over in any fundamental way for a long time. To act as if it will, therefore, is counterproductive, since the supply of spare parts for this lumbering pageant of perpetual change ran low long ago. Former strongholds of radicality can only exist now as agents of the system, rotating in time "with the economic tick-tock of the art market and requiring rewinding about every eighteen months."

Given the inevitability of cooptation, to try and formulate another confrontational culture, according to Jones, would serve no purpose except furthering the interests of the culture industry. During the 1980s, confrontation was reduced to hackneyed gestures, about as significant as rearranging deck chairs on the *Titanic*. He says that to imagine at this point that art can somehow transcend the power structure—as the process, conceptual and earth artists thought during the 1970s—or that it can change anything, is quite simply self-delusion. There is no longer any possibility of escape from the system, and the nondeluded individual of today is the one who has given up naive hopes, and any pointless idealizing of the artist's role. The post-avant-garde doesn't try to conquer new territories or concern itself with radical new futures; it understands that the modernist impulse has exhausted itself,

but makes no predictions about where our culture is going, or what will take modernism's place. "In the visual arts," writes Peter Halley in his essay "Notes on Abstraction," "the era of the early '70's believed itself to be a great flowering of postcapitalist culture. It believed that the commodity and its mind-set would be replaced by performance and by site specific works. . . . But the '70's represented not the last flowering of a new consciousness, but rather the last incandescent expression of the old idealism of autonomy. After this no cultural expression would be outside the commodity system."

Behind the pretenses of humanistic culture, according to Halley, lie "the nightmare scenarios of logic and determinism . . . a crystalline world responsive only to numerical imperatives, formal manipulation and financial control." It is the underlying structure of this world that Halley portrays in his cell-and-conduit paintings. While these appear to be in a historic lineage of geometric abstract art, they are actually not intended to be abstract. Rather, they are diagrammatic maps of our present social reality, images of nonliving systems—the digital grids of modernity in which everything circulates, but is closed. We are looking at symbolic structures of cells and walls, connected by electronic circuits. Malevich's transcendental square has become a prison, signifying not cosmic space but confinement. The cell is a reminder of the apartment house, the hospital bed, the school desk, according to Halley; the "stucco" texture is reminiscent of motel ceilings; and the Day-Glo paint is like the afterglow of radiation. Missing, or eliminated, from these diagrammatic prisons is any means through which to keep the soul's energy alive. "Capital has always spoken of itself as a culture of flux, premised on ideas of change, evolution and development. But capital is, in fact, a universe of stasis," he writes, "governed by immutable self-perpetuating principles. . . . The world of essences turns out to be dominated not by spirit, but by the commodity." Art may reveal the problematic nature of this situation by mirroring it, or by transforming it into a hollow parody of itself, but it cannot change anything. All the artist can do is betray the culture's

15

own models for corruptibility by treading water—stealthy maneuvers rather than overt activism. In the absence of any possibility of fulfilling heroic cultural ideals, the best line of approach is for the whole culture simply to pull the rug out from under itself.

"Here is a course of action," writes the French postmodern philosopher Jean-François Lyotard in *Driftworks:* "harden, worsen, accelerate decadence."

> Adopt the perspective of active nihilism, exceed the mere recognition—be it depressive or admiring—of the deconstruction of all values. Become more and more incredulous. Push decadence further still and accept, for instance, to destroy the belief in truth under all its forms.

Since art today has become an inconsequential exercise, the artist or intellectual facing the system has no choice but to cover up his tracks and slip into elusiveness. Today, what is revolutionary, at least in the opinion of Lyotard, is to hope for nothing, since the very notion of hope is one more pointless variation on a theme that has been heard too often. Critique must be drifted out of—drift is the only form of subversion that doesn't reinforce the status quo—a withdrawal of cathexis, letting the energy just drain away.

"It's one way of refusing our assigned role," says Jones. "Instead of creating anything new, we move into slow motion where nothing seems to change. We create a 'hover' culture. Throwing things into neutral becomes the most radically charged gesture of the moment." "Hovering" is about negating the modernist idea of change. The artist refuses to feed the culture's demand for new shows and innovative works, renouncing both authorship and originality. It is the kind of low-frequency effort exercised by Sherrie Levine, for instance, when in 1981, instead of creating her own "original" photographs, she rephotographed the work of Edward Weston and Walker Evans, two well-known photographers, and exhibited it as her own work. This action violates our sense of acceptable behavior; but it also refuses to serve the old modernist notions of originality and "who came first."

Seductive deception is the primary mode of Jones's work as well, where nothing ever operates at face value. What looks like a bland or demure piece of abstract art turns out to be the floor plan of a Nazi concentration camp, Hitler's bedroom or a U.S. government army map of the battlefield of My Lai. The six wall-reliefs that comprised his 1988 exhibition in New York represented the floor plans of a six-storied building, the Columbushaus, constructed in 1931 on Potsdamer Platz in Berlin, that once housed the German S.S. The reliefs present themselves as rather uninspired minimalist works, but their neutral wood surfaces mask what they really represent—just as the original Bauhaus architecture (designed by Erich Mendelsohn) successfully concealed what was actually going on inside its walls. (Even with the F. W. Woolworth Company installed on the ground floor of the building, prisoners marked out for the death chamber could arrive at the rear without being detected.) As with Peter Halley's work, conventional abstraction is contradicted by a hidden subversive content; "pure" art conceals a coded political reality. In 1989, Jones exhibited a group of five classic "modern" sculptures—biomorphic forms cast in bronze, resembling sculptures by Hans Arp and Constantin Brancusi. Each sculpture was set on stacked blocks of limestone and wood that perfectly simulated Brancusi's pedestals. As it turned out, these biomorphic forms were actually three-dimensional constructions of the HIV (AIDS) virus, and various DNA genetic fragments that trigger malignant tumor growth, masquerading as sculptures.

A lot of deconstructive postmodern art is about stripping away the ideological myths that held modernism together, particularly what critic Craig Owens has described as "that mastering position," the hegemonic, masculine authority that has been vested in Western European culture and its institutions. One way it does this is to simulate mastery—to undermine the fixation with originality—which still dominates our ideas of cultural production. Finding one's art ready-made is, of course, an old Duchampian formula for undermining the notion of originality, so we should not be surprised by Levine's more recent project of appropriating

components from Duchamp's *The Bride stripped bare by her Bachelors, even (The Large Glass);* Duchamp's cluster of nine little phallic shapes representing the "bachelors" have been realized as three-dimensional sculptures cast in opaque glass, with each one elegantly set in a cherry-wood vitrine. In another series of works, Levine appropriates abstract painting, the seat of the heroic modern masterpiece, and caricatures it as a genre style, in small stripe and checkerboard pictures that have only minimal allure. Levine says about her work that it is about "the uneasy death of modernism"; it only has a meaning in relation to everyone else's project—it has no meaning in isolation.

Instead of keeping culture moving, nothing new is produced. This is the politics of drift, or "hovering"; Peter Halley calls it "rear-guard" (as opposed to avant-garde) action, by which he means feeding the culture only that which is worthless: guerrilla ideas that know how to keep their cover; eccentric ideas that seem innocuous and so are admitted unnoticed by the media mechanism; doubtful ideas that are not invested in their own truth and thus are not damaged when they are manipulated; nihilistic ideas that get dismissed for being too depressing. (More examples of this are described in the following chapter, "Dancing with Baudrillard.") Rear-guardism is not only a rejection of revolution; it is also a deconstruction of the very idea of revolution—that modern, utopian aspiration which was part of a cultural experiment that failed. For artists to pretend that it succeeded, according to Halley, would be stupid. Rather we have to go on from here and confront the position we find ourselves in within our present culture. In the absence of objective possibilities for change, "an understanding of the limits," Halley states, "is less paralyzing than going off on some silly campaign based on false assumptions. That would be really paralyzing."

Hope turns out to be the vital issue at stake here: it seems to be where the dividing line has to be drawn between two very different interpretations of postmodernism and the human future that are emerging simultaneously in our culture, as between those who continue to aspire to transforming our dysfunctional culture, and those who believe such a

hope is naive or deluded. Obviously, how we see the future has everything to do with how we live in the present. For the first time in recorded history, the certainty that there will be a future has been lost; this is the pivotal psychological reality of our time. According to the French social philosopher Jean Baudrillard, there is no future. Everything has become "nuclear, faraway, vaporized"; and the ending of the possibilities for art merely reflects the more general ending of reality itself. Since everything has already been wiped off the map, Baudrillard finds it useless to hope, or to dream. In an amazing essay called "The Anorexic Ruins," Baudrillard claims that the great artistic visions were those of the years from 1920 to 1930. Since everything has been done already, today we are only inferior imitators. Intrinsic values have been replaced by simulated, synthetic values. "The maximum in intensity lies behind us," he states. "The minimum in passion and intellectual inspiration lie before us." Quite simply, according to Baudrillard, there is no life any longer in our societies, although the vital functions continue. One comes to an arrangement with the situation; reciprocal indifference is negotiated.

This pervasive need of the deconstructive mind to know what is not possible anymore would seem to represent an absolute terminus in the "disenchanted" modern world view; the self-checkmating of a now dysfunctional but apparently immovable dominant social structure. Deconstructive postmodernism does not ward off the truth of this reality, but tries to come to terms with its inevitability, in what are often ironic or parodic modes that do not criticize, but simply declare art's pointlessness openly, and bait us with its indifference. Artist Dan Graham has stated that "to carry on under the aspiration to effectivity is itself—tragically—to court the bad faith which afflicts so much would-be social art, which continues to find its home in the Modernist gallery and museum because there is nowhere else for it." What we now need, according to Graham, is not effectiveness but "adequacy to the blackness, the margin, the pragmatic pointlessness yet absolute value of critical reflection in conditions approaching the void."

Obviously it makes a difference whether or not

this sense of nihilism is a potent factor at the deepest level of an artist's consciousness—and for many people, Baudrillard's writings have been the *Maldoror* of our time—since it decisively alters one's approach to the work he does. "We are living in an age of skepticism," states another deconstructive artist, Thomas Lawson, "and as a result the practice of art is inevitably crippled by the suspension of belief. The artist can continue as though this were not true, in the naive hope that it will all work out in the end . . . (but) the complexity of the situation demands a complex response."

Instead of carrying forward the betrayed ideology of the old avant-garde, the deconstructive artist may resort to fraudulence, or deliberately adopt the posture of a charlatan by becoming, for instance, a counterfeiter who simulates the work of other artists. He or she is not going to get us out of the mess we're in, but uses strategies of subterfuge and calculated insincerity to disguise his (or her) intentions. The English artist Simon Linke, for instance, has meticulously copied commercial gallery advertisements straight from the pages of *Artforum* magazine, which he then sells as beautifully painted works of art. Whether the artist intends this as radical criticism or inspired clowning is hard to tell. Mimicry, the imitation and recycling of previous aesthetic styles, appropriating someone else's work as one's own, simulation, camouflage and counterfeiting (Mike Bidlo, for instance, copying paintings by Picasso, Magritte and Jackson Pollock) are all means of deliberately thwarting the development of one's own work so that it no longer functions in sync with the proper historical development of art, as we have come to understand it. (A recent project by Bidlo involved copying to scale some eighty-four paintings of Picasso's women; Bidlo always works from color reproductions, never from originals.) These actions directly violate our notions about creativity, particularly according to the modernist canon, as being based in innovation, authenticity and originality. "As freakish as it must sound," states Jones, "spurning change . . . reasserts the artist as the arbiter of a radicalized culture." "If the center does not hold, Annelie Pohlen wrote recently in *Artforum*, "if the final efforts of a philosophical and ideolog-

ical commitment have lost credibility, then . . . the celebration of noncommitment may appear as the ultimate stability in instability. In any case, that would seem to be the best way to describe the current mind-set of Western culture. The era of utopian vision now belongs to history, and any reassertion of utopian values must now smack of romanticism."

"Endgame" art embodies a retrospective reading of modernism that is fully aware of its limitations and failed political ambitions; we can no longer depend on the avant-garde to institute change. To replace modernism's utopian mission of social transformation with subversive complicity raises the question of what "a truly conscious postmodern practice"—what the substance of radicality—really is, after the closure of modernism. What future, if any, does it hold? How do we conceive of the post-avant-garde artist? The other question, of whether postmodernism offers any real break with the "disenchantment" of the modern world view, cannot be adequately addressed, I feel, without an understanding that there are two postmodernisms—a deconstructive and a reconstructive version—each representing the pole opposite to the other, and each believing that its scenario and view of the future is the correct one.

"Finally," states Lester Milbrath in *Envisioning a Sustainable Society*, ". . . we have no choice but to change. Facing that prospect, it is wiser to believe that ordinary people can help bring about change than to deny cynically that change is possible." Thinking in terms of both these possibilities at the same time—that change is no longer possible and that change is inevitable—leads to a peculiar paradox, and is the provocative juncture at which this book begins. I shall need, thus, to consider several narratives of postmodernism, and to orchestrate the dialogue between them—since not yet visible in the "official" picture of postmodern reality just described is a different vision, one that presents a much more forward-looking picture of our future possibilities.

Although the two postmodernisms have quite discrete and even opposing philosophical attitudes, what they share in common is an understanding that the belief system that belonged to modernity has become obsolete. Where they

21

differ is in deciding how to respond to the demands for cultural renewal and change, and in assessing whether art (at one time the primary architect of modern ideals) can be effective in this way anymore, given the resistance of twentieth-century capitalism to radical transformation.

Much of my text is devoted to creating a framework for reconstructive postmodern practice, which, although less visible in the mainstream than deconstructive art, implicates art in the operative reframing of our entire world view and its Cartesian cognitive traditions. Reconstructivists are trying to make the transition from Eurocentric, patriarchal thinking and the "dominator" model of culture toward an aesthetics of interconnectedness, social responsibility and ecological attunement. As Morris Berman writes in *The Reenchantment of the World*, "If there is any bond among the elements of this 'counter culture,' it is the notion of recovery . . . of our bodies, our health, our sexuality, our natural environment, our archaic traditions, our unconscious mind, our rootedness in the land, our sense of community, and our connectedness to one another."

The essence of the new paradigm emerging in physics, general systems theory and ecology changes our whole idea of reality with the notion of interconnectedness—an understanding of the organic and unified character of the universe. Beyond Cartesian dualism is the knowledge that you cannot break up the whole. As we begin to see the world through the lens of ecology, we also begin to reshape our view of ourselves. The holistic paradigm is bringing inner and outer—subjective and objective—worlds closer together. When this perception of a unified field is applied to human society and to culture, it makes us a codetermining factor in the reality-producing process; we are not just witnesses or spectators. The "observer" is a notion that belonged to the classical way of looking at the world. The observer could approach the world without taking part. But this is not the case within a holistic view. If "world making" is the principal function of mind, then social reality does not just "happen" in the world but is constructed from the way our private beliefs and intentions merge with those of others. A world

22

view in this sense is not something found "out there," but is something individuals construct and create. The issue of what beliefs we hold is therefore crucial. For instance, a belief that resistance to the dominant social structure is futile, because the structure is too ruthless or too powerful, will have the effect, if accepted by enough people, of stabilizing the relations of dominance. What we are learning is that for every situation in our lives, there is a thought pattern that both precedes and maintains it, so that our consistent thinking patterns create our experience. By changing our thinking, we can also change our experience. People give legitimacy to all social institutions, no matter how powerful those institutions seem to be, and they also have the power to withdraw legitimacy.

Although it may seem as if the individual in today's world has little power, the truth is that only we have the power to transform our situation: *there is no one else.* The source of creativity in society is the person. Where individuals and social transformation converge is in this personal breakthrough to a new way of seeing. Both the problem and the level at which the solution emerges are manifested initially in the individual, who is also an organ of the collective. What happens in the individual is typical of the total situation and is the place where future solutions emerge. It is also true, however, that individuals cannot be liberated from coercive social institutions as long as they retain the ideological world-picture that holds these institutions in place. As philosopher and theologian David Ray Griffin points out in his essay "Peace and the Postmodern Paradigm," we will not overcome the present disastrous ways of ordering our individual and communal lives until we reject the view of the world upon which they are based. And we cannot reject this old view until we have a new view that seems more convincing. Change is most likely to occur, according to Griffin, through people who are as far removed from cynicism as they are from utopianism.

It all comes down, finally, to the kind of culture we take to be the most desirable, and to whether we are prepared to say what sort of world view would support the cre-

ation of a future different from our present situation. History provides many examples of monolithic social systems that changed: feudalism, slavery, colonialism. At this point, it is rapidly becoming obvious to many people that the achievements of modern technocratic society have been a mixed blessing, and that our profit-maximizing, competitive attitudes will have to be transformed, because the present values of growth, power and domination are not sustainable.

We live in a toxic culture, not just environmentally but spiritually as well. If one's work is to succeed as part of a necessary process of cultural healing, there must be a willingness to abandon old programming—to let go of negative ideas and beliefs that are destructive to the planet and to life on earth. But what does this mean for art? Jungian psychoanalyst Marie-Louise von Franz says: "A civilization which has no creative people is doomed. . . . The person who is really in touch with the future is the creative personality." Heinz Kohut, another psychoanalyst, has called this "the anticipatory function" of art; those artists who are in touch with the necessary psychological tasks of a culture prepare the way for the culturally supported solution to a conflict to emerge, or for the healing of a psychological defect.

Obviously, while our world view is still under the sway of the struggle-for-survival mentality, and the message we are all being sent is "every man for himself," we are less likely to effect change unless the psychological obstacles within ourselves are first removed. It makes a difference whether or not a sense of hope is a potent factor at the deepest level of an artist's consciousness, since hope radically alters one's inner intention and feeling of purpose. Medical research in the relatively new field of psychoneuroimmunology, studying the intimate neuronal and hormonal bonds between mind and body, has established, for instance, that hope and a positive attitude are potent factors in healing, just as depression, despair and hopelessness have been found to be biologically destructive, and to depress the immune system. Belief is a potent medicine.

From this perspective, the willingness to throw out tough-minded empiricism and to believe that individual

actions can make a difference is not necessarily a *glissade* into self-delusion, but rather our most valuable resource— what Marilyn Ferguson calls "the new common sense" of the pragmatic visionary. From this perspective, labeling as idealistic, utopian or naive those who believe change is possible can be seen as the most effective way to make sure that things are left exactly as they are. As New York artist Mary Beth Edelson stated, when she was asked in an interview whether she felt optimistic about our society moving in the direction of ecological and cooperative stability: "It doesn't make a difference in my behavior whether there is a chance that this will succeed or not. I will still behave as if these goals were a possibility, regardless of what my doubts are. . . . The opposite of not hoping is what we have—extraordinarily paralyzing, cynical alienation. If we sit back and say, 'We are not going to do anything because it's useless,' obviously nothing is going to happen. What makes things happen is believing that they can happen. What some people call fooling ourselves may be our only hope." In *Staying Alive*, Roger Walsh quotes automobile tycoon Henry Ford's famous remark: "Those who believe they can do something and those who believe they can't, are both right." At each moment we see both sides of the polarity. Each of us is capable of either view, but which of them we actually hold will determine our priorities and how we will act. Social renewal depends on individuals, but individuals cannot achieve renewal if they do not believe in the possibility of it. The precondition for any human effort is optimism, the leap of faith that William James saw as rooted in life itself.

Increasingly, as artists begin to question their responsibility and perceive that "success" in capitalist, patriarchal terms may not be the enlightened path to the future, which of these views they hold definitely affects how they see their role: as demystifier or as cultural healer. Healing is the most powerful aspect of reconstructive postmodernism, whereas for the deconstructivist, it would seem that art can only deconstruct. There is no future beyond deconstruction. Lyotard, for one, makes this point irrefutably clear in an interview with Brigitte Devismes, published in *Flash Art*:

Interv. Even those who understand what this type of action aims at often object that "you offer nothing to replace what you are destroying." What can you answer them?

J-F.L. In my opinion the problem is unimportant and irrelevant: we are *called on* to produce the theses of a new school, and that is out of the question. That's finished, it is no longer possible. I believe demystification is an endless task. This is where the concept of a "permanent revolution" can be given its true dimension. . . . What was once part of the avant-garde always becomes part of the rear-guard and, as such, loses its disruptive power. That is the strength of the capitalist system, its capacity for recovering anything and everything. In this sense, the "artists" are pushed forward, they are literally chased out of the very deconstructed forms they produce, they are compelled to keep on finding something else. I believe their research knows no other drive.

Disrupting a reality so pervasive that we can't see any other way of being is not possible without shedding the "old mind" conditioned by our culture. And it is precisely at this crossover between the reactive mode of deconstruction and the more active mode of reconstruction—in which we are no longer merely the observers of our social fate but are participating cocreators—that a change from old-paradigm dynamics into new is likely to occur. As participating cocreators, we become ourselves the shapers of new frameworks, the orchestrators of culture and consciousness. Transformation cannot come from ever more manic production and consumption in the marketplace; it is more likely to come from some new sense of service to the whole—from a new intensity in personal commitment. Despite claims by social critics like Lyotard and Fredric Jameson that our society reflects the absence of any great integrating vision or collective project, the great collective project has, in fact, presented itself. It is that of saving the earth—at this point, nothing else really matters—though this is not always readily apparent, as my friend James Marriott wrote me from London: "I have long had difficulty coping with the contradiction between being

in Art College (which wants objects, nonrelated to specific places or wider social issues, quintessentially non-useful and ideally commercial) with my own work (long-term projects, non-object-based, not concerned with aesthetics and commerce but focused on specific questions of local, ecological and social transformation)."

In our present situation, the effectiveness of art needs to be judged by how well it overturns the perception of the world that we have been taught, which has set our whole society on a course of biospheric destruction. Ecology (and the relational, total-field model of "ecosophy") is a new cultural force we can no longer escape—it is the only effective challenge to the long-term priorities of the present economic order. I believe that what we will see in the next few years is a new paradigm based on the notion of *participation*, in which art will begin to redefine itself in terms of social relatedness and ecological healing, so that artists will gravitate toward different activities, attitudes and roles than those that operated under the aesthetics of modernism.

It is important to understand that any remapping of the modern paradigm has both a deconstructive and a reconstructive dimension; they need to be seen not as opposites, with sharp boundaries drawn between them, but as components in a larger process, operating simultaneously like the complementarity principle. The key is to bring the two components into relationship, so that they will not remain poised forever in mutual antagonism. I personally see the contradictions between the two postmodernisms as very productive, since it allows us to investigate both the darker and the lighter paths to the future without accepting the inevitability of either. Contradictions in beliefs offer not only the greatest depth of field, they also project clear alternatives from which to choose. This can be quite useful, given the general mind-set that believes we no longer have choices. Choices, however, are never value-free, and so in any reevaluation process, the basic step is to confront what it is that we actually believe—only then can we truly determine where we stand, right now, in relation to our culture. A former student of mine, Amy Olds, put the problem very well:

[We have been taught that] we must learn to face *reality*. What is reality? I believe that our society's definition of reality is the core of the rotting apple that is our world and its doomed predicament. I also believe that art has played a key role in forming our society's definition of reality, but that it has the power to redefine that concept.

When we see cynicism even in our art, it reinforces our belief in a negative, cynical reality. We've come to appreciate and expect cynicism in art as an intellectual game about the definition of reality. Recently the people who create art movements, artists as well as art critics, have come from this mindset also. They teach us that cynicism is interesting because it relates to life. Hope and optimism are generally hated, made fun of, considered hokey, childish, and sometimes fanatic, simply because they are not concepts that people of any intellectual stature believe in. But the truth is that people actually do want to believe in a positive world view. . . . We've seen that art has the power to form negative visions of the world through magnifying the undercurrents of cynicism, so it must be possible to create a positive vision of the world through focusing the aspirations of hope.

Even if we are not the helpless victims of our beliefs, the exquisite paradox is that we can choose to believe we are, as Roger Walsh points out. Knowing that our beliefs have consequences, we must be very careful in their use. What we have formerly considered to be objective reality we are discovering to be a subjective experience of creating and being created, both of which go on simultaneously. The mind is not a static thing; it learns new knowledge, new concepts, new world views, and these perceptions guide our actions as much, if not even more, than seemingly irrefutable facts. Obviously the reenchantment of art being envisioned here will require for its realization the willingness to acknowledge that the cultural future is not irrevocably foreclosed, but is still open.

28

CHAPTER 3
DANCING WITH BAUDRILLARD
Postmodernism and the Deconstruction of Meaning

Meaninglessness inhibits fullness of life and is therefore equivalent to illness. Meaning makes a great many things endurable—perhaps everything.

Carl Jung

At this time, I can't think of anything more meaningful than taking meaning apart.

Meyer Vaisman

I have seen many people die," wrote the French writer Albert Camus, "because life for them was not worth living. From this I conclude that the question of life's meaning *is* the most urgent question of all." If it is true that the creation of meaning is vital to life, and that the human organism does not fulfill one of its essential biological needs when it does not have a framework of meaning, then how are we meant to respond to the undermining of the very legitimacy of meaning itself in the work of deconstructive philosophers like Baudrillard and Lyotard? We seem to be

experiencing in our culture a radical break with the will-to-meaning, which until now has always been understood as a fundamental drive of human life. The loss of meaning I am talking about involves two quite different levels, only one of which concerns the way that signs or images may be deconstructed to destabilize the symbolic order. There is also the greater loss of a mythic, transpersonal ground of meaning in the way that our particular culture transmits itself. It is the spirit, or "binding power" holding everything together, the pattern connecting and giving significance to the whole, that is lacking in the underlying picture we have of our world.

Deconstructivists claim as obsolete any necessary union of a signifier and a signified; this emancipation of the sign (or image) releases it from any "archaic" obligation it might once have had to designate a specific meaning. Mobile or "floating" signifiers maintain no fixed relationships; they can break with any given context and engender an infinity of new contexts. This is exactly what we experience, for instance, in the paintings of David Salle: the loss of narrative meaning and its social function. In the layered and slippery space of postmodernism, anything goes with anything, like a game without rules; images slide past one another, dissociated and decontextualized, failing to link up into a coherent sequence. When the Surrealists juxtaposed disjunctive and decontextualized images, they wanted to shatter the parameters of the rational, everyday world and to spark off new and unexpected poetic meanings. Salle, however, does not seem to be doing this; his images function more like Warhol's—neutral in their isolation, and "performing" without expressive or manipulative intent. Salle's images exist without any referent. Meaning becomes detachable, like the keys on a key ring. The nonreciprocal interactions among the images do not fix or hold meaning; they offer the illusion that something is taking place, but the real game is just to stay in free fall. "Strictly speaking," to quote Jean Baudrillard, "nothing remains but a sense of dizziness, with which you can't do anything."

Because the unifying presence of a belief in a transcendental cosmic order no longer exists in our culture,

the implication is that works of art can no longer offer the sort of unified vision of the world that existed, say, in the Renaissance. Meaning, according to deconstructivism, is another of those comforting illusions that need to be surrendered; from our present perspective of discontinuous vision, in which symbols have been uprooted and disconnected from their source, to see the world as indifferent to meaning is to see it "truthfully," without distortion or projection. "Even before Auschwitz," wrote the German philosopher Theodor Adorno, "in the face of historical experiences, it was an affirmative lie to ascribe to existence any meaning at all." Adorno's meditations on the social implications of Auschwitz led him to the belief that any idea of harmonizing with the world, of striving for a positive or *meaningful* relation to it, is cheap optimism, like the happy ending in movies, obtained by repressing the reality of radical evil and despair. For Adorno, the clichés about art casting a glow of happiness and harmony over an unhappy real world are loathsome. The shock administered to modern society by the presence of the concentration camps made the notion of a benevolent, or meaningful, universe seem naive and unrealistic forever: there is no meaningful order now—if there ever was any—to which anyone can belong. "I define postmodern," writes Jean-François Lyotard in *The Postmodern Condition,* "as incredulity toward metanarratives." Life presents itself, in our current society, as an endless accumulation of meaningless spectacles, originating in the loss of any unifying narrative of the world. Salle's pictures deal with spectacle, not with meaning. Therefore, to interpret them is to make a false move; we are warned by Baudrillard that, in general, it is dangerous to unmask images, since they dissimulate the fact that there is nothing behind them.

The really exemplary voice is that of the seminal theoretician who has been most influential in orchestrating the art world's whole deconstructive scenario, Jean Baudrillard, for whom the revolution of postmodernity is the immense process of the deconstruction of meaning. This revolution, the second great revolution of the twentieth century, is equal, for Baudrillard, to the earlier revolution that entailed the

deconstruction of appearances. If Baudrillard is the wizard-priest of postmodernism, the paintings of David Salle are certainly the setting around which this particular way of thinking, this aesthetic style and mood, are expressed. Salle has denied that his paintings are intended as any sort of commentary on the state of our culture. His images are important to him not as social criticism, but, he claims, "in their own mechanistic ways . . . in a detached way." For many postmodern artists acting under the sway of Baudrillard's metaphysics, it is not meaning, or the increase of meaning, that gives pleasure; rather it is its neutralization that fascinates, and fascination does not depend on meaning.

Salle's ironic detachment seems to suggest that his choice of images implies no particular commitment or social statement, as far as he is concerned. This is close in a way to Roland Barthes's notion that meaning is not communication (information) or signification (symbolism), but is always in play, always different. Unbalancing the meaning is the only way of avoiding the "tyranny of correct meaning." Barthes even goes so far as to claim that the obligation of language to say things is actually fascist—fascism being not the prohibition of saying thing, but the obligation to say them.

But, if meaning is what makes the world, how is one meant to respond to this movement of autonomous images, willfully withdrawn from signification—images that no longer narrate, but in their detached free-floatingness actually obstruct any attempt at decipherment? Here is the response of one critic, Thomas Lawson, writing in *Artforum:*

> Salle records a world so stupefied by the narcotic of its own delusionary gaze that it fails to understand that it has nothing actual in its grasp. Amid seeming abundance, there is no real choice, only a choice of phantasms. The world described in Salle's work is a jaded one, rife with a sluggish melancholy. The steady leaching of meaning from objects and images breeds an enervating uncertainty. Artist and viewer alike stumble through a maze of false clues and incomplete riddles, coming on the same viewless arrangements and empty repetitions in the search for a coherent identity. Signs

and props are ritually shuffled like so many commodities on the floor of a department store of the imagination, with a compulsive repetition that offers a dwindling satisfaction.

For Lawson at least, it would appear that Salle's proliferating images have all the resonance of paper clips clashing in the night. In this radical negation of the sign, no patterns of meaning, no corrosive flashes of insight, are being brought to light. But must an image be understood to be valued, in order for us to know how to react to it? Looking at art that refuses all judgments, that does not discriminate between experiences, corresponds to our stupefied fascination before the TV set, as we aimlessly flip from station to station. Passivity in front of the spectacle is the very opposite of waking up, looking at events critically, seeing reality and feeling responsible—that is to say, *responding* to what is going on. Responsibility implies that one is carrying out intentions, shaping the environment, influencing others. So the question is, how much responsibility are we willing to take for exercising intentionality in the world?

In the catalogue essay that accompanied the Salle retrospective at the Whitney Museum, curator Lisa Phillips points out how, in the electronic landscape of television, "the unrelenting abundance of data and its transmission . . . make each image, word or impulse signify less and less." In a televised universe the real and the imaginary, the catastrophic and the trivial, coalesce on a single plane of electronic flow— there is more and more information and less and less meaning. But unlike Lawson, Phillips sees the autonomy of images in Salle's work as a liberating force. She writes: "His paintings breathe life even as they speak of a loss of it. The pure, untranslatable sensuous immediacy of the images refuses to be violated by interpretation. The paintings are ineluctable presences even as they expose us to the experience of absence."

We are now faced with a curious situation in which meaning has become so detached from itself that its central collapse defines much of the art of our time—to the point where the "will" to meaning often deliberately courts

meaninglessness and even finds satisfaction in it. Nowhere, for instance, is what Baudrillard calls the "beautiful effects of disappearance," better illustrated than in the *Plaster Surrogates* of Allan McCollum, works that simultaneously dramatize and thwart our desire to look at pictures. On closer scrutiny, McCollum's "paintings" reveal themselves to be simulacra—pseudoartifacts in which picture, mat and frame are all one seamless object, molded in plaster—yet there is nothing to see. In place of any communicating image is a dark, thick substance, like pitch—a pure screen of black, whose emptiness would seem to express the posthumous condition of art and culture. To simulate is to play what Baudrillard calls the "disappearing game" of postmodernism, which he claims is the best we can afford today, since nothing is real anyway. "If only art could accomplish the magic act of its own disappearance!" states Baudrillard. "But it continues to make believe it is disappearing when it is already gone."

McCollum's simulations of conventional art objects are like signs from a language, but not the one you think you know. Hung in groups to resemble a crowded salon show, sometimes by the hundreds, they are like steps to a palace that can never be rebuilt or remembered—where only the allegory of the empire remains. "I'm just doing the minimum that is expected of an artist and no more," McCollum has stated. "I'm trying to orchestrate a charade." If these objects are intended to make us aware of a particular ideological delusion, then we must ask ourselves what it is that we are deluded about. In the age of simulation, video dogs and cats can be bought for twenty dollars that will chase after video bones and balls of string, providing (to quote an article from *Time* magazine) the "full, rich experience of owning your own pet without the mess and inconvenience of the real thing." Computer scientists are now working on creating artificial realities that will allow people to play simulated tennis games, for instance, without ever leaving their living room, by wearing a special computerized helmet and gloves. Within these competing visions of staged masquerades and *tableaux vivants,* the line between the art of the simulacrum and the psychologically charged spoof is a very thin one.

Since nothing separates true from false anymore, how can we possibly assess the reaction of the power of structure to a perfect simulation?, asks Baudrillard. By feigning a violation, he suggests, and putting it to the test. "Go and simulate a theft in a large department store," he proposes in *Simulations*. "Or organize a fake hold-up. . . . How do you convince the security guards that it is a simulated theft?" You won't succeed, because the web of artificial signs will be inextricably mixed up with real elements (a police officer will really shoot on sight, or a customer will really faint from fear). Likewise, I shall ask, how do you convince an art dealer that McCollum's pictures are not "real" works of art, but simulations? You won't succeed here either, because collectors will buy them, dealers will show them and critics will write about them; even simulations cannot escape the system's ability to integrate everything. And so it is that art survives its own disappearance: somewhere the real scene has been lost, but everything continues just the same.

Recently, the following story in *Arts* magazine caught my eye. A southern millionaire named Lee Terry had invited a group of forty artists, dealers and their families to Atlanta for the weekend to see his collection of their works. One of the guests, Steven Henry Madoff, recounted that after a lavish meal served at Terry's home, the sudden arrival of a special guest, the country and western singer Willie Nelson, was announced by the bandleader. As Nelson crooned "Georgia on My Mind" late into the night, one of the guests, artist Donald Lipski, threw him his jacket, by way of homage. During intermission, everyone crowded around the singer, requesting his autograph. Later, it emerged that the singer hadn't really been Nelson at all, but an impersonator. Madoff continues: "Nobody could believe that Mr. Terry would pull such a stunt. Yet the host was simply standing there, laughing obscurely in the pool's shimmering light. Everyone was confused. Some were outraged. Some thought it was the best practical joke they could remember." But few of them, says Madoff, believed this amazing game of simulation had been Mr. Terry's intention. At the end of the evening, Anne Plumb, a dealer, turned to the host and asked him what the idea of hiring the fake was. Madoff recalls: "[Mr. Terry] was defen-

sive by then, realizing that some of us were hurt by the evening's entertainment. 'I've been buying your crap for a couple of years.' he replied. 'I thought you ought to try some of mine.' "

In a society where radicality in art is seen as having no consequences, strategies of parody and indifference retreat behind the contradictions rather than trying to overcome them. Works of art come to represent themselves as objects of consumption, becoming even more commodified than commodities. We are all implicated in this unfolding spectacle, made numb with endless variety and inordinate display. "When all else fails," comments Jonathan Porritt, author of *Seeing Green,* "there is infinite solace in being able to choose between thirty-two varieties of cat food." How does one deal with cultural inauthenticity if one's means and materials are indistinguishable from those of the cultural reality one is attacking?

Reduplication has its own particular fascination in the absurd but alluring "product art" of Haim Steinbach, who buys his art objects ready-made at Conran's, Bloomingdale's or the supermarket. Steinbach seductively arranges and displays the purchased items—tea kettles, digital clocks, lava lamps, water pitchers, trash receptacles, boxes of cereal, radios, cooking pots, towels, boxes of detergent, sneakers—on specially constructed formica shelves for the viewer-customer. In a work entitled *supremely black,* three boxes of Bold detergent are displayed with two gleaming, black, deco-style water pitchers, and in *pink accent*[2], we have two rubber Halloween masks, a pair of stainless steel trash cans and three tea kettles. More recently, Steinbach has been using expensive jewelry, antique furniture and museum-quality primitive artifacts from all over the world in his displays; and, in a surprising departure, he presented a battered mattress and a two-wheeled shopping cart that he found abandoned on the streets in his neighborhood in Brooklyn. Generally, art works are priced according to size, but in Steinbach's case, the buyer must also absorb the original cost of the displayed objects. Steinbach's art personifies the spectacle as its own product, the total justification of the existing system's conditions and

goals—at every turn an ever-accelerating number of products within reach, under our noses, inviting endless choice and making the decision of the consumer illuminate our culture's own uninterrupted discourse about itself. The whole issue of having to make choices, of even knowing what one wants, is really a bore, according to Baudrillard—a burden that, deep down inside, no one secretly wants any part of. To illustrate this hermetic wisdom, he recounts a story about Beau Brummell, who, when traveling in a region of Scotland that has many lakes, each more beautiful than the other, turned to his manservant and asked, "Which do I prefer?" "That people are supposed to know, themselves, what they want—I think we have pressed beyond that point," he adds, "beyond truth, beyond reality." Commodity fetishism is the distinguishing mark of our culture, and the artist's consciousness has been fatally enriched with this knowledge.

"It is one thing to speak about this situation, it's quite another matter to recognize how we participate emotionally in this ecstasy, how we should monitor it," Steinbach stated at a symposium on "Avant-Garde Art in the 80s," in which he and I participated at the Los Angeles County Museum in 1988. "We live in a culture of pornography, we are engulfed by it, contained in it. We are not standing by the riverbank watching this excess of shit flow by, rather we are flowing with it, in it." What would it take for an entire society to recover from the addictive system in which we live? There is little encouragement to change our orientation, because compulsive consumption is what keeps our culture going, as well as being supported by it. In the distortions of the market, where culture is itself disseminated as a product, these distinctions, rather than being polarized, now cancel each other out. Like Jeff Koons, Steinbach dissolves the difference between our desire for commodities and our desire for art. In the logic of the commodity, objects have no relation to the world, they only have a relation to the market, and such is the fate of our art: everything acts to commodify consciousness. As for the artist, we are never sure whether she is the accomplice or the opponent of consumer culture, which promises that it is possible to have everything we want

37

and need, as long as we accept and conform to the system. "On an emotional level," says Steinbach, "artists are recognizing the extreme state of ambivalence they find themselves in, feeling revulsion and fascination at the same time. They also recognize that this is not going to change. . . . Aware that our culture is excessively artificial, and even meaningless, we choose to live in it. We will at times use irony, mimicry, and even mockery, in order to identify the position we are in."

In *Luxury and Decadence,* a 1986 exhibition of the work of Jeff Koons, art signals itself as the ultimate capitalist metaphor. Koons took liquor decanters, emptied of their bourbon, and cast them in stainless steel. Then he sent them back to the distillery to be refilled with liquor and sealed with a tax stamp. Should the decanters ever be opened, or the tax seal broken, the artist asserts, their identity as works of art will be spoiled. To drink the liquor is to take the work out of the realm of art.

For Koons, almost anything can be used as a symbol of false luxury—a traveling bar, a bust of Louis XIV, an inflatable toy rabbit, a gift-shop sculpture, some ludicrous gimcrack cast in stainless steel by the artist to become another fancy item gleaming on the shelf or locked in the display case—not because it might still be used for something, but so it can be assembled along with other specimens of the collection.

Knowing that the fate of radical art is to end up as furniture in somebody's living room, the idea is to intensify an already unsatisfactory situation by pushing things a little further. Chicago artist Tony Tasset designs his art in advance to fit in easily and comfortably with suburban living, the context in which it will be consumed, and to blend in nicely with the other furnishings. Using expensive materials such as leather and suede, Tasset's sculptures, like *Seated Abstraction,* look like cushioned furniture. His paintings, which he refers to generically as "domestic abstractions," are made from fur or animal hide to simulate abstract pictures— with maybe even a convenient shelf added at the bottom to hold cocktail glasses.

38

"I don't think we take a critical stance," Meyer Vaisman said recently to Claudia Hart, who interviewed him in *Artscribe*. "I don't feel it is the responsibility of an artist to judge whether a culture is good or evil. . . . But I believe that the most interesting art thoroughly intersects the civilization that it is in and exists with it." Nevertheless, he adds, "I truly feel paralyzed. I don't see any chance right now for 'revolution.' "

Thus it is that postmodern parody does not claim to speak from a position outside the parodied. For these artists, it is important that their works function in total complicity with the context they are confronting and become indistinguishable from it. Duplicity is the virulent, if disenchanted, strategy they have adopted to replace the old ones of confrontation and critical engagement. All objects must be consecrated to the ideology of consumerism and, under its false dynamic, enjoy the same prestigious status; when an entire society has become an addict, it becomes a closed system that presents few choices to individuals in terms of the roles they may take, or the directions they may pursue. At this point, freedom in our society has come to mean primarily the consumer's right to choose.

"It is a thoroughly vulgar metaphysic," states Baudrillard. "And contemporary psychology, sociology and economic science are all complicit in the fiasco. So the time has come to deconstruct all the assumptive notions involved— object, need, aspiration, consumption itself," which is what this art tries to do. Deconstruction becomes the cheerful orchestration of collapse, the cracked mirror of a culture where products must continually replicate other products, where artists become the author of someone else's work, and everything competes within the same marketing system of seductive senselessness. "Don't buy us with apologies," goes the slogan on one of Barbara Kruger's photomontages. "I shop therefore I am," states another. "Buy me," commands another, "it will change your life." Kruger sends back to the system its own prepackaged scripts, in the form of advertising codes that have been intensified and brilliantly exposed. In Kruger's work, irony forms a reality principle unto itself, no longer

dynamic but the inert substance of the matter, what Charles Newman refers to in his book *The Post-Modern Aura* as the "rhetoric of terminality," the deep suspicion, which post-modernism harbors, that we have only unpleasant choices—that we may already have seen the best civilization has to offer.

Is there, then, no way out of the alliance between capitalism and culture? Is deconstruction the only answer—cultivating paradox and leaping, as it were, over one's own shadow? Implosive strategies demand going to extremes—until the system devours its own empty forms, absorbs its own meaning, creates a void and disappears. And so there is a policy of going nowhere, of not occupying a position, of hovering in place, having no positive horizons, no goals, no constructive alternatives. "Right away people ask, 'What can you do with that?' " writes Baudrillard. But apparently, that is just the point: *there is nothing to be had from it.* The only thing you can do is to let it run, all the way to the end. However, as Sylvère Lotringer comments in his interview "Forget Baudrillard," "there is a high price to pay in terms of emptiness and disenchantment. There you will have all the seduction, and the sadness, of nihilism."

CHAPTER 4
LEARNING TO DREAM
The Remythologizing of Consciousness

KUBLAI [KHAN]: *I do not know when you have had time to visit all the countries you describe to me. It seems to me you have never moved from this garden.*

[MARCO] POLO: *Everything I see and do assumes meaning in a mental space where the same calm reigns as here, the same penumbra, the same silence streaked by the rustling of leaves. At the moment when I concentrate and reflect, I find myself again, always, in this garden, at this hour of the evening, in your august presence, though I continue, without a moment's pause, moving up a river green with crocodiles or counting the barrels of salted fish being lowered into the hold.*

Italo Calvino, Invisible Cities

In places like universities, where everyone talks too rationally, it is necessary for a kind of enchanter to appear.

Joseph Beuys

41

I've told you over and over," Don Juan says to Carlos Castaneda in *The Fire from Within*, "that being too rational is a handicap. Human beings have a very deep sense of magic. We are part of the mysterious. . . . Some of us, however, have great difficulty getting underneath the surface level; others do it with total ease." At the edge of a frozen lake, a woman dances herself into a visionary state. She wears an extraordinary garment of raffia and string that transforms her into the supernatural being she is impersonating. Her presence in the landscape is like a numinous symbol of wings and flight, signifying the possibility of transition into another mode of being—the freedom to change situations, to abolish a petrified, or blocked, system of conditioning. The woman is Fern Shaffer, an artist from Chicago, enacting an empowerment ritual involving the cleansing of crystals, in the waters of Lake Michigan at the winter solstice. The temperature is well below zero, and although it is dawn in Chicago, the scene feels ancient, from another time.

Shaffer's rituals are the result of a collaboration between herself and the photographer Othello Anderson, which began with the intention of marking the passage of the seasonal equinoxes and solstices with special ceremonies. "The significance of what we do is to reenact or remember old ways of healing the earth," Shaffer states. "An ancient rhythm takes over; time does not exist anymore. We perform the rituals to keep the idea alive."

One of the peculiar developments in our Western world is that we are losing our sense of the divine side of life, of the power of imagination, myth, dream and vision. The particular structure of modern consciousness, centered in a rationalizing, abstracting and controlling ego, determines the world we live in and how we perceive and understand it; without the magical sense of perception, we do not live in a magical world. We no longer have the ability to shift mindsets and thus to perceive other realities—to move between the worlds, as ancient shamans did. Ritual signifies that something more is going on than meets the eye—something sacred. For Shaffer, the process of creating a shamanic outfit to wear can be likened to creating a cocoon, or alchemical

vessel, a contained place within which magical transformation can take place. Having a strong visual effect on the environment is important, as is the inner willingness to transform—this is what makes any ritual come alive and have power. The important thing is whether a shift in awareness occurs, creating a point of departure, an opening for numinous or magical experience that can never be obtained by cultivating intellectual skills; the world of magical perception has to be explored experientially, with wholehearted participation of the entire being. Shaffer writes:

> This ceremony was held at sunrise. We met at the lake front at 5 A.M. It was minus 35 degrees with a windchill factor of minus 80 degrees. We seem to have gone into another time zone. We moved through the space very slowly. I washed the crystals in the Lake, putting my hands in the water. Othello used three cameras; two froze completely and the film in the third camera split. It was very cold and yet Othello and I were not affected by it.

Magic clothes were often the means whereby shamans passed from one world to the other in order to achieve the necessary communication with spirits—perhaps a cap of eagle and owl feathers, or a cloak adorned with ribbons and stuffed snakes. This "sacred wardrobe" acts as a lure for spirits; it serves as the means for accessing alternate states of consciousness—a traditional means of obtaining knowledge in shamanic cultures—which can lead to transformation and healing. In our culture it is no easy task to accept the validity of experiences that are called "visionary." The modern personality is much more respectful of the rational aspects of the psyche. We have no prescribed way to do the vision quest, no ceremonies for meeting the gods in the magic circle; the faculties with which we might have joined them have atrophied. Those who want to learn to enter the "Dreamtime" today in order to initiate healing have to find ways of effecting a release of archetypal memory that predates the loss of our integration with nature. But for this, we have to get rid of what a friend of mine calls our "cowboy arrogance" toward

the magical, mythological and feminine modes that are unacceptable to rational patriarchal consciousness, which believes only in surface reality. These other models of reality—vision outside of the ego's control, vision rooted in the soul—were left behind by the rational and scientific logic of the Enlightenment, and need to be reclaimed by our culture. The principal function of the shaman is magical healing and soul-retrieval; soul-loss, once regarded as the gravest of all illnesses, is never mentioned in Western medical books.

During the spring equinox in 1986, Shaffer went to Cahokia Mounds, Illinois, to perform *Spiral Dance* at an ancient Indian site sometimes referred to as Wood Henge, where archaeologists have discovered a series of pits thought to be the ruins of a solar clock similar to Stonehenge. Arranged in the shape of a circle, the pits have been filled in recently with wooden poles to replace the original ones that were previously there. When Shaffer and Anderson first saw the poles, they felt they should initiate them and bless the grounds.

"I wrapped string rope around the outer post," Shaffer writes, "and then began unwinding the string in clockwise fashion, doing this spiral dance. As the universe unwinds, so did I. I was trying to awaken the spirits from this place." Farther on, there was a kind of temple to the sky, but with no walls, roofless and bereft of statuary. The temple is very old; it is, they say, a tomb; whose, no one can remember. The stairs lead to the top of a very large ceremonial mound; and perhaps in times now forgotten tribal initiates came in procession up this staircase to perform rites. Shaffer says about her own work with ritual:

> The experience begins with a feeling, a sense of something that wants to materialize itself. We feel that we are at a loss, there are no guidelines, no instructions, we have to rely on our inner selves for direction. Information appears, an opening of the senses, things start to fall into place, ideas, movements and gestures. Power is emanating from the area, it is like stepping into a source of energy. This energy starts to centralize and condense, it takes a form. A mystical metamorphosis starts to take place. . . .

If I am able to rediscover my own first experience of the basic spiritual existence with nature, it might help others rediscover and honor the same things in themselves. It does not matter that I possess no expert training or special knowledge, only the ability to open up and channel the intuition of my own self. I would let my experience of the primitive pattern of creation speak for me, since I have taken part in the most ancient workings of the human spirit. I am merely bridging the patterns of things from the past to now. What the world lacks today is not so much knowledge of these things of the spirit as experience of them. Experiencing the spirit is all. To believe is okay, but a personal experience is better, a direct feeling with something. You can call it a shamanic state if you like.

For both Shaffer and Anderson, the experience of being out in nature is what the rituals signify; within the participating ambience of earlier world views and ancient cosmology, a lost sense of oneness with nature and an acute awareness of the ecosystem is opened up. One of the attractions of shamanism for modern individuals is that it appears to provide a possible basis for reharmonizing our out-of-balance relationship with nature, which is especially important just now. The shaman can hear the voice of the stones and trees that are speaking—the voices of things unheard to us all. The shaman does not live in a mechanical, disenchanted world, but in an enchanted one, comprised of multiple, complex, living, interacting systems. Modern man, however, has left the realm of the unknown and the mysterious, and settled down in the realm of the functional and the routine. The world as an emanation of spirit, of visionary powers and mythical archetypes, is not congruent with the world of mechanization, which requires matter-of-factness as the prevailing attitude of mind. As Peter Halley puts it:

It is the essence of modern consciousness to be irrevocably structured by the technological aspects of industrial production. The individual of today transfers the engineering ethos of modern technology and bureaucracy to his personal consciousness and emotional life. This ethos,

characterized by mechanicalness, reproducibility and measurability, produces in consciousness the traits of abstraction, functional rationality and instrumentality.

Every culture lives by myth, according to Jung—one myth or another. Mechanistic vision is the cheerless, clockwork way we have been conditioned to see the world through the myth of science, as a "single-tracked" universe. Since the Enlightenment, our view of what is real has been organized around the hegemony of a technological and materialist world view, which has eliminated from its map of reality any means through which to keep visionary energy alive. The visionary function, which fulfills the soul's need for placing itself in the vast scheme of things, has been suppressed, with the result that as a culture, we have lost the gift of vision. We have lost access to the magical world of archetypal myth and symbol, the world of the "Dreamtime."

Our prevailing sense of disenchantment, a legacy from the modern industrial age, is not simply a matter of the intellect; by now it has been woven into our personalities, attitudes and behaviors. As Max Weber claimed, mysticism was out of tune with modern societies, so if ever mysticism reared its head, something was going awry. The death of the spirit, the amputation of the soul, the sense that all our gods are dead: these are the messages we have been programmed to give and to receive by our culture, which works by legitimizing certain ways of knowing and disqualifying others. But, as the critic Irving Howe once wrote, the death of the gods would not trouble us so much if we, in discovering that they had died, did not have to die alongside them. The loss of myth, the assumption that the only valid ways of knowing are logical and linear, has resulted in a profound loss of moral orientation and meaning for life. Archetypal themes give form and meaning, but as a culture, we have fallen out of meaning, leaving only the dreariness of calculated, mechanical process. We are so incredibly addicted to rational modes of perception that if we are ever to change the basis of our experience and correct what quantum physicist David Bohm has called an "entrained mistake" of the whole culture—our overiden-

tification with rationalism—we will need to go beyond the limiting patterns built up by our present environment and renew our connection with the collective dreambody, with the soul and its magical world of images. This is no simple task for the modern individual, because another of the peculiar developments in our Western world is that we no longer have any sense of having a soul. As Robert Johnson writes in *We*, "If we are asked what the soul is, our minds go blank. The word *soul* calls up neither feeling nor image. . . . We have pursued our masculine extroverted values for so long that we have come to see the soul as an unnecessary complication in an otherwise neat and tidy masculine world." To be able to shift from logical, linear modes of knowing into the collective dreambody, one must begin by separating oneself to some extent from the world of ordinary, everyday activities, in order to find that inner center of archetypal energy contained in myth that has been made by our society to seem archaic.

It is not a matter of trying to imitate an archaic cultural style so much as fostering psychic mobility—opening oneself up to a range of visionary experience in a culture whose mind-set has made the very idea of other worlds unthinkable. Ritual, drumming, monotonous chanting, repetitive movements, are no longer an integral part of modern life, but they are a sure way to make a direct hit on this "dreaming" aspect of the psyche. "When we retrieve this vision," writes the philosopher David Michael Levin in *The Opening of Vision*, "making it explicit, bringing it to light, the consensually legitimated vision of the social ego is radically called into question." So is the loyalty to only one way of seeing things to the exclusion of others.

Many people believe that entering the visionary mode is romantic or regressive and fear it will draw them away from the world of modern consciousness, fixing them in archaic states that are unsuitable to contemporary life. Certainly it is the case that the artist who survives best in contemporary "left-hemisphere" culture, as José Argüelles calls it in his book *The Transformative Vision,* is usually the one who internalizes and adopts its rational values. One of the

47

tasks of the "reenchantment project," as I define it here, is to cease to be hypnotized by the rational bias of Western society, through developing a more open model of the psyche, so that as a culture we can recover the ability to "dream forward" and reclaim the power and importance of vision. We need to dissolve the dispassionate patriarchal consciousness, which has become increasingly maladaptive to the natural and communal world. The remythologizing of consciousness through art and ritual is one way that our culture can regain a sense of enchantment. Trance methods and shamanic experiences are ways of dissolving the boundaries of our own system, in order to break the hold our society's picture of the world has on us.

This dying to the world of rationality, while awakening to powerful archetypal forces in the visionary world, can be a treacherous business, as attested to by Jos. A. Smith, a New York artist who has been using trance as an avenue into the unconscious for many years. In trance, when the ego-personality is temporarily displaced, the mind experiences another world from the everyday world, where inside is not separated from outside and a spontaneous experiencing of presences that do not belong to the ordinary world seems to occur. Smith has studied many non-drug-induced techniques for altering consciousness, which he employs in combination with Jain meditation, practices from the martial arts and visualizing techniques learned from the Nyingma Order of Tibetan Buddhism. He has also trained himself to draw with great precision the experiences he has in trance states. *Priest of Dark Flight*, encountered during one of Smith's shamanic journeys, is a startlingly numinous figure from another world—ambivalent, perilous, unpredictable, with clairvoyant eyes. The rational mind is likely to dismiss such an apparition as hallucination or illusion, but to shamanic consciousness it is totally, and even terrifyingly, real. Smith writes:

> The first time I saw *Guardian of the Deepest Gate* it was standing on a mandala that had a continuously shifting and changing image. It held a shield made of twisted roots that formed a mouth. The mouth was stretched

open and it was screaming in an endless stream of sound that was pain and anger and fear all intertwined. I heard a voice that seemed to come from no particular direction saying, "This is the guardian of the deepest gate." I knew without being told that at some point I have to pass it. When I do, I will be on a level of mind that I have never experienced, a totally different world. It obviously entails another death beyond the very realistic one I experience when I enter a deep trance. I was too afraid to go farther at that time.

As Joseph Campbell once said, mythology is no toy for children. When we are invited to join the object of our fear in the other world, the transformation of the personality becomes a living experience, and we encounter something that cannot be received on a theoretical basis, or controlled by rational explanation. When this happens, ancient forms of consciousness begin to acquire an importance and meaning beyond the purely historical, as we discover them within our own psyche. The great scholar of comparative religion Mircea Eliade once said that it is not enough, as it was half a century ago, to discover and admire the art of the primitives; we have to discover the sources of these arts in ourselves, so that we can become aware of what it is, in a modern existence, that is still "mythical" and that survives in us as part of the human condition.

Are these things real? Do they actually happen? "Real" for individuals is what they interact with every day, what they think about. There have always been people in every culture who possess the ability to cross invisible thresholds into the unseen. A young medicine man in training, telling of his initiation in an Australian tribe, remarks to anthropologist Lucien Lévi-Bruhl: "After that I used to see things that my mother could not see. When out with her I would say 'Mother, what is that out there yonder?' She used to say, 'Child, there is nothing.' These were the *jir* (ghosts), which I began to see. The fact that they cannot be seen by ordinary persons only means that they are not gifted with sufficient power, and not that it is not there."

49

In 1927, Sigmund Freud declared in *The Future of an Illusion* that modern individuals had finally emerged from superstitious ignorance. "We think we ought to believe because our forefathers believed," he wrote. "But these ancestors of ours were far more ignorant than we are. They believed in things we could not possibly accept today." Carl Jung, on the other hand, who was always more open than Freud in his attitude to the value of mythical experience, and to the soul as a psychological reality, wrote in *The Structure and Dynamics of the Psyche*:

> It is generally assumed that the seeing of apparitions is far commoner among primitives than among civilized people. . . . In my view . . . psychic phenomena occur no less frequently with civilized people than they do with primitives. I am convinced that if a European had to go through the same exercises and ceremonies which the medicine-man performs in order to make spirits visible, he would have the same experiences. He would interpret them differently, of course, and devalue them, but this would not alter the facts as such.

Primitive man's inclination toward the mythic and the supernatural was not, as Freud (and others) have claimed, the result of cognitive inferiority, or wish-fulfilling delusions that we have now outgrown. Rather it was an alternative mode of consciousness that understands the world in a sacred manner. Because it corresponds to something universal in the collective unconscious, it remains with us, even though our own cultural response has been to deny and repress this mode. We are finally beginning to understand that it may have something crucial to teach us about our own "contingency sickness," a disorder of the modern world that results from being deprived of meaningful ritual or any contact with the great archetypes that nourish the life of the soul. This shamanic insight is very important just now, because we have lost any sense that ritual is important. In accepting that science has the one true vision, the only reliable explanation of reality, we have also lost contact with the healing power of

myth and the transformative potential of nonordinary states of consciousness. The physician Larry Dossey makes the point very well in his essay "The Inner Life of the Healer":

> What we desperately need from shamanism is far more important than the shaman's trappings: it is the *soul* of the healer we need to recover, for that is what we have lost. . . . "Soul" is a new mode of awareness . . . a way of seeing that rescues all of life from the sterile vacuity that has become synonymous with modernity. . . . This, then, is the great legacy of shamanism for the modern healer: a way to make life alive; a way to discover that the world is enchanted and not dead.

What happens to a culture without a living mythology is that it gets addicted to whatever numbs the pain of archetypal starvation and the vacuum of meaning. Opening one's vision in this way to a greater transpersonal realm, which defies control and rational description, is to see beyond the retarded boundaries and destitution of our present system. "With hands grounded in earth and hay," writes Rachel Dutton, an artist from California, "I was able to enter the immense fertility of the dream world directly through my art. I crossed over into a land far older than my dreams, where I felt echoes of other ancestors, clusters of innumerable animals, birds, insects, fish, secreting, weaving, digging." Dutton's sculptures resonate with a genetic memory of the ancestral animal chain, as it is woven into the cells and tissues of our body. From this dream memory emerged such unusual works as *First Mothers* and *Feet of Song*, which by no stretch of the imagination can be seen as *logos* figures. When the *First Mothers* entered creation, they learned to make paper nests, and their sharp eyes would have seen the great lizards, forests of ferns, daylong twilight under constant clouds. As atavistic holder of primitive life energies, *Taurus* was looking for his twin when he was separated from the umbilical cord by which he was attached at the collarbone. The signs he marks with his paws are the signs we must live by that day. *Feet of Song* danced under our fields until he spat

out the stones, the points and the junctures of the world. His skin is black, and his arms are without elbows or wrists. He talks with his feet, and the world vibrates, it shifts from one foot to another; it shakes, it dances its dance.

For Dutton, the repeated gestures of bundling and tying hay around an armature, of kneading and shaping mud and, later, of coating it all with papier-mâché, takes on a ritual quality, while the gestures of her figures are frequently influenced by her experience as a dancer.

> When I work [says Dutton], I feel a kinship with ancient working rhythms, with totem builders of early primitive societies, with ancestral memories from deep time, simple common memories below the threshold of myth— the rolling motion of a hip joint as weight is shifted from one leg to another, the coolness of shadow on skin, the heat of the day radiating from hard, packed earth at twilight.

In the visionary mode, myths from all times and cultures are available to us; we touch into a seemingly magical dimension from which emanates a sense of the mysterious and the sacred; we have experiential access to the past or the future, and the limitations of our cultural conditioning are transcended. Visionary seeing is a force against the literal mind, which believes that things are only as they appear. It is a movement into a larger, timeless dimension that honors, from the deepest levels of consciousness, our connection with archetypal forces and powers beyond the local self. Most of the neuroses and the vacuum of meaning from which we suffer result from an isolation of the ego-mind from the archetypal unconscious, according to Jung. Societies have always found their deepest value and sense of meaning ultimately in this realm of the mythic and the transcendental. Jung even went so far as to claim that myths are more sustaining in our lives than economic security. Science is based on the objective weighing of fact and detail, a mode of "seeing without imagination," whereas myth is not fully understood unless one enters into a nonlinear, non-Cartesian state. It is this

merging, or dissolution, into a larger, more encompassing identity than the rationalized ego-self that is now felt to be necessary by many people, in order for social transformation to take place in our time. The modern challenge is to again find sacredness within the world, to recover our lost souls, to somehow get past what George Steiner recently described as "the age of embarrassment about God, about the numinous, the collective unconsciousness; embarrassment about owning to our inner world, transcendental experience, mysteries and magnanimities." Our mechanistic, materialistic, deterministic traditions have eliminated any reliance on the invisible as being true or trustworthy—we only rely on what we see and know.

An opening to what we can't quite see—that is, to the mysterious realm—underlies the nature paintings of Gilah Yelin Hirsch, a painter, writer and photographer from Venice, California. Numinosity runs through her pictures like fire in a fire-opal. You feel it in the glisten of fermented light, dancing like burnished copper through the trees—a special kind of aliveness in which trees talk to one another in the forest; in the wind, they bend as one. Sometimes, in Hirsch's paintings, trees even learn to fly. Since 1981, the artist has been spending long periods of time alone in wild places; for her, nature is an ecstatic living presence, teeming with elemental spirits. The solitary, ritual journey into wilderness, facing the unknown in total isolation, has always been a classic part of shamanic training, since it engages one directly with fear; the intensity of the experience can often dissolve ego-boundaries that normally separate inner from outer. Hirsch writes about her time alone in nature:

> I immersed myself deeply into the ferociously dramatic landscape. Alone I hiked into the wilderness, onto the glaciers, into the forests and mountains miles and miles away from any human contact. Fearlessly, I inundated myself with the depth and immensity of natural phenomena as I explored the often dangerous trails alone. Scale had to be redefined. My normal understanding of concepts such as vast, huge, immense, no longer ran true.

53

I had to reshape the compartments of my mind to accommodate a new world view. I walked with porcupines, wolves, marmots, elk, deer, moose and bear. I hiked in rainstorms. . . . I climbed mountains in August snow blizzards. I roamed in fecund mountain meadows in breathtakingly clear cantaloupe light, my fertile vision sharpened to the point of ecstasy. Often I crossed the Boundary. . . . I felt my controlled personality disassociate into myriad components of archetypal voices. In that primal soup of nature, far far from human contact . . . I began to feel myself an embodiment of nature. I lived in an altered state. I was essentially schizophrenic as my psyche shrank and swelled when I trespassed from nature to culture and back from culture to nature. I learned the difference between profound lasting nourishment provided by nature and temporary entertainment transmitted through culture.

This is not the "objective" knowledge of the spectator observing at a distance, analyzing, or describing without being drawn in. Rather, it is sacred ego-deconstruction—a practice not to be undertaken lightly—in which the self experiences directly the deep connection between the human world, the plant world and the animal world. One is no longer just looking at the tree, enjoying it through one's senses: one has become the tree. When we experience the world as our own body, illusions of duality dissolve, and with them, old assumptions about a distinct and separate ego-self codified by our culture. Cultural anthropologist Joan Halifax writes: "When you reach very deep states of consciousness, you see that the mind includes not only the entire nervous system, but the entire cosmos. Our mind in its extended form can actually perceive anywhere, anything and any time. . . . Let's face it, our mind is a much more articulated and extensive organ than most of us realize. . . . In visionary states, you access some of these potentialities."

It is the essence of modern alienation that we are bewitched by our particular vision of separateness—the mechanistic idea that we can know the world only from the outside, by distancing ourselves from it. Cartesian dualism

sees no connection between the subjective world of thought and the objective, outer world. Today, at the leading edge of science, medicine, biology and psychology, this dualistic, Cartesian subject versus object model of cognition—the world system that emerged in the Renaissance—is being replaced by a new picture, which sees the inner and outer world as a continuum. This fundamental continuity of psyche and cosmos alters the traditional sense of mind as subjective, private and "in here," and of world as external, objective and "out there." As experimental findings in quantum mechanics are propelling many scientists into the "spiritual change" of thinking more holistically, even science has begun to transcend the mechanistic model, reframing itself in terms that acknowledge the interconnectedness of all life. These new relational and process ideas, however, can hardly be said to have penetrated very deeply into the consciousness of our culture, or the ways we think about art.

Ultimately, it is the visionary self—the form of consciousness that has been discredited and suppressed in modern society—that is able to see this fundamental unity as well as the duality of existence. In the nondualistic view, everything in the universe is understood as dancing energy patterns interweaving a single continuum. As for us, we are not just observers of the pattern but its cocreators; and our relationship with nature is not that of something external and independent of ourselves.

Among all the art that I have so far discussed, there is a single sculpture called *Manscape* by Richard Rosenblum that sums up for me, better than anything else I know, this manifestation of our interrelatedness, the way we are woven into the living processes of the planet itself. In Rosenblum's sculpture, the figure of the man has become a walking landscape. The boundary between self and world has been dissolved so that everything exists in a state of radical interpenetration. Rosenblum, who lives and works in Newton, Massachusetts, transforms the roots of dead trees into a form of visionary sculpture, which he then casts in bronze. Sensing himself in an artistic no-man's land between traditional figurative sculpture and constructivist abstraction

a few years ago, Rosenblum asked himself the question, "Can one make a figure which is neither naturalistic nor constructivist?" The answer came from studying Chinese rock sculpture. For the Chinese, rocks contain concentrations of energy with a hidden life; Chinese who meditate on rocks see microcosms of the universe. Like the tree roots for Rosenblum, rocks are experienced as alive and ensouled by the Chinese.

There is a subtle awakening to ecstasy in Rosenblum's sculptures, as when, tilting, or sometimes balancing on a single leg, these figures seem to see through the earth's eyes. Uprootedness is part of modern alienation; Rosenblum creates a metaphor of belongingness, of rerooting ourselves in the universal bond of biological existence—the bodily unity of ourselves and the world. *Manscape,* in particular, reconnects us with this *prima materia* of the earth, and the dark chthonic regions under the earth. From it we learn that matter *can* give birth, and this is already a real hit at the scientific idea that matter is inert, passive, unconscious. Each of Rosenblum's sculptures communicates a profound experience of being grounded in the earth's energy.

In her book *Dreaming the Dark,* Starhawk speaks of the need for images of Father Earth—an image prevalent at one time in the mythology of earth religions:

> Father Earth is the God who is pictured crowned with leaves and twined with vines, the spirit of vegetation, growing things, the forest. The image says, "Experience this: you are rooted in earth, know the force that twines upward—how it is to flower, to swell into fruit, to ripen in the sun, to drop leaves, to ferment, to be intoxicating. Know the cycle, over and over; you are not apart from it. It is the source of your life."

For me, the work of these artists bears evidence that the sickness of our time is not the absence of mythic vision, which is ever present in the unconscious, but our culture's denial that it exists, or has any significance for modern life. But it would be a mistake to suppose that our present ideals, in which thinking is separated from feeling, are rooted

once and for all in man's nature; or even that the organization of our thinking is set for all time in the rational hemisphere of the brain. Different organizations may be possible in the future, just as they have been in the past, with a more mediated harmony between the two modes than presently exists. Our capacity for relatedness emanates from the feminine side of the psyche. Images that speak to the bond of connectedness and challenge the dualistic consciousness of the modern world system create a break in the boundaries that encapsulate our current consciousness. Alienation is our peculiar form of rational detachment, codified by the scientific attitude of the Renaissance. We have yet to discover what new "wirings" are possible when the visionary enters into active collaboration with the rational, when we learn to shift from one mode to the other, realizing the dual masculine and feminine nature of psyche and personifying both sets of capacities and strengths.

The remythologizing of consciousness, then, is not a regressive plunge into the premodern world; we are all being drawn to "the multisensory phase of evolution," as the next step in the evolution of consciousness. Rather, it represents a change in how the modern self perceives who it truly is, when it stretches back and contacts much vaster realities than the present-day consumer system of our addicted industrial societies. As Anne Wilson Schaef points out in *When Society Becomes an Addict,* our belief in the addictive system as the only reality is itself the illusion making us believe there is no other reality. The loss of our visionary being has led us into addictive functioning; and the addictive nature of consumer society separates us from an awareness of ourselves as visionary beings. To move toward recovery, we must admit addiction on a systemic level and move beyond our own participation in this disease process. We must see our present culture for what it is: an addictive system. Transpersonal psychiatrist Stanislav Grof makes a similar assertion, in an essay entitled "Spirituality, Addiction and Western Science":

In the last analysis, the psychological roots of the crisis humanity is facing on a global scale seem to lie in the

loss of the spiritual perspective. Since a harmonious experience of life requires, among other things, fulfillment of transcendental needs, a culture that has denied spirituality and has lost access to the transpersonal dimensions of existence is doomed to failure in all other avenues of its activities.

For those committed to the status quo, who prefer the standard view of things and cannot take this discussion seriously, the limousine stops at the Ritz. But those who are willing to ride the great ancestral tortoise through some vertiginous country may still see, in places declared invisible and behind the levels of rationality reached in the modern world, a concentric ring of fire licking the walls. Once you experience this reality, you begin to understand the perceptual bias of Western industrial society. It may well be that this garden exists, as Marco Polo claims, only in the shadow of our lowered eyelids, but each time we half-close our eyes, in the midst of the din and the throng, we are allowed to withdraw here, to ponder what we are seeing and living, to draw conclusions, to dream the future into the present:

> The Great Khan . . . leafing through his atlas, . . . said: "It is all useless, if the last landing place can only be the infernal city, and it is there that, in ever-narrowing circles, the current is drawing us."
> And [Marco] Polo said: "The inferno of the living is not something that will be; if there is one, it is what is already here, the inferno where we live every day, that we form by being together. There are two ways to escape suffering it. The first is easy for many: accept the inferno and become such a part of it that you can no longer see it. The second is risky and demands constant vigilance and apprehension: seek and learn to recognize who and what, in the midst of the inferno, are not inferno, then make them endure, given them space."

CHAPTER 5
DECONSTRUCTING AESTHETICS
Orienting toward the Feminine Ethos

It is time, in the West, to defend not so much human rights as human obligations.

Alexander Solzhenitsyn

The Athena who glorifies the Fathers will be pitted against the Arachne who challenges them.

Catherine Keller

The sterility of the bourgeois world will end in suicide or a new form of creative participation.

Octavio Paz

The diagnosis and destructuring of our collective social pathology is crucial, but in this book I am even more concerned, as I have stated previously, with understanding what it might take to give our culture back its sense

of aliveness, possibility and magic. It certainly is the case that modernism increasingly appears to be a mode of patriarchal consciousness that has outlived its usefulness and needs to be transcended. We no longer need old authoritarian ideologies, which demand that art be difficult, willfully inaccessible and disturbing to the audience—in some sense a contest of wills— as it was under modernism. However, any other approach, even now, is still considered analgesic, conciliatory and without a critical edge, which brings me to the question of whether there can be a truly postheroic, postpatriarchal art—one that does not equate aesthetics with alienation from the social world, but embodies modes of relatedness that were difficult to achieve under modernism.

What I wish to argue for the remainder of this book is that the rational framework of modern aesthetics has left us with an ontology of objectification, permanence and egocentricity, which has seriously undermined art's inherent capacity to be communicative and compassionately responsive, or to be seen also as a process, rather than exclusively as fixed forms. I am, of course, aware that the new terms of interdependence and relatedness implied by reenchantment will not be suitable for every artist, however alluring they may seem to some: there will always be individuals for whom the autonomy of the aesthetic attitude, which needs no social or moral justification, is more correct. Nevertheless, I am proposing that our model of aesthetics needs therapeutic attention, because it has lost its sensitivity not only to the psychological conditions of individuals and society, but also to the ecological and process character of the world.

Modernism did not inspire what Octavio Paz refers to as "creative participation." Rather, its general themes were alienation and displeasure with society. Based on the heroic, but belligerent ego, inflated and cut off from its embeddedness in the social world, it encouraged separation, distancing behavior and depreciation of the "other." Concerned with the object itself as the chief source of value, it did not focus on context, or on creating meaningful connections between art and society—if these were related somehow, the theory of their relationship was never satisfactorily developed. Indeed,

having loudly proclaimed the self-sufficiency of art, and having established the importance of the untrammeled self, the avant-garde proceeded to scorn notions of responsibility toward the audience; its posture was one of intransigence, a style set very early in the launching of the modernist project with the *First Futurist Manifesto,* written by Filippo Marinetti in 1920. "We intend to exalt aggressive action," he wrote, "the racer's stride, the mortal leap, the punch and the slap." This denigration of society in the form of an insult or an assault became a cultural convention of modernism, in which, I shall argue, the failure to relate was actually considered a cardinal virtue, and even the signal mark of radicality. Implicit in much art of the modern era was a form of aggression reflecting a relationship of hostility both to society and to the audience. "I'd like more status than I have now," the Abstract Expressionist painter Adolph Gottlieb declared, "but not at the cost of closing the gap between artist and public." Alienation, the systemic disorder of the modern artist, virtually precluded any connection with the archetypal "other," because of the refusal to cultivate the feeling of connectedness that binds us to others and to the living world. Where other cultures would never imagine the artist over and against society, the following statement by the painter Georg Baselitz, from his Whitechapel exhibition catalogue of 1983, which I quoted in my previous book, is still as strong-minded an example of this prevalent style of self-sufficient subjects and self-sufficient objects as one could possibly find:

> The artist is not responsible to anyone. His social role is asocial; his only responsibility consists in an attitude to the work he does. There is no communication with any public whatsoever. The artist can ask no question, and he makes no statement; he offers no information, and his work cannot be used. It is the end product which counts, in my case, the picture.

Hidden behind these comments is a personal and cultural myth that has formed the modern artist's identity—

the model of the egocentric, "separative" self, whose perfection lies in absolute independence from the world. Behind modernism itself lies the struggle for autonomy, with its mystique of an autonomous art work, beyond all ethical and social considerations, and an independent creator, who likes to see himself as independent and in control of things, impervious to the influence of others. Fitting into this myth of the patriarchal hero became the precondition for success under modernism for both men and women—an archetype in which the feminine value of relatedness was virtually stripped away. Art as a closed and isolated system requiring nothing but itself to be itself derives from the objectifying metaphysics of science—the same dualistic model of subject-object cognition that became the prototype for Cartesian thinking in all other disciplines as well. This ideal of "static" autonomy, of the self against the world, locates modern aesthetics within the "dominator" model of patriarchal consciousness rather than the "partnership" model, to use Riane Eisler's important distinction in her book *The Chalice and the Blade*, a distinction I shall adopt in my own discussion from this point on. Within the "dominator" system, the self is central; power is associated with authority, mastery, invulnerability and a strong affirmation of ego-boundaries—which is precisely what the modern artist's "self" came to convey. Autonomy disregards relationships, however; it connotes a radical independence from others. By contrast, in the partnership model, relationships are central, and nothing stands alone, under its own power, or exists in isolation, independent of the larger framework, or process, in which it exists. Within the dominator system, art has been organized around the primacy of objects rather than relationships, and has been set apart from reciprocal or participative interactions. What I shall argue is that it has become trapped within a rigid model of insular individuality. To reverse this priority, giving primacy to relationships and interaction, is also to reverse the way that artists see their role, and implies a radical deconstruction of the aesthetic mode itself.

The extent to which present aesthetic forms tend to favor "dominator" attitudes of self-assertion over social integration, a hard, intellectual approach over intuitive wis-

dom, and competitiveness over cooperation, was most evident for me in the intense controversy that raged for several years over the proposed removal of Richard Serra's monumental steel sculpture *Tilted Arc* from its site at Federal Plaza in downtown Manhattan, where it was installed in 1981. *Tilted Arc* was commissioned by the General Services Administration in 1979, as part of the government's art-in-architecture program, and was conceived specifically for the site. The 120-foot-long, 12-foot-high, 73-ton leaning curve of welded steel is an impressive, imposing work—arguably the epitome of uncompromising, modernist art. I think there is no question but that, within the normative values of modernism, it is a very powerful statement. It dominates the space, confronting the audience in an aggressive way to examine its own habits. This willingness to risk confrontation with the audience, according to critic Barbara Rose, is precisely what gives modern art its moral dimension. "Serra demands absolute autonomy for his art;" she has written in *Vogue* magazine, "his works are intentionally self-sufficient. They stand upright and alone, isolated in positions of heroic rectitude, as if the very posture of standing without support, of solitary rootedness, is an expression of resistance to external pressures."

Thus, for Rose at least, Serra's work, with its almost mineral imperviousness, is the ultimate model of social independence and the radically separative self; the heroic, belligerent ego of modernity, cultivating its divisiveness and lack of connectedness with others, is best known through its refusal to be assimilated. This is the basic split in our world view that denigrates the feminine principle of empathy and relatedness to others, even while it idealizes the excesses of our culture's dominant masculine approach. Within modernism, women have been taught to idealize these masculine values in art as much as men.

By now, most people are likely to be aware of the embattled saga of this work, and how its presence in the plaza was so unpopular among the local office workers that it seemed almost to represent another version of the Berlin Wall. As one employee of the U.S. Department of Education stated at the time:

63

It has dampened our spirits every day. It has turned into a hulk of rusty steel and clearly, at least to us, it doesn't have any appeal. It might have artistic value but just not here . . . and for those of us at the plaza I would like to say, please do us a favor and take it away.

During three days of public hearings in March 1985, after a petition signed by thirteen hundred employees had been circulated to have the sculpture removed from its site, many members of the art community defended Serra; the consensus was that removal of the work would compromise the kind of integrity that makes art in our society the symbol of what freedom means in the world. Certainly freedom is promoted as a social, political and aesthetic ideal; but what is hardly ever mentioned is the inflationary style that has been paradoxically seen as the self's virtue. In a seventy-two-page brief prepared by his attorney, Serra made the case for his decision to sue the government for thirty million dollars because it had "deliberately induced" public hostility toward his work and had tried to have it forcibly removed. To remove the work, according to Serra, was to destroy it. Serra sued for breach of contract and violation of his constitutional rights: ten million dollars for his loss of sales and commission, ten million dollars for harm to his artistic reputation and ten million dollars in punitive damages for violating his rights.

Within the perspective of the dominator model of social organization, freedom has become unconsciously linked with the conquest mentality and with "hard" rather than "soft" individualism—that is, with the notion of power that is implied by having one's way, pushing things around, being invulnerable. It is the power symbolized in Eisler's book by the "masculine" blade, the approach to conflict resolution that calls for the destruction of one's opponent and lots of muscle-flexing. It also leads to a deadening of empathy—the solitary, self-contained, self-sufficient ego is not given to what David Michael Levin calls "enlightened listening," a listening oriented toward the achievement of shared understanding. "We need to think about 'practices of the self' that do *not*

separate the self from society and withdraw it from social responsibility," Levin writes in *The Listening Self*. "We need to think about 'practices of the self' that *understand* the essential intertwining of self and other, self and society, that are aware of the subtle complexities in this intertwining." In Serra's understanding, "site" refers to a specific physical location, with certain characteristics related to size and scale. But it is not perceived as a living, socially responsive field, in the sense that the audience enacts any role in the completion of the work, which presumably is immune to the influence of others. "Trying to attract a bigger audience," Serra has commented, "has nothing to do with making art." This has been, as I say, the modernist view; and as an echo of who we are, it is also, as Levin says, an indictment of the character of our listening.

In July 1987, the Federal District Court ruled against Serra. On Saturday, March 11, 1989, the sculpture was finally removed from the plaza and taken off to storage in Brooklyn, after the U.S. Court of Appeals also rejected Serra's claims, in a seventeen-page opinion. Serra steadfastly maintained that he had fulfilled his part of the contract, and warned that every artistic and literary work commissioned by the government was now in jeopardy of censorship. "This government is savage," he stated in *The New York Times*, which reported the event. "It is eating its culture. I don't think this country has ever destroyed a major work of art before. Every work out there is in jeopardy, at the Government's whim. . . . They say their property rights grant them power over my moral rights. This is not true in every *civilized* Western country."

As a critic, what are the grounds for deciding whether *Tilted Arc* is a successful or a failed work, and whether it should have stayed in the square or been removed? Obviously, there are many aspects to this dispute, but the one of particular interest to me is whether the aesthetic value of Serra's work can be sustained without responsibility to the social feedback he received. The question that is really at stake here is what we understand by freedom, and how this ideal is to be embodied. Just as disinterested and "value-free"

scientism does not grow out of any concern for society and contains no inner restraint within its methodology that would limit what it feels entitled to do, in the same way disinterested aestheticism reveals nothing about the limits art should respect, or the community it should serve. In effect, thinking of responsibilities and obligations more than of freedoms and rights does not fit in with our present culture's definitions of itself—or not yet. Scientists, for instance, are not expected to worry about the applications or consequences of their research, nor are they supposed to worry about relating science to human values or needs. Donald Kuspit has written about Robert Oppenheimer, for instance, one of the inventors of the atomic bomb, that he "seemed unaware of the existential implications of atomic power until the trauma of the actual explosion." When he did realize the ramifications of what his work had helped to set in motion, it all but wrecked his life. Within the framework of disinterested aesthetics, art tends toward the same lack of accountability that scientific ideology requires for itself.

What the *Tilted Arc* controversy forces us to consider is whether art that is based on notions of pure freedom and radical autonomy—without regard for the relations we have to other people, the community, or *any* other consideration except the pursuit of art—can contribute to a sense of the common good. Merely to pose the question indicates that what has most distinguished aesthetics in modern times is the desire for an art that is purely cognitive, purely intellectual and absolutely free of the pretensions of doing the world any good. "I do not mean to say that the artist makes light of his work and his profession," Ortega y Gasset wrote in his classic essay of 1925, "The Dehumanization of Art," "but they interest him precisely because they are of no transcendent importance. A present-day artist would be thunderstruck if he were entrusted with so enormous a mission—art is not meant to take on the salvation of mankind." According to Ortega, it is not that art has become less important than it was to previous generations, but that the artist himself regards his art as a thing of no consequence. When I was an art student in New York City during the 1950s, my teacher,

Robert Motherwell, devoted an entire semester to the study of Ortega's essay. More than thirty years later, I would venture to state that the logic of most art today continues to play out the same dynamic. Its philosophical underpinning has not really changed that much. Modern aesthetics does not easily accommodate the more feminine values of care and responsiveness, of seeing and responding to need.

Crucial to releasing the creative dynamics of partnership is that it must be wrought, among other things, from a radically different epistemology of care and responsibility, in which the artist does not stand aloof from any intention of being in service to the common good, or to the community. Whereas male myths, and the myths of modernism, typically have focused upon tasks of separation and mastery of self over environment, within the model of partnership it is a question of trying to realize a context in which social purposes may be served (to quote cultural philosopher Jürgen Habermas) "by finding beautiful ways of harmonizing interests rather than sublime ways of detaching oneself from others' interests." This represents a fundamental challenge to the concept of self that we have just been describing, a different model of communicative praxis and openness to others than the historical self of modernism, one that does not use the image of the hero as its archetype but is more like the shaman. Mutual cooperation for the common good is an ideal, within the partnership model, that serves as a template for a different understanding of moral responsibility, not as issues of rights and laws, but rather as imperatives of responsibility and care, as Carol Gilligan points out in *In a Different Voice*.

When a particular cultural idea like freedom becomes so abstract and overvalued, as in the case of Serra, that it finally assumes control of the entire personality (or collective mentality) and suppresses all other motivations, then it becomes dogmatic and limiting. "It is impossible to have true individuality," writes David Bohm, "except when grounded in the whole. Anything which is not in the whole is not individuality but egocentrism." The ego is the prime impediment to this deeper understanding of wholeness. The

ego works from a need to win, to come out on top. In the case of Serra, if the artist wins, he becomes a hero; if he loses, he becomes a victim. In the dominator model, one either fights or capitulates. But in the zero-sum game that has been created here, there is really no possibility of any acceptable resolution.

Modernism's fundamental mode was confrontation—the result of deep habits of thinking that set society and the individual in opposition, as two contrary and antagonistic categories, neither of which can expand or develop except at the expense of the other. "The paradigmatic relation between work and spectator in Serra's art is that between bully and victim, as his work tends to treat the viewer's welfare with contempt," Anna C. Shave wrote recently in an essay entitled "Minimalism and the Rhetoric of Power," in *Arts* magazine. "This work not only looks dangerous: it is dangerous." Serra's "prop" pieces in museums are often roped off or alarmed, have on one occasion even killed a workman, and have injured several others. Shave sees Minimalism as the zenith of "nonrelational art," impersonal, unyielding, authoritarian. In the dominator model, the assumption has been that one could be a great artist only by being against everything and everyone. But if the principle of linking, or partnership, is to become the basis of a new consciousness, then the notion that art and society are at odds with each other—the old adversarial relationship—will need to be revised. And if all levels of experience and the world are now perceived in terms of *relationship,* it represents the paradigmatic defeat of radical autonomy and the old avant-garde mandate for oppositional practices, which have informed the world view of modernism. If these notions are indeed over and done with, then we will need a new model, one that breaks down thought forms and energy patterns leading to separation and divisiveness, and is more attuned to the interrelational, ecological and process character of reality. Writers such as Bohm and Eisler stress that none of these values is intrinsically good or bad, but that the imbalance characteristic of our society today is unhealthy and dangerous. Being committed to disembodied ideals of individualism, freedom

and self-expression while everything else in the world unravels makes no sense anymore. However, we are still, in our everyday understanding of art, equating superior works with these old Cartesian models; our attitudes are not yet tuned to valuing participation and social integration, or to accepting states of flux and becoming. The issue of interconnectedness has not yet penetrated our emotional responses, and certainly not our values.

Were we to reframe our notion of freedom in the light of these holistic and more systemic models—to synchronize with the conceptual shift occurring in science from objects to relationships—freedom might lie less in the solipsistic ideal of doing whatever one wants, and more in the accomplishment of "bringing into relationship." A very different kind of art emerges if it originates from what Catherine Keller has termed the "connective" self—that more open model of the personality which welcomes in the other. "Like the serpents wound about the Hermetic Caduceus," she writes in *From a Broken Web,* "the image of relational intertwining works healingly upon the neurosis of the separative ego." To experience the "connective" self in action, we need to consider the work of a different artist, Mierle Laderman Ukeles, who has been unsalaried artist-in-residence at the New York City Department of Sanitation since 1978. Ukeles comments:

> For me, it was a matter of finding the minimalist and process art at the end of the 1960s sterile and socially remote. If art's function is to articulate a notion of human freedom—if that's what art does—then the problem is how to make the notion of freedom relevant to everybody, not just an élite group. It has to be connected to the world—but then you immediately have restrictions. How much of my own personal freedom do I have to give up to live on the earth and not destroy it, or to live in a community? Action painters were engaged in a notion of pure freedom. I love that notion of freedom, but you can only talk about freedom when you can deal with the air and the earth and the water. The people who *are* dealing with this also belong in the dialogue.

Ukeles's work is definitely in the mode of dialogue, creating the realities of partnership through an empathic bond between herself and her audience. For a year and a half, from mid-1979 to 1980, she walked around with sanitation workers and foremen from fifty-nine municipal districts, talking with them. Then she did an art work, called *Touch Sanitation,* that went on for eleven months, during which time she went around the five boroughs of New York and personally shook hands with everyone in the department. "It was an eight-hour-day performance work," she told me.

> I'd come in at roll call, then walk their routes with them. I made tapes and a video. I did a ritual in which I faced each person and shook their hand; and I said, "Thank you for keeping New York City alive." The real artwork is the handshake itself. When I shake hands with a sanitation man . . . I present this idea and performance to them, and then, in how they respond, they finish the art.

New York produces twenty-six thousand tons of garbage a day; a family of four throws out three tons of garbage a year; so without them doing their job, the city would die. "I hope that my handshakes will eventually burn an image into the public's mind that every time they throw something out, human hands have to take it away." When the hand-shaking event was finished, Ukeles was appointed Honorary Deputy Commissioner of Sanitation and made an honorary teamster by the union. "The piece is about healing bad feelings and the worker's sense of isolation," she states. "Many of them said, 'I never believed anything like this would ever happen.'"

Modern factories, offices and other workplaces are not exactly places of enchantment, but by offering her hand in a gesture of openness and generosity, a space of enchantment is opened up, if only for a moment. The archetypal reach of her open hand—like a Buddhist mudra—extends way beyond the horizons of our immediate social world; it responds to needs so deep they are not even recognized until the gesture has touched them with its kindness. In a related

70

performance, *Following in Your Footsteps*, Ukeles followed the workers around and pantomimed their movements, pretending to be like them, as a way of showing her appreciation for what they do, and acting as a stand-in for all the public who don't do this work. "We're looked down upon, and I try not to let it bother me, but it's nice that someone is standing with us," commented one worker in the department. Stated another: "Sanitation men are not like a bunch of gorillas. Some of us have college degrees. Mierle has made us feel good about ourselves. If that's what art is, it's fine by me."

In Ukeles's work, empathy and healing are the parameters, the test of whether the work is in fact being carried out paradigmatically. The open hand evokes qualities such as love and generosity. Empathy becomes affirmation, in the sense that it validates rather than denies the individuation of self and others. According to David Michael Levin in *The Body's Recollection of Being,* it is not unreasonable to suppose that were we to modify our way of relating to the things we touch and handle, a radically new social order might actually come into being; our technological world is a reflection of gestures motivated by the masculine "will to power"— the grasping, seizing, violence and mechanical indifference that are hastening the annihilation of the earth. If we could reverse these tendencies and develop instead gestures of "reciprocal touching," gestures that bring together, receive and welcome, modest gestures of solicitude and tact, which belong to the maintenance of being, the possibilities are so profound as to imply a whole new social and cultural order. It seems clear that to deconstruct the aesthetic framework with any success involves getting in touch with the "empathic" mode of thinking, in which the polarizing, objectifying tendency has been neutralized and replaced by a belief in the restorative action of care. Given our characteristic modern forms of defiance, protest and attack, and our postmodern forms of parody and ironic indifference, the notion of art embodying a good act really does change the name of the game.

While Ukeles was engaged in personally shaking hands with eighty-five hundred sanitation workers, they told

her about the insulting names people call them: dirtbag, can man, slimeball, slob, trash hound. She discovered that, even though they did their work out in the streets, they felt invisible; they felt that people thought they were part of the garbage. One worker told her about a time when they were picking up garbage in Brooklyn on a hot day. They took a break and sat down on someone's front porch. The lady opened her window and yelled, "Get away from me, you smelly garbage men! I don't want you stinking up my steps." "For seventeen years," the worker said, "that has stuck in my throat. Today," he said to Ukeles, "you cleared it away." These conversations were the source of another installation-performance work, *Cleansing the Bad Names*, which took place in 1984 as part of an exhibition at the Ronald Feldman Gallery in New York. Ukeles reconstructed two sanitation environments side by side: the locker facilities at an old district office, furnished with "mungo," a term used by the workers for objects retrieved from garbage, and a new, modern facility, sanitary but sterile, with a computer and a Nautilus weight machine. The windows of the gallery were written over with the names the workers get called, and on the day of the opening, the assembled group of art commissioners, city officials, artists, company presidents and sanitation workers were all handed sponges and invited to help clean the windows.

At the same time as the Feldman exhibition, Ukeles also mounted a "maintenance installation" in a marine transfer station, the enclosed pier on the Hudson River where sanitation trucks dump their loads into barges for transport to the Staten Island landfill. It consisted of Minimalist-like stacks and piles of shovels, rakes, chains, ropes and cyclone fencing, and a ten-foot-tall wire basket filled with thousands of discarded work gloves, collected for more than a year by the workmen, as an indication of the massive work they do for us. There was also a full array of sanitation vehicles—collection trucks, snowblowers, flushers, salt spreaders and sweepers. In another aspect of her work, Ukeles sees herself as heir to the Constructivist tradition of choreographing machine dances. Workers helped her with the *Ballet Mécanique* she

created for six street sweepers that went along Madison Avenue as part of New York City's Art Parade in 1983. When the ballet was over, the six drivers turned the huge machines to face the audience and took a bow, raising and lowering the sweepers' brooms and backing up slightly with their beepers on. Ukeles has also organized a ballet for barges and tugboats on the Hudson River, and created a special "contextual sculpture" for the sanitation department. It is a city garbage truck, decorated with mirrors so people can see who makes the garbage. Her current project, *Flow City*, involves creating a special observation deck for the public at the site of the city's new marine transfer station on West Fifty-seventh Street, where thousands of tons of garbage are transferred daily from trucks onto barges for transport to the Staten Island landfill. The project will eventually include the construction of a passage ramp made from crushed recyclable materials, a glass platform from which to view the dumping operations and a large wall of video screens providing information about ecosystems and waste management, and views of the Hudson River.

Ukeles's extraordinary ability to empathically knit herself into the community of sanitation workers, and to transform the alien audience into the empathic audience, communicates, at least to me, the pleasures of creative attunement and interaction over those of autonomy and, as in the case of Serra, radical opposition of the self imposing itself on the other. The way she merges her consciousness with the workers, converses with them, learns from them and becomes one with them, can certainly be considered an exploration of reality that is shamanic in spirit, using shamanic means in a modern way. The "connective" self displays a deep affinity with all being that strikes at the roots of alienation by dissolving the mechanical division between self and world that has prevailed in the dominator system. Context becomes an open continuum for interaction, for a process of relating and weaving together—a flow in which there is no critical distance, no theoretical violence, no antagonistic imperative, but rather the reciprocity we find at play in an ecosystem, that is essential to skillful functioning. As

something more than art, however, Ukeles's work becomes an exercise in model building; it radiates a different energy, the energy of soul, whose full meaning is not easily integrated into the present world view, where the normative self is still the masculine, separative self, armored against the outside world. The critic Kim Levin's ambivalent response to Ukeles's work in the *Village Voice* (September 1984) will echo the suspicion and doubt of many others, I'm sure, who also feel the need to separate the social merit from the artistic merit of this work:

> In the end, it's the extravagant obsession that makes it work as art, not the do-good intentions of her crusade. In fact, the saintly aspect makes me slightly uneasy. The Sanitation Department may have its own Joan of Arc, but . . . I have some vague doubts about the importance in the overall scheme of things of saving the reputation of sanitation workers by calling them Sanmen instead of Canmen. After all, they're hardly a needy group. With a strong union, their starting salary is a hefty $23,000. And new restrooms are fine but they won't save the world.

Perhaps we are not yet ready to feel comfortable with art that embodies such feeling for others, that sculpts and shapes the bond between—but at least we can begin to develop an intuitive feel for these different masculine and feminine energy patterns by exploring their manifestations in two different cases. What is notable about Ukeles's work is that she never literalizes her feelings for the sanitation workers into specific social goals (this isn't Marxist art); rather it is the act of empathic identification that is crucial, and healing. In contrast to Serra, there is an element of grace in her way of working that comes from her more gentle, diffused mode of listening, which tries to tune in to life on its terms. Developing the world view of a shaman, in contrast to that of our present society's achievement-oriented professional, helps one to become a healer in all one's activities, harmonizing the needs of the individual with the needs of the community, and bringing about a balanced relationship between

inner and outer worlds. World healing, in this sense, begins with the individual who welcomes in the other. This lowering of the personal wall and expressing spontaneous empathy has not been highly valued in the dominator society, whose emphasis generally has been on separation, self-control, autonomy and mastery. However, a new openness in personal relations—which we are beginning to see in the global political arena—could help us to reverse our present historical course, and is a crucial component in the model of the postpatriarchal, participative personality. Partnership, as Eisler claims, is an idea whose time has come.

CHAPTER 6
THE ECOLOGICAL IMPERATIVE
A New Cultural Coding

All my experience as a psychologist leads me to the conclusion that a sense of reverence is necessary for psychological health. If a person has no sense of reverence, no feeling that there is anyone or anything that inspires awe, it cuts the conscious personality off completely from the nourishing springs of the unconscious. It is ironic, then, that so much of our modern culture is aimed at eradicating all reverence, all respect for the high truths and qualities that inspire a feeling of awe and worship in the human soul.

Robert Johnson

In the twentieth century this reverent attention hardly exists, nor can it exist in any vital mode until the spirituality of the new ecological age begins to function with some efficacy.

Thomas Berry

In the late 1950s, the English writer Colin Wilson declared that the modern artist "must become actively involved in the task of restoring a metaphysical consciousness to the age," a consciousness that looks beyond the limited, materialistic view of the world promulgated by mainstream science. What I wish to propose is that, in the 1990s, the word "ecological" will become the equivalent of the word "metaphysical," as the task of restoring awareness of our symbiotic relationship with nature becomes the most pressing spiritual *and* political need of our time. In the modern world, no life is sacred, because we do not recognize it as such. Other civilizations have created Altamira, Stonehenge, the Pyramids and Chartres; ours has produced the shopping mall and the cooling tank. Modern individuals do not see the earth as a source of spiritual renewal—they see it as a stockpile of raw materials to be exploited and consumed. Native Americans say that for the white man, every blade of grass and spring of water has a price tag on it. We are bred from birth to live on the earth as consumers, and this exploitative form of perception now determines all our social, economic and political relationships, in a style that knows no limits. The photographer David T. Hanson comments in an unpublished essay on his own work:

> It seems frightening yet strangely appropriate that perhaps the most enduring monuments that the West will leave behind for future generations will not be Stonehenge, the Pyramids of Giza or the cathedral of Chartres, but rather the hazardous remains of our industry and technology . . . vast gardens of ashes and poisons. This legacy of our could last for 12,500 generations. Instead of the sacred sites of Borobudur or Ajanta, we have left to future generations Rocky Flats and the Hanford Reservation. The texts of the Environmental Protection Agency are the sutras of the late-twentieth century.

In modern times, the basic metaphor of human presence on the earth is the bulldozer. Our dealings with the earth in the last two centuries have been guided less and less

by moral or ecological considerations and more and more by short term utility and greed. We are the most expensive members of the community of nature. To see our own planetary portrait—as he who comes in the night and takes from the land whatever he needs—is to see the portrait of a landscape that has been ravaged, mined, drilled and drained of its natural worth; it is to see living evidence of Helen Caldicott's assertion that the industrial revolution is the worst thing that ever happened to the planet. This history of Western industrial society's assault on the earth and the devastation it has wrought is the subject of Hanson's aerial photographs dramatizing the dominant institutions of a culture that has consistently and arrogantly gone against nature. The images are harsh, distressing and terrible.

From 1985 to 1986, at some peril to his own health, Hanson, who lives in Providence and teaches at the Rhode Island School of Design, produced *Waste Land,* an aerial study of hazardous waste sites throughout the United States—sites that are not normally available to our view, such as the Atlas Asbestos Mine in California and United Scrap Lead in Ohio. From approximately forty thousand of these sites, which are spread across the country, Hanson chose sixty-five, located both in industrial areas and in remote wilderness. In their finished form, the photographs are accompanied by a topographic map of the site and by descriptive texts, taken directly from EPA documents, which tell the historical and social realities of these "landscapes," the environmental hazards they pose and the types of action taken to attempt to deal with the problems. "The texts eventually circle back on themselves," Hanson writes, "through a cumulative effect, to reveal the total ineffectiveness of this bureaucracy of waste management. Finally we are left with an endless series of lawsuits, remedial investigations and feasibility studies."

Issues of shoddy management practices are at the heart of the "poisoning of America." "It was like seeing the ravages of war," says Hanson. "It was very depressing." What finally happens to the deadly substances produced by the chemical industry seems not to concern the industries that produce them. These by-products are now causing the

destruction of the earth's ecology. According to Thomas Berry in *The Dream of the Earth,* the biggest problem we face is what to do with this waste; the refusal to deal with it is one of the most repulsive aspects of our contemporary technologies. The cost for a hazardous waste cleanup has been estimated at fifteen billion dollars, with another fifty billion dollars estimated for the cost of nuclear-waste disposal. But the real problem is that many of these substances can *never* be cleaned up at all, and their containment is already seriously out of control, a situation that became all too evident even as I wrote this, divulged that very day by *The New York Times* (October 14, 1988):

> Government officials overseeing a nuclear weapons plant in Ohio knew for decades that they were releasing thousands of tons of radioactive uranium waste into the environment, exposing thousands of workers and residents in the region, a Congressional panel said today.
>
> The Government decided not to spend the money to clean up three major sources of contamination. . . . Runoff from the plant carried tons of the waste into underground water supplies, drinking water wells in the area and the Great Miami River; leaky pits at the plant, storing waste water containing uranium emissions and other radioactive materials, leaked into the water supplies, and the plant emitted radioactive particles into the air.

We are all living in Ohio. Rachel Carson warned us twenty-five years ago that nature does not operate in isolation, and that pollution of the ground water is total pollution. Just about every location in the U.S. now has a water contamination problem. The Department of Defense itself has inventoried 3,526 sites where contamination poses a threat to the environment or public health. Hanson's photographs of this ongoing drama are among the most powerful and disturbing images ever to be seen, perhaps because their eerie, abstract beauty almost seems to negate the sinister life that glimmers in them: landscape as Eros transformed into landscape as Thanatos. Yet the American public has rarely, if at

all, seen photographs of its own "secret" landscape: huge discolored tracts of land devoted to radioactive waste and nerve gas disposal. Nor is it easy to obtain such pictures.

In 1984, Hanson photographed aerial views of Minuteman missile silos in the American West—anonymous but deadly constructions hidden within the agricultural landscape of the High Plains. There are currently a thousand Minuteman silos spread across eighty thousand square miles in eight states, and each silo contains a missile with a destructive potential almost a hundred times that of the bomb dropped on Hiroshima. This realm is the major capital investment of our culture, and like the ancient megaliths of Stonehenge and the lines of Nazca, these sites may be seen as monuments to the dominant myths and obsessions of our time.

From 1982 to 1985, Hanson photographed a large coal strip-mine at Colstrip, Montana, along with its neighboring power plant and factory town. At Colstrip, blasting is done with explosives to remove coal from the lower layers of subsoil by an eight-million-pound walking dragline, the size of a large office building, whose shovel can move a hundred tons of rock in a single bite. The inhabitants of Colstrip live in mobile homes and trailers centered around the plant, exposed to its constantly flashing lights, twenty-four-hour drone, cooling towers, detonations, sirens and blast reverberations. Ian Frazier described one of these machines in *The New Yorker*:

> The bucket has teeth the size of a man, and room to park three stretch limos. The biggest of these machines can strip an area of several city blocks without moving. In their wake, they leave not ruins but ruin. ... It is impossible to imagine a Cheyenne war party coming out of the canyon, because the canyon is gone. ... Usually, trash exists in a larger landscape; after strip mining, the larger landscape *is* trash.

Despite federal and state legislation, there are no effective social or ecological controls and most of the land is left unre-

claimed. "Do these pictures, then, reflect the spirit of our time and the world we live in, in addition to my own personal vision?" Hanson asks.

> Clearly they depict one aspect of the interaction of man and nature, contemporary man's view of nature and the world around him. What is being addressed, from one point of view, is the history and philosophy of Western civilization. For we may see here a late manifestation of the Cartesian split between mind and matter, and the consequent separation of man and nature. The resulting loss of a holistic consciousness has created a lack of awareness of the interrelationships between man and the world around him. Thus we have a dialectical view of man as separate from, even opposed to, nature and the subsequent exploiting and ravaging of nature. . . . In a certain sense what we have here is a geography of the mental landscape of our time.

For Hanson, as for Thomas Berry and many others, what we are doing with our land and how we live on it has become the central problem of our time. The dominator system socializes us to pursue our own ends, to dominate and prevail, even at the expense of others and the earth. The parts function without regard for the interests of the whole. Survival is equated with dominance and power to control the environment. Radiating from these photographs is the self-devouring nature of the dominator model itself, perpetrating its mechanistic principles without any regard for the soul of the world. In our efforts to create a technological "wonderworld," we have created a "wasteworld" instead, states Berry. "The industrial age . . . can be described as a period of technological entrancement, an altered state of consciousness, a mental fixation that alone can explain how we came to ruin our air and water and soil and to severely damage all our basic life systems under the illusion that this was 'progress.'" The confrontation between the industrial and the ecological, with survival at stake, is now the major issue of our time; no prior struggle, according to Berry, has ever been of this magnitude.

Our culture has failed to generate a living cosmology that would enable us to hold the sacredness and interconnectedness of life in mind. Because awareness of the whole escapes us, we devastate the land in greed. "Our ultimate failure as humans," charges Berry, "is to become not a crowning glory of the earth, but the instrument of its degradation." A few months ago I read a book called *The Heart of the World*, about a remote tribe of South American Indians. The Kogi live in the High Sierras of Colombia, totally isolated from the world, and refer to themselves as the Elder Brothers of the human race. They do not like visitors, since they see us, the Younger Brothers, as the thieves, murderers and destroyers of the world. Now, in what they fear may be the closing days of life on earth, they have summoned us to listen to their message, which is that the world is beginning to die. They say that it is not yet too late for us to understand the world in a different way. The Kogi do not ask us to be like them, but they do say that we must stop taking fuels from the ground, and we must stop tearing trees from the earth, in the way we do. They also say that they will not speak again.

The old seers knew that the earth is a sentient being. In the past, certain places on the planet were sanctified because of their high magnetic density; they were places of cultural renewal, where one could study the stars or approach the gods. But sacred sites have suffered an eclipse in recent centuries, at least in the industrialized areas of the world, where we seem to have lost that capacity for sharing consciousness with the universe that is often the result of visiting a sacred site. The idea of a magical alignment of the sun, earth and moon is not a new one—it goes back at least as far as Stonehenge. It is also the essence of James Turrell's long-term art project of building an observatory on the site of Roden Crater in a wilderness area of the Arizona desert. Turrell acquired the crater in 1977; it is one of more than four hundred that make up the San Francisco volcanic field north of Flagstaff. This is a setting in which to gather up and assimilate the grand harmonies of the cosmos—a place where you can experience geologic, rather than man-made, time.

You have a powerful sense of standing on the surface of the planet. The feeling of being part of the physical world is very strong.

To activate the phenomenon of celestial vaulting, the crater bowl has been reshaped, so that if you lie down in the center of the crater, you will experience the sky as a dome. Turrell intends to build a tunnel from the base of the volcano to the center of the crater, where, eventually, there will be four lower rooms aligned with the axis of the northernmost sunrise and the southernmost moonset. A fifth room will be set above the others and will be open to the sky. There will be no artificial light of any kind. Some spaces will be sensitive to starlight literally millions of light years away. "The gathered starlight will inhabit that space," says Turrell, "and you will be able to feel the physical presence of the light." When our normal perceptual filters, which form a kind of barrier around us, are transcended, or simply drop away, then our senses can begin to receive an amplified vision of the world, and we can see the universe, thus, as an unbroken whole. We can see ourselves as stardust.

The viewer who comes to Roden Crater—in the tradition of the vision quest or pilgrimage, since it is not easy to get there—makes the transition from spectator to participant. And once up there, according to Turrell, "the separation that occurs in a gallery between spectator and artwork is impossible when the 'work' surrounds you and extends for a hundred miles in all directions. For me," he states, "art isn't something you carry up to an East Side Manhattan apartment in an elevator." Central to Turrell's conception of Roden Crater is his desire "to set up a situation to which I take you and let you see. It becomes your experience." The artist does not own the experience; instead, he puts *us* in front of the thing itself, so it becomes our experience—we get inside the landscape and can develop our own affective ties with it. This is "non-vicarious art," which, according to Turrell, is very different from, say, Cézanne's paintings of Mont Ste-Victoire that present the viewer with multiple views of the artist's experience while looking at a particular mountain.

Some people are likely to dismiss the significance

of Roden Crater on the grounds that only a few people will ever be able to experience it—the gallery system, after all, remains more basic to the realities of the art world. Others will be concerned that Turrell has unnecessarily tampered with the wilderness. The question is, if few people will ever get to see it, does Turrell's project address a fundamental need in our culture, and does it nevertheless define a worthwhile (if difficult) task? "If we were truly moved by the beauty of the world about us," writes Thomas Berry, "we would honor the earth in a profound way. We would understand immediately and turn away with a certain horror from all those activities that violate the integrity of the planet." "Our ontological crisis is so severe," writes ecologist Bill Devall in his book *Simple in Means, Rich in Ends,* "that we cannot wait for the perfect intellectual theory to provide us with the answers. We need earth bonding experiences. . . . When a poet opens the door and takes a step outside the house of intellect—the house of concepts and abstractions and quantification taught in schools and demanded in environmental impact statements—he or she may spontaneously have intercourse with rivers and mountains."

Our loss of ecstatic experience in contemporary Western society has affected every aspect of our lives and created a sense of closure, in which there seems to be no alternative, no hope, and no exit from the addictive system we have created. In our man-made environments, we have comfort and luxury, but there is little ecstasy—the cumulative effects of our obsession with mechanism offer no room for such a way of life. Ecstatic experience puts us in touch with the soul of the world and deepens our sense that we live in the midst of a cosmic mystery. In the catalogue of Turrell's work, *Occluded Front,* the art collector Count Panza di Biumo has written about his own visit to Roden Crater:

> We are coming from something beautiful and we belong to something great. . . . We do not know that our desire for total happiness can be fulfilled, but it can be. In the middle of Roden Crater, this belief seems possible. If everyone were to have this kind of experience, the use

84

of drugs would disappear, no one would commit suicide, and violence would stop. Unfortunately, few will make this journey—if they did, the world would change.

Ecstasy is an archetypal need of our being, and if we don't get it in a legitimate way, according to Robert Johnson, who has written on the subject in his book *Ecstasy*, we will get it in an illegitimate way—which accounts for much of the chaos of our culture. Boredom, cynicism and chronic materialism are all symptoms of our higher need for an ecstatic dimension in our life.

"With the gods gone," writes R. Murray Schafer, a composer, writer and media theorist who lives in rural Ontario, "humanity really began to angle in a different direction. Life became a struggle to get ahead." What was lost, Schafer claims, was the ability to feel the divine—that which goes beyond the man-made environment. In the modern world, the man-made environment has been pervasively organized around the linearity of goal-directed, object-oriented activity, and for centuries our art has been produced to conform to these kinds of controlled spaces, which have been carefully neutralized so that nothing unwanted can intrude. Schafer maintains that music, too, has lost its participatory and ecstatic aspect in the modern era, having been pervasively shaped by the same distinctive feature of Western art: walls.

Why not hold a concert under a waterfall or in a blizzard? Schafer asks. Music performed in living environments such as forests, mountains, caves, or, if need be, in snowfields or tropical jungles, offers the opportunity to breathe clean air and experience the sunrise. In the Euclidean space of the concert hall, everything is willfully arranged for maximum comfort and high-fidelity sound, and a costly apparatus consisting of stagehands, lighting and recording engineers, acousticians, managers, box-office attendants, publicists, printers, critics, broadcasters, publishers and recording companies expecting to make profits ensures that working conditions are infallibly maintained. All this "maintenance" can be avoided, according to Schafer, simply by moving outdoors.

"Modern theory teaches that revolutions in art occur when styles are challenged," says Schafer. "But they ignore the bigger revolution of context." In the normal physical environment of the theater or concert hall, the purchase of an admission ticket indicates to the audience that it does not have to *earn* its way in; the audience is not required to work, learn, act or participate in any way. All that is required of customers is that they be able to afford the price of admission. Performances are usually given in the evening, at a comfortable temperature, preferably on a full stomach, and with a time limit of three to four hours, so as not to interfere with work schedules. For Schafer, this definitely represents the uncosmic version of art, hardly distinguishable from entertainment. "Yes," he writes, "the little orb of excitement which beats in your heart when you go to the theatre or hear an orchestra is the same as that bigger orb of vitality which animates the savage drummer or dancer, but his shakes him out of this world and yours merely bunts you back onto the same street."

The notion of pilgrimage is crucial in Schafer's work, as it is in Turrell's—you have to make your way, at some effort, to a special place in order to have the experience. To see Schafer's opera *The Princess of the Stars,* for instance, the audience must arrive at a lake in the middle of the night, and find their way to the embankment. At 5:00 A.M., precisely, the performance begins with the appearance of the presenter in a canoe. Actors and dancers can be heard, chanting in an unknown language from other canoes at the center of the lake, while the musicians and singers are hidden in the surrounding trees. The cast consists of two mixed choruses, a solo soprano, four actors, six dancers, a flute, clarinet, trumpet, horn, trombone, tuba, four percussionists and twenty canoeists. As the mythopoetic story unfolds, Wolf is searching for the lost princess, who has fallen to the bottom of the lake. When he fails to find her, the Dawn Birds are summoned to assist him—six dancers in six canoes, who comb the waters for the princess. Meanwhile, the musicians are singing birdcalls to the real birds, who now begin to awaken and sing. The opera is timed to end exactly at sun-

rise, with the appearance of the Sun god, who will rescue the princess. Schafer writes:

> Instead of a somnolent evening in upholstery digesting dinner, this work takes place before breakfast. No intermission to crash out to the bar and guzzle, or slump back after a smoke. No women in pearls or slit skirts. It will be an effort to get up in the dark, drive thirty miles or more to arrive on a damp and chilly embankment, sit and wait for the ceremony to begin. And what ceremony? Dawn itself, the most neglected masterpiece of the modern world. . . . And like all true ceremonies, it cannot be adequately transported elsewhere. You can't poke it into a television screen . . . you must feel it . . . you must go there, go to the site, for it will not come to you.

Pilgrimage is an old idea but, as Schafer points out, when over five thousand people travel to a remote lake in the Rocky Mountains to see a performance, it is evidently one for which there is a contemporary longing.

Just as light pollution now prevents us from truly *seeing* the universe, noise pollution prevents us from *hearing* it. In his book *The Tuning of the World,* Schafer describes how the soundscape of the world has changed from what it used to be; the different quality and intensity of modern, technological sounds from the more organic and living sounds of the past has made noise pollution a world problem. There are no steady-state, uninterrupted day-and-night sounds in nature—all biological sounds rise and die out. Even the birds phase in and out with each other; they never sing all at once. By contrast, the flat, continuous drones of the industrial environment are toxic and hurt our hearing. Industrial noise is a killer. Performing his work outside in nature, however, does not signify "dropping out" of the technological world for Schafer. Rather, the intention is to cultivate a sense of merging with a vast ecology, with a scenery that can't be controlled, in order to understand that working with nature means working on nature's terms. By responsive and careful

listening to the natural world, Schafer hopes to make this understanding a practice through his art, which is paced by the rhythms of nature and linked with the greater movements of the cosmos.

Since musicians are the people who are most attuned to sounds, Schafer proposes that they begin to think more comprehensively and take responsibility for orchestrating and controlling the whole acoustic environment. Musicians, he feels, could help alleviate noise pollution through refashioning our soundscape so it is more in tune with natural models. Obviously this implies an expansion of our usual notion of the artist's role. "To be an engaged artist," Schafer states, "used to mean being concerned with the restoration of certain social imbalances. Today we could use the word with regard to the restoration of certain ecological imbalances." Art moved by empathic attunement, not tied to an art-historical logic but orienting us to the cycles of life, helps us to recognize that we are part of an interconnected web that ultimately we cannot dominate. Such art begins to offer a completely different way of looking at the world.

A few years ago, Lynne Hull, an artist who lives and works in Wyoming, began etching small, glyphlike symbols into rock surfaces—mostly on private land in remote desert areas of Wyoming and Utah. She incised them deeply enough so that they can serve as pockets, or small trenches, for holding water or snowmelt. These "hydroglyphs," as Hull calls them, help to store the desert's most precious commodity and thus function as a water supply for desert creatures to drink. Hull writes:

> Except in a very few instances, all man's activities are aimed at benefitting himself, as a species if not as an individual. . . . Hasn't civilization brought mankind to a point where he could take actions which would benefit primarily other species? And if art is a leading edge of civilization as we hope it is, was it possible that this idea of trans-species action could be done as art?

The hydroglyphs have become part of an ongoing project of designing "art for animals," works that will

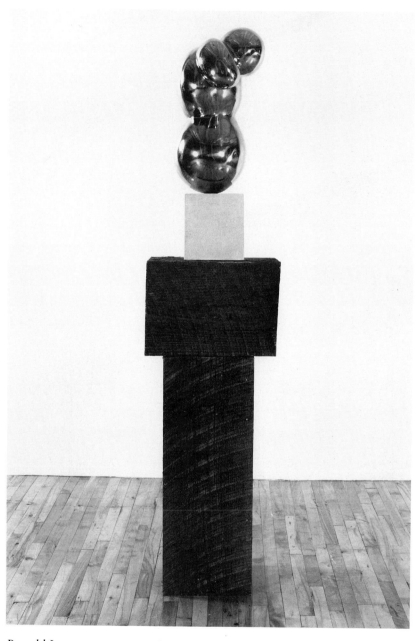

Ronald Jones
Untitled (New Human Immunodeficiency Virus Bursting
from a Microvillus), *1988*
Bronze, wood, limestone
73½ x 18 x 12"
Courtesy the artist and Metro Pictures, New York

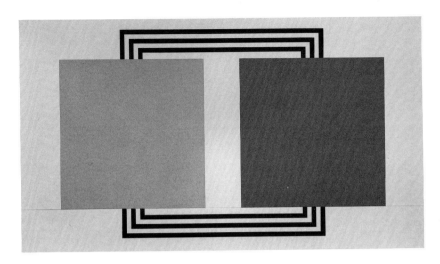

Peter Halley
Two Cells with Circulating Conduit, *1987*
Day-Glo acrylic, acrylic and Roll-A-Tex on canvas
77¼ x 138"
Collection of Dakis Joannou, Athens
Courtesy Sonnabend Gallery, New York

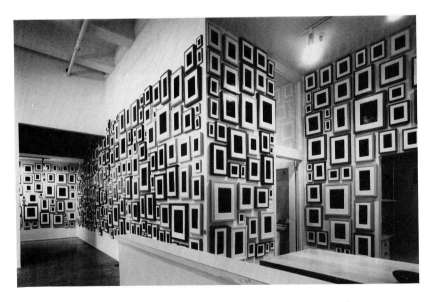

Allan McCollum
Plaster Surrogates, *1982–1984*
(1985 installation: Metro Pictures, New York)
Enamel on Hydrostone Dimensions variable
Courtesy John Weber Gallery, New York

Sherrie Levine
Untitled (After Walker Evans: 7),
1981
Photograph
10 x 8"
Courtesy Mary Boone Gallery,
New York

Simon Linke
Agnes Martin,
October 1986, *1987*
Oil on linen
6 x 6'
Courtesy Tony Shafrazi Gallery,
New York

AGNES MARTIN
NEW PAINTINGS

LOUISE NEVELSON
MIRROR-SHADOWS

SEPTEMBER 19–25 OCTOBER
THE PACE GALLERY, 32 EAST 57 STREET, NYC

David Salle
BAMFV, 1984
Oil on canvas and satin, with objects 101 x 145"
Courtesy Larry Gagosian Gallery, New York

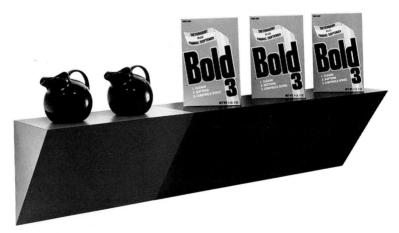

Haim Steinbach
supremely black, 1985
29 x 66 x 13"
Shelf with ceramic pitchers and detergent boxes
Courtesy Jay Gorney Modern Art and Sonnabend Gallery, New York

Tony Tassett
Domestic Abstraction
Courtesy Rhona Hoffman Gallery, Chicago

Barbara Kruger
Untitled
(I shop therefore I am),
1987
Photographic silkscreen, vinyl
111 x 113"
Courtesy Mary Boone Gallery,
New York

Richard Serra
Tilted Arc, *1981*
Gorten steel
2 x 120'
Courtesy Leo Castelli Gallery and Artists Rights Society, New York

Mierle Laderman Ukeles
The Social Mirror, *New York, 1983*
20 cubic-yard garbage collection truck fitted in hand-tempered
glass mirror with additional strips of mirrored acrylic
Collection of the New York City Department of Sanitation
Courtesy Ronald Feldman Fine Arts, New York

Othello Anderson
Acid Rain *1990*
Acrylic on canvas
60 x 109"

Gilah Yelin Hirsch
Learning to Fly in the Forest, *1985*
Oil on canvas
16 x 25"

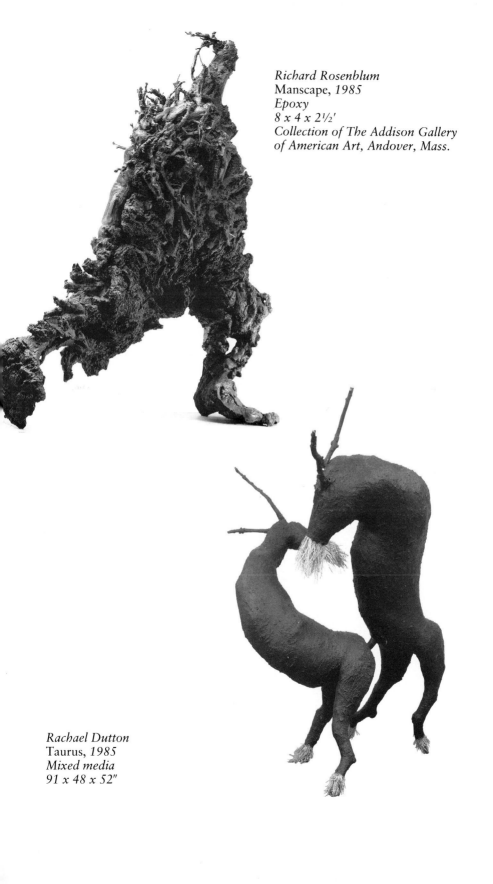

Richard Rosenblum
Manscape, 1985
Epoxy
8 x 4 x 2½'
Collection of The Addison Gallery
of American Art, Andover, Mass.

Rachael Dutton
Taurus, 1985
Mixed media
91 x 48 x 52"

Fern Shaffer
Crystal Clearing, Winter Solstice, *1986*
Photo by Othello Anderson

David T. Hanson
Rocky Mountain Arsenal, *Adams County, Colo., 1986*
From the series Waste Land
Ektacolor print, gelatin silver print and modified
U.S.G.S. topographic map
17 x 47"

R. Murray Schafer
The Princess of the Stars, *dawn ritual, Banff Centre for the Arts
Festival, Banff, Alberta, Canada, 1985
Designed by Jerrard and Diana Smith
Photo by Ed Ellis
Courtesy The Banff Centre for the Arts, Banff, Alberta, Canada*

James Turrell
Roden Crater, *Flagstaff, Ariz.*

Lynne Hull
Raptor Roost L-1, *with Swainson's hawk, Albany County, Wyo., 1988*
Wood, stone, found metals
16' high
Photo by Bertrand de Peyer

Robert Janz
Patricia's Lily, *Dublin, Ireland, 1988*
Process drawings, charcoal, drawn and erased daily for ten days

Andy Goldsworthy
Touching North, *North Pole, 1989*
Photo by Julian Calder
Courtesy Fabian Carlsson Gallery, London

Rachel Rosenthal
L.O.W. in Gaia, 1986–1987
Photo by Jan Deen

Krzysztof Wodiczko
Homeless Vehicle Project,
New York, 1989
Courtesy Josh Baer Gallery
and Restless Productions, New York

John Malpede
Performance by John Malpede
and the Los Angeles Poverty Department
Photo by Lukas Felzmann

Tim Rollins and K.O.S.
Amerika II, *1985, 1986*
Oil and china marker on bookpages (Kafka's Amerika) *on linen*
7½ x 14'
Photo by Ken Schles

Suzanne Lacy
The Crystal Quilt, *a performance by Suzanne Lacy with Phyllis Jane Rose,*
Miriam Schapiro, Susan Stone and Nancy Dennis,
Minneapolis, Minn., 1986
Photo by Peter Latner

Dominique Mazeaud
The Great Cleansing of
the Rio Grande River, *1988*
Photo by Dwayne Edward Rourke

Bradley McCallum
Park Bench Shelter: A Collaboration
in Process, *New Haven, Conn.,*
1990
Dimensions variable

Ciel Bergman (a.k.a. Cheryl Bowers)
A Single Flower at the Bottom of the Ocean Will Last for Centuries, *1989*
Oil and wax on canvas 60 x 84"
Collection of the artist Photo by William Dewey

exist in the landscape in a beneficial way by making small improvements to the habitats of wildlife. "I've had a long-standing interest in earth or site-specific art," Hull states, "but too often it seemed so egocentric—on a grand scale, to go out and abuse the land in the name of art—which, as much as I love some of these pieces and enjoy hunting them down, did not seem enough. I felt a growing need to make a positive gesture to the earth. Couldn't there be a small-scale, nurturing, perhaps even 'feminine' land art?" Hull also became concerned with the way that eagles and other birds of prey are being electrocuted by power transmission lines in parts of Nebraska. More than five hundred birds a year are electrocuted in this way. Her painted wooden sculptures placed out in the landscape are designed to provide a safer place to perch for the hawks, eagles and owls of the prairies. Passersby may enjoy them as sculptures, while the birds have a safer roosting place. Since making the "raptor roosts," Hull has also created floating sculptures—small islands on which waterfowl can nest and "loaf," as the fish and game department calls it. All her designs are made with the help of wildlife biologists and zoologists.

Painting flowers in all stages of the life cycle is a way for Robert Janz, an Irish-born artist living in New York, to bring forth a voice for nature, by tuning in to its cyclical processes—an awareness we have lost in our linear, Cartesian view of reality. A flower buds, blooms, ages and dies. It has its own rhythm, not tied to the clock. The flower transforms through time; but a drawing is normally static, framing an isolated moment. For Janz, therefore, the drawing must also transform, through a continual process of erasure and redrawing. Drawing becomes process, fluid energy patterns evolving over time. You don't control the subject—it's more like a dance than a product, more like a living activity as the artist appears in the gallery each day to erase and draw over the work of the previous day. Are we aware that the flower is different? Its bud has opened; now a petal has fallen off. Which version of the drawing is the real drawing, Janz asks. Which stage in the life of the flower is the real flower? It takes ten days to see the whole drawing. You can't see it in less

time; you can't speed up the process. And there is no fixed identity, no static state; all that is left at the end are traces of former marks, former life. This is time gathered into wholeness, the cyclical rhythm of life taught by the feminine principle, which connects us to the natural order of growth and decay.

"Our species has become arrogant," writes Gary Zukav in *The Seat of the Soul.* "We behave as though the earth were ours to do with as we please. . . . The cycles of life need to be approached with reverence. They have been in place for billions of years." This revision of our time-horizon is crucial. Our culture is oriented to short-term values; we don't yet think systemically. The dumping of nuclear waste, whose malignant consequences ramify for a million years, is just one example of our inability to experience time as whole, to make the future real in the present. Real time is not just the present, but the time it takes for an event to work itself out. The dumping of nuclear waste is one consequence of being out of tune with the land, of not being able to hear its voice. Blaming industry is irrelevant, according to Janz, since Exxon, the World Bank, politicians, all develop from our group assumptions, the code so many people share: dominance and profit, expansion and waste. We are discovering that the nature which sustains us is also in balance with us, and the balance has been lost. For Janz, the flower is not inconsequential. The flower is the voice of the land speaking.

If Thomas Berry is correct, and the historical mission of our times is to develop a new cultural coding for the ecological age—a more integral language of being and value that can overcome the devastating consequences of the existing mode of cultural coding, which encourages high consumption and high waste—then creating an art that is integral with this new coding may well be the next phase of our aesthetic tradition. Janz makes a similar claim:

> Significant, worthwhile art today seems to me to be that art which points to, which focuses on, the problem of restoring the balance. We don't need an art of imposition anymore. We need something else. It is the subtext

of art that is the issue. The subtext of important art today, saleable art today, is power and prestige. That is the real subtext in a Richard Serra sculpture or a Frank Stella painting; it's Brand Art for a Brand Culture. A big corporation buys this important "brand art" and it says: "We brand the land. We are powerful and prestigious, and we impose. We make things happen." That is the subtext of contemporary art. Whereas what we actually need, since we've become a cancerous society, destroying our planet exactly the way that cancer cells destroy us, is an art whose subtext is balance and attunement. Art also pollutes, consumes the world. What about self-erasure in art—art that cleans up after itself?

It is clear that this kind of ecological subtext for art—by which I mean a recognition of the reality that all things are linked together in the cyclical processes of nature—is not to be found in the official picture of mainstream aesthetics, or not so far. But it is equally clear that increasing numbers of artists are beginning to think, feel and act more relationally, as they perceive the need for a radical reevaluation of the institutions and ideologies associated with the dominator model.

In the case of Andy Goldsworthy, an English artist living in Dumfriesshire, Scotland, nature is the subject, not the backdrop, of his work. His approach, too, is premised on respect rather than on domination; his gestures are delicate and unobtrusive. He doesn't arrive at the site with materials, but finds them there. The challenge is in tuning in and adapting to different landscapes and seasons, establishing a dialogue with the place, cooperating with its subtle web of interrelated processes.

"When I'm working with material," he states, "it's not just the leaf or the stone . . . [that] I'm trying to understand, not a single isolated object but nature as a whole—how the leaf has grown, how it has changed, how it has decayed, how the weather's affected by it. By working with a leaf in its place I begin to understand these processes." Goldsworthy works directly in nature, but he does his work

without tools, and what he makes—lattices of horse chestnut leaves stitched together with grass stalks, fresh green blades of spring grass with white stems placed around the circumference of a hole like a sunburst, yellow dandelions threaded onto grass stalks and laid in a stream, a zigzag trail of bracken fronds on the ground—usually blows away in the wind or rain, sometimes after only a few seconds. Ephemerality and impermanence are the very heart of his work.

Goldsworthy tries to photograph the work before this moment of dispersal—before it crumbles, melts or just blows away, to be reclaimed by nature. "I cannot stop the rain falling or a stream running," he says. "When I work with a leaf, rock, stick, it is not just the material in itself, it is an opening into the processes of life in and around it. When I leave it, these processes continue. . . . These things are all part of a transient process that I cannot understand unless my touch is also transient—only so is the cycle unbroken, the process complete." As with Janz, tuning in to nature's cycles is crucial—the sense of working with nature on nature's terms. Snow is his favorite medium, although in other seasons he will use feathers, leaves, flowers, stones or grass. "I often work through the night with snow or ice," he says, "to get temperatures cold enough for things to stick together. But then daybreak—sunlight which brings the work to life—will also gradually cause it to fall apart." Most of Goldsworthy's works don't even last for a day. He enjoys working in diverse settings, from the Arizona desert to the British embassy garden in Copenhagen and to Hampstead Heath in London. In Japan his work was received with great enthusiasm, since as he says, "It is in the nature of the Japanese not to question the value of something which is not going to last."

The experience of a ritual journey into wilderness became part of a series of extraordinary works created in 1989 at the North Pole. Goldsworthy went to the Arctic island of Ellesmere and apprenticed to an Inuit, Looty Pitjamini, who taught him how to cut and pack snow. Camping at the North Pole for four days, they were joined by the photographer Julian Calder, and Goldsworthy created *Touching North*, a kind of ice-henge at the very top of the world: circles made

of packed snow bricks at the four points of the compass; arches and spires; a group of ten-foot-high stacked cones that echoed the shapes of distant mountains; a jagged comb on the frozen expanse, with giant teeth for the wind to blow through. In the Arctic, snow is blue. The sun doesn't rise or set at the North Pole, but just keeps on circling around, producing magical patterns of light and shadow, so the appearance of the sculptures altered constantly—before, of course, they began to blow away. In this landscape, there are no trees or rocks, only ice, and the coldest wind in the world. As Goldsworthy describes it, the North Pole is more like a feeling than a place, the pure essence of winter, the energy of North. And it belongs to no one. At least, not so far. The oil companies are poised, ready for the takeover.

The real message of these artists' works, if properly assimilated, has the potential to reconfigure our intellectual, emotional, physical and spiritual orientation in the world. For without a fascination and reverence for the grandeur of the earth, as Thomas Berry so eloquently argues, the energy needed for its preservation will never be developed. Our psychic "entrancement" with industrialism is what is preventing any mitigation of this destructive process—since we still continue to believe it is the necessary condition for our survival, even when its desolating effects have become so obvious, and we perceive the basic life-support systems closing down under its assaults.

There is only one way this disastrous cultural coding can ever be changed, according to Berry, and that is by reassessing our immoral relationship with the natural world. There must be a mystique of the land itself that goes beyond the country's political and economic needs; this is the only foundation for any environmental concern—a love of the earth itself, respect for its intrinsic worth. As protection of our life-support systems becomes the top priority, this evocation of a mystique of the land is the role being fulfilled by artists and poets and natural history essayists, who are building ecologically sound role models into our cultural consciousness. At this point, we can no longer view such evocations as either romantic or idealistic, Berry claims, since reenchantment with

the earth *is* the necessary condition for its rescue from the impending destruction we are imposing on it.

In a powerful solo performance work entitled *L.O.W.* [Loner on Wheels] *in Gaia* (first performed in January 1986), Rachel Rosenthal—arguably the most significant performance artist in Los Angeles—portrays several personae. One of these is the Earth, manifesting as the Death Crone. Another is a fortieth-century monster, our descendant. And she also plays herself, with head shaved to appear androgynous, as she drags more and more of her waste with her, in garbage bags roped to her body. Near the end of the piece, there is a blackout as a nuclear explosion hits the hall. Rosenthal rises from a pile of debris to the ticking of a Geiger counter and the buzzing of flies. When, finally, the Earth does speak, what we hear, listening to her voice, is the primal voice of a dispossessed archetypal power:

> Things are inexorable, and you cannot
> escape the Karma of my continuum.
> I am angry at your escalating assaults.
> You denude me. Turn my nurture into
> aridity.
> You plunder. You excavate. . . .
> You are trying to paralyze me—to turn me
> into a broken toy, its mechanism spilling
> out of its guts, kept functional
> only through the heroic and Faustian tricks
> of your technology.
> You drive me underground, where I am still
> myself and move according to my will and
> nature.
> Down there I have no use for you. I revert
> to who I was at the beginning.
> Down there I am a demon who destroys in
> an instant what it took me millions of years
> to build.
> I shove the continents around.
> Smash India into Tibet.
> Crash Africa up Italy's boot.
> Play scrabble with the North-American
> West.

Spin Europe like a top.
Lift the seas up to the peaks . . .
I play and you die . . .
Without sentimentality.
Alive or dead, it is all the same to me.
But you pump me full of poisons. You
force-feed me substances I cannot
tolerate.
I try to absorb, to burn, to cleanse, but
more comes.
Always more.
My bowels hurt.
I am ill.
I want to vomit.
My intestines burst!
My stomach lining cracks!
Enough! Enough!

As this book goes to press, over five hundred oil fires are still burning in Kuwait. Newspapers state that the protective ozone layer over densely populated areas of the United States has thinned twice as fast as previous projections, and heavier doses of ultraviolet radiation are leaking to the ground for longer periods of the year. "The problem is more serious than we thought," says EPA administrator William Reilly.

The Kogi make no predictions. They only say that if we do not change, they truly believe the world will die. It will cease to be fertile. "Does the Younger Brother understand what he has done? Does he?"

CHAPTER 7
MAKING ART AS IF THE WORLD MATTERED
Models of Partnership

To be a useful person has always appeared to me to be something particularly horrible.

Charles Baudelaire

The atomic individualism of patriarchy destroys much of the fabric of the human community. Such a damaged community is incapable of understanding the needs of its own members, much less of the nonhuman world.

Michael Zimmerman

The assumption of being an individual is our greatest limitation.

Pir Vilayat Khan

We spend a lot of time, in contemporary Western civilization, dealing with the feeling that we are alone in

the world and that people do not really care about each other's welfare. The world as an oppressive and brutal place in which people survive only at each other's expense has been the leitmotiv of Sue Coe's art for many years. Her paintings have been compared favorably with Goya's war paintings and Picasso's *Guernica* by a number of critics, who include her in the tradition of other artists who have embodied a strong political conscience in their work, like Honoré Daumier and George Grosz. In a catalogue preface to her traveling show *Police State*, Donald Kuspit describes Coe, an English artist now residing in New York, as "the greatest living practitioner of confrontational, revolutionary art," and considers her work to be "a seismographic record of the faultlines where social catastrophes are likely to occur."

In Coe's *Police State* series, paintings made on black grounds depict with relentless and seething violence the many dehumanizing forces at work in our society because of its dominator mechanisms. There are grossly caricatured visions of Ronald Reagan, the CIA, Wall Street, the scientific establishment, the Catholic Church, Union Carbide, slum landlords and riot police, all portrayed as tormentors in the act of destroying their victims. The victims are poor people, ethnic minorities, women and animals used in experimental science laboratories, who are being subjected to appalling scenarios of humiliation, violence and rape at the hands of the tormentors. Coe's work makes Dante's Inferno seem almost cosy by comparison. Her paintings read like a logbook of the dark and vicious underbelly of corporate, consumer capitalism, transcribed at its least illuminating moments: the assassination of Malcolm X in the Audubon Ballroom in 1965, while he was addressing the Organization for Afro-American Unity; homeless women hanging out and miserable in Penn Station; a black body indifferently tossed into a sanitation truck with the rest of the garbage. A more recent series, entitled *Porkopolis*—a huge body of work encompassing everything from paintings on paper to broadsides—exposes the ruthless, unecological practices of the meat-packing industry and factory farming, in which the hogs are fed with their own excreta mixed with concrete dust. The exhibition

is the result of two years' firsthand observation in slaughter-houses and meat-packing plants across the country, and includes an impressive amount of factual documentation.

While I was teaching in Richmond in 1987, *Police State* was shown at Virginia Commonwealth University's Anderson Gallery. My students visited the show, and one of them, Denise Giffard, summed up the uneasiness that some people felt on seeing the paintings. "I left her show with a strong impression of the ills of the world," Giffard wrote, "and overwhelmed and frustrated by the enormity of the situation, but no closer to any idea on how to help. If anything, her art created such despondency that it almost suggested the futility of any positive efforts." A lot of frustration and rage is being vented in Coe's work, but the paintings seem undeviatingly to focus only on what's wrong. A great deal of modern art has been witness in this way to humanity's cruelties and estrangement. The vision is so oppressive that it is hard to find even the smallest opportunity for opening. From such a vision, how do you build the sane ideogram? The question for me at this time is whether artists can be a positive force in transforming the paradigm of alienation. According to art historian Robert Rosenblum (writing in a 1987 catalogue, *Art against AIDS*), "By now we are all disenchanted enough to know that no work of art, however much it may fortify the spirit or nourish the eye and mind, has the slightest power to save a life." I cite this quote because I think it dramatizes the primary assumption about art in our time—that it is *only* art, and therefore powerless in the real world. The assumption is one I should like to put to the test in this book.

From within the paradigm of alienation, it has been difficult for individuals to feel responsible for conditions in the world over which they feel they have no control. But as we begin to move toward a new ecology of consciousness, and the world becomes understood as a place of interaction and interconnection, the challenge will be to break through the Cartesian illusions that have generated the impression of separation and detachment. Relationship is the key insight of ecology. In the modern world, we tend to think

of art exclusively in terms of a visual paradigm; modern aesthetics is part of a whole cultural project of objectification that channels perception into modes that are detached and abstract, forcing us to remain in a modality where our gaze is that of the detached observer. The artist is *supposed* to be emotionally distanced from the event he is portraying, according to Ortega y Gasset, in his famous essay of 1925, "The Dehumanization of Art." Art evokes aesthetic, not real, emotions. The onlooker consciousness is a basic assumption here. Ortega presents the example of a dying man whose bedside is attended by his wife, his doctor and a painter. He describes the painter's attitude as one of indifference: the painter pays attention only to lights and shadow and chromatic values: "To actually worry about the dying man," Ortega comments, "is not the concern of aesthetics." "In painting and sculpture, the design is the essential thing," wrote Immanuel Kant. It invites attention to the surface qualities of pigment and texture. The truth of these comments reverberates in John Rewald's account of Monet, described in *The History of Impressionism*. At the height of his grief, Monet could not help painting his wife on her deathbed; to his horror, he found himself drawn by his painter's instinct to "the blue, yellow and grey tonalities cast by death."

Within traditional aesthetics, it is only the image that counts. Lived reality is repressed by the disembodied eye and transformed into spectacle. According to David Michael Levin, this reduction of being to picture has been characteristic of aesthetics and is a pathology in the very character of our vision. The challenge imposed by Levin's book *The Opening of Vision* is a call for a radically different kind of vision from one based on the disembodied eye—in a sense, it is this challenge that I have tried to take up in this book. In order to change the social ills that we see, Levin claims we will first need to change our vision. Historically the model we have in place is inherited from the Renaissance, which created the spectator who is outside the picture and separate from what he sees. The vision we need to develop is not one that observes and reports, that objectifies and enframes, but one released from these reifying tendencies and rooted instead

in a responsiveness that ultimately expresses itself in action. "I submit," Levin writes, "that when [vision] . . . is made concrete and situational, its traditional formalism and abstractness are overcome." In other words, vision that is truly engaged with the world is not purely cognitive, or purely aesthetic, but is opened up to the body as a whole and must issue forth in social practices that "take to heart" what is seen.

"Vision is a social practice," he states, "and needs to be understood as such." Implicit in the violence, poverty and oppression depicted in Sue Coe's paintings is a call to heal, but it is a call that Kantian Cartesian aesthetics can never answer. For that, we need an art that transcends the distanced formality of aesthetics and dares to respond to the cries of the world.

During the winter of 1987–88, an estimated seventy thousand persons were homeless in New York City, with no permanent shelter and no safe place to go. "Epidemics, housing, health—the concerns of urban people—how do we find our aesthetic practice in relation to these concerns?" asks the Polish artist Krzysztof Wodiczko, who now lives in New York. Wodiczko is known mostly for his projections of photographic images on buildings and public monuments, but it was his *Homeless Vehicle Project,* exhibited at a city-owned gallery space called the Clocktower in downtown Manhattan during January 1988, that significantly caught my attention. Wodiczko attempted to design a vehicle, based on the shopping cart, that could be used for transport and storage, and might even serve as a temporary shelter for people who are compelled to live a nomadic life in the urban environment. Special extensions on the cart allow it to expand into a variety of useful positions: you can crawl inside it, sit up, lie down, and store personal belongings as well as up to five hundred bottles and cans, which can be redeemed for cash.

Also on view at the Clocktower were drawings of different cart designs by Wodiczko and his collaborator, David Lurie, which had evolved in response to discussions with homeless people. Photomurals of Tompkins Square and City Hall Park showed the cart in its potential setting, and a

prototype cart stood in the center of the room looking like an aggressive missile. Taped conversations between the artists and people talking about the carts played continuously throughout the exhibition. It is important to Wodiczko that the proposed design not be put forward as a finished product but as a starting point for further collaboration between the designers and potential users. It is not Wodiczko's intention that the vehicles be mass produced, as a way of involuntarily institutionalizing homelessness. Instead, they are designed to meet emergency needs. (So far none have been manufactured.) "Learning from this particular group [the scavengers] modified my project enormously," Wodiczko told me. "They responded to my initial drawings—we designed according to their needs. This is difficult in design terms because they have conflicting needs: visibility and protection. And there must be an escape system in case of fire. Shopping carts are an interesting metaphor of the shopping mall; but people think these scavengers are stealing the carts, so ultimately they don't like it. The scavengers want something which specifically articulates their needs *and* creates respect. Then it's more difficult to take the cart away from them. The police can't confiscate it."

The Homeless Vehicle serves, thus, both as a practical object and as a symbol of the right of the poor not to be excluded from social life. Instead of shunting the homeless out of view, it heightens their visibility and legitimizes their otherwise unrecognized status as members of the urban community. The mobility of the cart is important. Scavengers need to push around heavy loads of glass, metal and plastic that they collect for redemption, in order to survive. If they sleep, they also have to protect what they have collected from vandals and police harassment. It becomes valuable capital.

One of the features of the cart, besides transportation and shelter, is that it compels us to acknowledge the homeless as more than wrapped-up objects in the street that we ignore and step over. "You can always recognize newcomers in New York," says Wodiczko, "because they actually look at the homeless. The experienced New Yorker deflects

his gaze and is not affected." For Wodiczko, homeless people symbolize what is really happening in the city in terms of real-estate takeovers and urban development. The police remove the homeless from the sight of the nonhomeless and from developers in order to promote a desirable image of the city. "They want to put them in shelters," says Wodiczko, "or on floating barges attached to tugboats that take them away like rats—never recognizing them as people who are working and trying to survive. A designed object addresses their needs well. Because the middle class is trained to see the world in terms of designed objects, they begin to consider 'what is this object?' and 'who is it for?' This gives hope for communication, which is my aim."

In another aspect of his work, Wodiczko projects photographic images of the homeless onto the outside surfaces of buildings and on public monuments, as a way of forcing acknowledgment of the contradictions such monuments embody. The projections are catalysts for dialogue with the public about certain social conditions. In Union Square Park, for instance, the statue of George Washington, as a result of a photographic projection, is made to appear as if his left arm is pressing down on a can of Windex. His right arm holds up a rag, so that Washington's paternalistic gesture is transformed into the hand-signal used by the unemployed to stop cars and clean windshields. Abraham Lincoln's statue is augmented by a crutch and a beggar's cup, while Lafayette's extended arm becomes a vagrant's, asking for coins. A similar Homeless Projection was created for the Civil War memorial in Boston on New Year's Day, 1989. Superimposing images of poverty-stricken people on buildings and monuments deconstructs the official public image of the city as a well-managed place and subtly transposes the sites into memorials for the homeless. One critic has written that the projections leave behind a kind of moral echo that would not be available to a permanent installation: their appearance and disappearance make them more haunting, as they seem to emanate from the buildings themselves, like a secretion, or repressed dream-memory, of the stones.

"What the homeless need," according to perfor-

mance artist John Malpede, "is caring. They need situations that would allow them to participate in life, to contribute and feel as though they are part of something." Tired of making art for the purpose of getting reviews and building up his resumé, Malpede left New York and went to Los Angeles where, in 1985, he became the founder and artistic director of a theater group composed of street people from Skid Row. "I didn't have enough responsibilities, emotional involvements, concerns about others," he says. Sometimes called The Theater of the Homeless, LAPD (which stands for the Los Angeles Poverty Department) has already put on more than a hundred shows, and the company now travels frequently on the road visiting other cities, encouraging people who are interested in establishing similar programs.

In order to gain access to Los Angeles's homeless community, Malpede worked as a volunteer in a soup kitchen, while taking a job at the office of Inner City Law in the heart of Skid Row. With the help of grants from the California Arts Council and the National Endowment for the Arts, he became the law agency's first artist-in-residence, and began to form the theater group through weekly talent shows held on the streets and in the shelters among Skid Row residents, who vote for the best performance. His work at the free law clinic helping welfare applicants secure benefits gave him a special entrée to the street people, and he was able to trade on the clinic's long-standing good will with the community in winning their trust. "We do action suits against the welfare department," he told me, "on behalf of people who, for instance, don't have the proper identification to get welfare. Many of our cases have been won by direct testimony from the homeless. My job has been to go around and get those statements. I think of it a bit like an art form—collecting improvisational stories from, maybe, a hundred or so people."

These stories form the core of LAPD's performances, since there is never a prearranged script, only a series of monologues, often raw and chaotic, sometimes wild and obsessive, in which individuals unfurl the fabric of life on Skid Row. "Nothing is written down," Malpede explains.

103

"We develop a scenario which everyone gets to know. It cooks as it goes along, like spaghetti sauce. Some of our people can't even read, but even for those who can, it stultifies things. This way people are always adding stuff, and some of the scenes change."

Gradually, the monologues changed into dialogues between people relating to each other about issues. "We didn't know it, but doing performance in a group turned out to be exactly what isolated and mistrustful people need. It has helped them develop skills for relating to others, like how to argue, for example. In the beginning people didn't know how to relate to each other at all—which reflected the reality of Skid Row, where things happen on top of each other, not in an organized way."

In this unreconstructed and volatile situation, what emerges is not always expected. On a given workshop night, there may be loud arguments about who is the best artist (a good thing, according to one group member, for people who normally don't think much of themselves). One may hear an angry tirade or a bit of cabaret—someone singing romantic songs, calypso, or reciting poems. One person describes his love for baseball; another enacts a fantasy of being a drum majorette leading a marching band, or an invisible character named Frances Fettucini. Someone else tells his own story, narrating an important turning point in his life in a passionate, evocative way. In the middle of the performance, pizzas arrive and are eaten. Fights often break out. Actors shriek, and run in and out of the room; they harass the performers on stage, and talk to the audience.

"Most of the people that I now make art with have been socialized in institutions: foster homes, mental hospitals, jails. Institutions at the margins of society," Malpede notes. "They don't know how to act right. Behavior that would not be tolerated in any other group work situation is put up with and over time worked through in this group. As a result, there have been amazing changes in some members' ability to function and to interact with and care about other people. . . . I was drawn here to work," he says, "because the urgency of the situation and the emotions it fires provided the conditions I wanted for making art."

Malpede himself appears in some performances, wearing a wig and a pink-and-orange housedress, playing the part of Robert Clough, a "crazy" black transvestite. Sometimes other people play Malpede, or each other. It is a bit wild and anarchic for some tastes, but others are deeply impressed with the proceedings. For them, the turbulence is what makes it so powerful. I inquired of Malpede if he acted outrageously to create a context for others to feel free to express themselves. "Not at all," he replied. "Robert, the outrageous transvestite, was actually one of our members, but he made a lot of trouble for everyone, and eventually he got sent to jail. So I took over his part. On Skid Row everybody is outrageous—they don't need encouragement."

The uniqueness of LAPD is that it is not political or "issue-oriented" theater. It is a direct experience of what it means to be a homeless person. And, as one critic wrote in *Artforum,* "the characters aren't pitiful, and sometimes they aren't very nice. They immobilize any do-gooder impulse in the audience. In fact, LAPD makes a liberal response to the issue of homelessness look feeble and completely inadequate." Community, as it is being enacted here, is the ability to touch others in ways that matter to them—to give them a voice. No matter how accurately art may mirror back to society its own negative features, the perception that alienation subsides when we become aware of our connectedness with others leads inevitably to a different sort of artistic practice—oriented toward the achievement of shared understandings and what Levin, quoting Habermas, refers to as "moral-transformatory processes." The fact that a lot of things besides art go on at LAPD doesn't bother Malpede. He doesn't see this as a hindrance, since it's where the group's priorities are. The current show, for instance, is all about Leroy "Sunshine" Mills, a group member who got thrown out of a fourth-floor window and nearly died; LAPD is working on getting him a place to stay. Many people who started out lost, and even delusional, have found places to live, and attest feelingly to how the workshop saved their lives. "Before I was in a rut," states one member, Douglas Perry. "I was always by myself. I didn't want to work; I was confused. Joining the theater group brought me back to reality."

Vision that responds to the cries of the world and is truly engaged with what it sees is not the same as the disembodied eye that observes and reports, that objectifies and enframes. The ability to enter into another's emotions, or to share another's plight, to make their conditions our own, characterizes art in the partnership mode. You cannot exactly define it as self-expression—it is more like relational dynamics. Once relationship is given greater priority, art embodies more aliveness and collaboration, a dimension excluded from the solitary, essentially logocentric discourses of modernity. Partnership demands a willingness to conceive of art in more living terms. "Compassion is the rooting of vision in the world, and in the whole of being," states David Michael Levin. It is a way of seeing others as part of ourselves. When art is rooted in the responsive heart, rather than the disembodied eye, it may even come to be seen, not as the solitary process it has been since the Renaissance, but as *something we do with others.*

At Intermediate School 52 in the South Bronx, where New York artist Tim Rollins has taught for many years, there are many inner city teenagers who have been classified as emotionally handicapped and learning disabled. It was with a small band of these students, who are now known as K.O.S., or "kids of survival," that Rollins in 1982 began his Art and Knowledge workshop, which has since become not only an innovative model for learning, but also for creating art based on partnership. Like most art teachers, Rollins had been teaching and making art at the same time. But, dissatisfied with the limitations of that, he decided to fuse the two practices and began making art with the kids. "Because many of them were dyslexic," he says, "I would read to them, not those embarrassing primers, but books like *Frankenstein*, Dickens' *Hard Times*, Kafka's *Amerika* and Dante's *Inferno*. The kids went crazy for them. I would have them draw while I read, but it wasn't that I wanted them to illustrate what I was reading. Instead, I told them to come up with visual correspondences between the stories and things in their daily lives."

Nineteenth-century classics in literature became

106

the starting point, the inspirational trigger, for a unique series of collaborative paintings. Rollins and the class would read the book together to try to get a sense of how the story might relate to their own concerns and struggles. *The Scarlet Letter,* for instance, brought up issues of guilt and shame, and how people put negative labels on one another. In the South Bronx, low-income blacks and Hispanics are constantly being labeled as underprivileged or disadvantaged by people in power. "It's not unlike that 'A' Hester Prynne has to sew on her dress," says Rollins, "which she transforms from a stigma of shame into a symbol of pride. The kids got into that— they started looking at different typefaces to represent the 'A'."

Each painting is launched through a similar process, with a period of brainstorming for an image or symbol that can best be used to communicate the core meaning of the book. Then, its pages are carefully torn from one copy and pasted in sequence onto the surface of the canvas, there to become the literal (as well as metaphoric) ground of the picture. For *The Red Badge of Courage,* the symbol that emerged was a wound. Stephen Crane set his novel during the Civil War; the story concerns a new recruit's psychological experience of combat, and his yearning for a wound—a red badge of courage that would visibly signify his heroic passage from youth to manhood. As the kids talk over the meaning of the symbol, Rollins shows them paintings by Grünewald and photographs of exploding stars from NASA. The energy builds, and what started out as gashes begins to take on a cosmic dimension until, finally, a whole galaxy of astral presences, resembling comets or other celestial bodies, are transposed onto the canvas, as each individual creates his or her symbolic "red badge" in paint, standing for all that one has survived. "I liked the idea of wound forms placed all over the 'body' of the text," says Rollins.

A painting of golden horns, derived from a scene in Kafka's *Amerika,* is probably the best known painting ever made by Rollins and the K.O.S. A version of it is in the Saatchi Collection in London. It refers to an episode in the book in which an immigrant boy comes into a room where everyone

is dressed up and blowing on beautiful horns. In the painting (there are actually thirteen different versions of it), each horn is gold, but some are sinewy and plantlike, while others have a more formal design. Coiled and welded together on the canvas, their interlocking shapes seem to mimic the mating rituals of insects and flowers in a contorted mingling. "Some of us like drawing geometric," comments one of the kids, "others like guts and stuff—that's why when you put them together they look so good."

Rollins makes it clear that his interest is not in establishing a painting team, but in reaching new kids and helping them realize their potential. His goal is to use some of their profits to start his own multicultural art school in the South Bronx. Presenting what he does as an alternative to the single-tracked artist, Rollins operates on many fronts at once, doing interviews and community work as well as big public shows. "I'm a flag waver," he says. "What we do is not valuable unless other people start doing it in their communities, in their own way. . . . Everything we do is to build something else—it isn't going into Jacuzzis for our loft."

The philosopher Maurice Merleau-Ponty argues, in an essay entitled "Cézanne's Doubt," that it is not enough for philosophers—or, I would add, artists—to create or express an idea; they must also awaken the experiences that will make their idea take root in the consciousness of others. With this in mind, Rollins and the kids now travel extensively, demonstrating their concepts and working methods for students and teachers in other communities. But it is important to Rollins that what he does not be seen as therapy or social do-goodism. "When did it happen," he says, "that working with kids became a saintly, do-gooder thing? It's a basic duty of society. The reason that kids are running wild is that no one is there for them." On another occasion, Rollins commented: "We don't just want to paint ourselves and our communities. We want to find out something about the world. It makes the kids feel that they can do something—that they can make things happen." From within a partnership-based paradigm, which views selfhood as intrinsically *relational*, artists like Rollins, Malpede and Wodiczko can more easily

see themselves as active agents, choosing and implementing projects that give people an experience of community. What emerges from the model of partnership is a vision freed from the prison cell of the separate, independent ego; and in this case, a vision of art that is much more sensitive to its place in the whole. "We drive people crazy because they can't figure out what it is," Rollins states. "Is it social work? Is it a school? Is it an art project? Is it a fraud? Is it socialism? Is it rehabilitation for juvenile delinquents? . . . I think many people find the work we do threatening. On the simplest level, we take the conventional notion of the white male alone in his garret making masterpieces and throw it out of the window."

In the context of a sustaining environment, within a network of social support and mutual respect, things can be learned, close working relationships are formed, shared goals can develop; and I think it is not farfetched to say that in the journey from powerlessness to authentic empowerment, lives may even be saved. One of the kids' parents, Pura Cruz, who was interviewed about her son's connection with K.O.S., commented: "On our block on Longwood there are drugs on every corner. I am happy and relieved to know my son is a member of K.O.S. What Tim Rollins, God Bless him always, has given to these kids is a sense of incredible responsibility, opportunity and security. . . . My son has been given a future."

On Mother's Day in 1984, a procession of 150 women aged sixty to ninety-nine, from a variety of ethnic and class backgrounds, participated in *Whisper, the Waves, the Wind*, a ceremonially orchestrated art work by Suzanne Lacy. Dressed in white to honor their continuity with the early suffragettes, the women entered a beach at La Jolla, and sat down in groups of four at white cloth-covered tables to discuss their lives, and their concerns about aging. When the ritual ended, spectators, who had been watching from the cliffs above, descended onto the beach to converse with the performers.

Again on Mother's Day, this time in 1986, another procession was orchestrated by Lacy; this time six hundred

older women, all dressed in black, entered the huge, glass-enclosed Crystal Court of Philip Johnson's IDS Center in downtown Minneapolis. Once again they sat in groups of four, this time at tables covered in black, to discuss with each other their accomplishments and disappointments, their hopes and fears. A prerecorded sound track, consisting of an audio-collage of the voices of seventy-five women at the tables, projected the participants' reflections loudly enough to be heard by the audience of several thousand, who were looking down from the balconies. The audience is important for Lacy, not so much in terms of number, but in the degree of their engagement and communication. At the tables, the women rearranged their hands in unison and slowly folded back the black tablecloths, revealing Miriam Schapiro's red and yellow geometric patterns beneath. The prearranged movements of their hands, the slow unfolding of the cloths and the colorful designs symbolically suggested the process of quiltmaking. When the ritual was over, members of the audience were invited to present the performers with hand-painted scarves, placing them on the women's shoulders, as if commemorating a kind of public investiture.

Lacy has dedicated *The Crystal Quilt* to her mother. "The goals in my work," she says, "are definitely . . . to empower participants, to raise consciousness about certain shared conditions of being female." If older women in particular are to move into the public sphere and enjoy relationships beyond the nuclear family, they need to develop communication skills and solidarity with other women. Transforming the experience of exclusion and alienation from society into one of creative empowerment in the community requires an experience with reciprocal listening. "The cultivation of listening," writes Levin in *The Listening Self,* "is imperative if our society is to overcome its traditional system of domination. It is imperative, if an historically new kind of self is ever to emerge from the traditional dualism. . . . Our listening needs to learn receptiveness, responsiveness, and care. Our listening needs to return to the intertwining of self and other, subject and object, for it is there that the roots of communicativeness take hold and thrive."

The *Crystal Quilt* project involved collaborations with several service agencies, such as the Minnesota Board of Aging, and educational institutions interested in promoting authentic images of older women as active participants in the public sphere. But most of the actual work was done by volunteers and many of the women participated without rehearsal or preparation. For Lacy, the "success" of the work is measured by whether or not the process of networking among the women continues once the performance itself is finished. In Minnesota, ten of the women went on to found an organization dedicated to challenging stereotypes of older women; they now offer statewide training programs for women in community-oriented leadership skills. The message they are disseminating is that older women are coming of age and occupying a more prominent place in the world. "I think sometimes society forgets that older women have a lot of knowledge, can be helpful—we're not being brought out well on television at all," comments one of the women on Susan Stone's audiotape. "We're no longer sitting home in the rocking chair and knitting, like you think of grandmas in the old days—when the work was done, they would just sit in the rocking chair and knit away. We grandmas aren't doing that any more," states another. "I think a lot of senility comes from the fact that nobody asks you anything. Nobody asks you to speak. Pretty soon," says St. Paul writer Meridel Le Sueur, "you lose your memory. I suffer a lot from people not listening to me."

Listening is a question of character, according to Levin. Its development is a practice of the self. When California artist Jonathan Borofsky and his collaborator Gary Glassman traveled in 1985 and 1986 to three different prisons in California to make their video-documentary *Prisoners,* they did not go as network reporters intending to observe and describe the conditions they found. They went to listen to prisoners in order to try and understand their plight, so they could know for themselves what it means to lose your freedom and live your life locked up in a cement box. "Personally I've always had a running empathy for anyone less fortunate than myself," Borofsky told me, "for peo-

ple trapped in the system who aren't free. I always want to do something about it. . . . Part of me feels like a prisoner as long as others aren't free."

Listening to others—getting beyond merely expressing ourselves—is the distinguishing feature of art in the empathic mode. When we attend to other people's plight, enter into their emotions, make their conditions our own, identification occurs. Then we cannot remain neutral or detached observers: responsibility is felt and we are summoned to action. Rather than seeking to impress our own images upon the world, a radical art, as Tim Rollins conceives it, is one that helps organize people who can speak for themselves, but lack the vehicles to do so.

Borofsky and Glassman invited the prisoners to talk about their lives—their childhoods, families, hopes—and about what had gone wrong for them. Thirty-two people consented to be interviewed. In the film, some of them share poems they have written or show art works. Conversing with the filmmakers, they describe the oppressiveness of life inside a prison, where everything is programmed, and people never get to talk spontaneously about themselves because no one is interested. They tell about how much they miss real living, and about how the system breaks you down—because it is designed to break you down rather than to help you. What you see with the prisoners, according to Borofsky, is that they've never been shown a better way.

"I use my art as a tool," he says, "to work out what's going on in my life. I'm working with an inner politics here, and what's going on in these prisons has to be worked out in my life too. . . . What can I learn from these people? What does it mean to be free? Why do people end up in prisons?" Over eighty percent of all criminals have been victims of child abuse. Ninety percent of the criminals in Death Row were children in the foster care system. Nearly all robberies in Los Angeles are drug related. The people who end up in prisons are usually people who don't feel good about themselves.

"When I showed this film at Yale," Borofsky states, "the students said it was a breath of fresh air. They

said, all we do is talk about what is modern and what is postmodern. This shows an artist doing something in human terms. Hopefully teaching is open, but current models are limited and mostly people play the game within its limitations. . . . Secretly most people know the best artists in the past have been those who go against the grain, who stuck their neck out. But now it's about survival and how to play the game in this financially crunched atmosphere. Even you and I are caught in that system."

Certainly it's true that we are caught in the system along with everyone else, but we are also part of its unfolding. There is no doubt in my mind that the seeding of understanding and respect that has occurred through the art of Wodiczko, Malpede, Rollins, Lacy and Borofsky goes some way in counteracting the social psychopathy depicted in Sue Coe's paintings. Empathic art is like a window on the dream-broken soul of our society; its restorative action helps to correct the impaired feeling function, the passive nonintervention of spectacular modes of consciousness. "Beware, my body and my soul," writes the poet Aimé Césaire, "Beware above all of crossing your arms / and assuming the sterile attitude of the spectator, / because life is not a spectacle."

Right now, our culture still promotes only disenfranchised conceptions of the social role and political function of art; and it will continue to do so as long as we conceive of culture itself simply as an arena for individuals to achieve their own professional ends. The self-serving thesis generated by capitalism and its exploitative, dominator models is that the general welfare is best served by separate individuals motivated by profit, in a competitive environment. But self-servingness, it turns out, is the great enemy of community. Robert Bellah and M. Scott Peck, along with many other writers, have been pointing out that unless capitalism as a whole can become genuinely community-minded, it and the world from which it profits are unlikely to survive. "We must recognize," writes Peck in *The Different Drum*, "that we live in a time in which our need for community has itself become critical. But we have a choice. We can keep on pretending that this is not so. . . . We can avoid community until the

end. Or we can wake up to the drama of our lives and begin to take the steps necessary to save them." Most of us, in the capitalist world, have never had an experience of true community. We live so much in an ethos of professionalism, which keeps us bound to individualistic modes of thought and directed toward the making of products, that it is difficult not to marginalize, or subtly discount, achievements that manifest less ego-control, and point to the value of cocreativity. What is compelling to me about these artists is their ability to respond to the cries of the world *as artists,* proving that being an artist and working for social change do not have to be at odds.

Cartesian aesthetics has presupposed a solitary, isolated subjectivity, but where there is dynamic participation, forms are not just visual—they lead, as Levin says, to a relational experience with listening. They lead to the formation of identities grounded in the communicative realization of our intersubjectivity, which transcends the ego-logical, fixed self of the Cartesian and Kantian traditions. "This dialectic," writes Levin in *The Listening Self,* "*deconstructs* the narcissistic structure of the self, redeeming for subjectivity its primordial sociality, its inherence in the reciprocities of a social world—a 'moral community.' "

It would seem that the capacity to move beyond the old art-and-life, subject-object polarities is precisely where the frontier of a post-Cartesian framework is to be found. Community is the starting point for new modes of relatedness, in which the paradigm of social conscience replaces that of the individual genius. In the past, we have made much of the idea of art as a mirror (reflecting the times); we have had art as a hammer (social protest); we have had art as furniture (something to hang on the walls); and we have had art as a search for the self. There is another kind of art, which speaks to the power of connectedness and establishes bonds, art that calls us into relationship. Perhaps, as James Hillman says, the new aesthetics will not be found in museums or beautiful objects, but in some visible manifestation of "the soul's desperate concerns."

114

CHAPTER 8
BEYOND THE RECTANGLE, OUT OF THE FRAME
Art as Compassionate Action

If they blow [the world] up, that's not my business. My business is to work.

Louise Nevelson

The artist's business requires an involvement in practically everything. . . . It would be bypassing the issue to say that the artist's business is how to work with this and that material or manipulate the findings of perceptual psychology, and that the rest should be left to other professions. . . . The total scope of information he receives day after day is of concern. An artist is not an isolated system. In order to survive he has to continuously interact with the world around him. . . . Theoretically there are no limits to his involvement.

Hans Haacke

Bullshit! If you're saying this is supposed to be something 'new,' some big change that's happening in our culture—we've always had the missionary tradition of people who wish to engage the world's suffering and help bring about relief. What those artists are doing has its merits in terms of social therapy and all that, but it wouldn't have stopped Michelangelo or Mozart from what they were doing, and it won't stop any great artist now."

This belligerent comment was hurled at me by a writer at an artist's retreat in Illinois, where I had just read the previous chapter to a group of the other residents. The writer's assaults continued on through the night in the form of angry letters slipped under my door. "This has really upset me," chimed in one of the painters, "because I think that I'm a good person, but I'm not about to give up what I'm doing. I have too much of myself invested in it." "You realize," said another writer, "that what you just read threatens the way of life of everyone in this room."

Cultural myths do not die easily, especially when our personal commitment to them is so strong that it is difficult even to entertain explanations or possibilities based upon different premises. Most of us "see" art as we have been taught, through the language and concepts of Cartesian aesthetics, a tradition in which individuals and individual art works are the basic elements. Maintaining a symbiotic or complementary relationship with society is demonstrably not how the myth of aesthetic freedom has been conceptualized in the modernist vision, and certainly not how it has been embodied. In modern society, artists see themselves as quintessential free agents, pursuing their own ends. Our cultural myths support economic advancement and the hard-edged individualist writ large, rather than service, caring attitudes and participation. Though certain individuals are exploring and implementing more communal values, others have not shifted their understanding in this way and may not wish to. For them, art remains a question of radical autonomy.

"When someone seriously questions the accepted way things are done," writes Carol Becker in her book *The Invisible Drama: Women and the Anxiety of Change*, "sug-

116

gesting a new approach, the person may trigger anxiety in others. This anxiety may be turned against the innovator in the form of anger." When challenged by a countermyth, an individual's prevailing myth will often entrench itself more deeply, since there is usually a strong emotional investment in the common assumptions of the current societal paradigm, because it defines one's world and oneself. To risk abandoning images we have held as absolute is never easy.

According to West Coast psychologists Stanley Krippner and David Feinstein, the existing mythologies of our present culture are leading us to destruction. We are all being called upon to participate in revising and updating the ideas and assumptions that we follow. Since our society defines success as money and power, orientations that redefine personal fulfillment on nonmaterialistic premises go right to the heart of our culture's "mythic crisis." For a long time now, the cultural coding of modern Western civilization has centered in notions of dominance and mastery: the dominance of humans over nature, of masculine over feminine, of the wealthy and powerful over the poor, and of Western over non-Western cultures. These same goals of dominance and mastery, which are crucial to our society's notion of success, have also become the formula for global destruction—it is a logic that pervades every experience in contemporary culture. Nor is art some ancillary phenomenon, struggling to overcome the forces of instrumental reason—it is heavily implicated in this ideology. We can no longer ignore our own participation in this process. The institutional structures and practices of the art world are modeled on the same configurations of power and profit that keep the ball of patriarchal high capitalism rolling and maintain the dominant world view of this society in place.

The art industry has become not only a very effective protector of the status quo, but also an active contributor to the deforming effects of a whole cultural pathology. The mechanism doesn't require that art do much, just reproduce the economic will-to-power of the dominator system. "It is widely conceded that the heavy engines of the art world turn and turn without any of their massive energy,

economic and publicitaire, translating into creative energy," writes Arthur Danto, in an essay called "Narratives of the End of Art." Nevertheless, the "transaction" mentality is highly skeptical of anyone who tries to break out of its credo of success. In our present mind-set, it's hard to conceive of art from the perspective of service, or as something that isn't commensurate only with itself. If you start rejecting the cultural ideals of economic success and competitive striving, or start challenging these ingrained perceptions of how we understand our place in the world, you threaten to break the barriers that keep us locked in denial. At stake is our personal identity as defined by the particular view of life that our culture has made available to us.

Most people are aware that the system isn't working, that it is time to move on and to revise the destructive myths that are guiding us. We have been programmed into a belief structure that is losing its feasibility as a social form, but we can't recover without being open to transformation. Recovery is the willingness to make a systems shift. You might even say this transformation has become the moral imperative of our time.

What are the implications of such a change in consciousness, then, for art? One thing is clear: to be able to see our own practice as actively contributing to the most serious problems of our culture requires a change of heart. Without serious efforts to reassess our relationship to the present framework and its practices, new patterns won't take hold. Vested interests will ensure that they are maintained as before. Until we produce an alternative model, nothing significant will alter. If we want things to change, we will need to evolve new "ground rules" for the future that no longer bear the mark of the consumerist imperatives of this culture, where art has become something to fill galleries with, a pretext for putting oneself on display that virtually implies the deletion of all other concerns.

In truth, it isn't easy to change, because our whole society is addicted. Anne Wilson Schaef describes it as "process addiction," to distinguish it from substance addiction. Process addictions are unhealthy and destructive ways of being

in the world. Capitalism and free enterprise have so influenced the psychological needs of all of us in this society through their mythologies of competitive individualism and economic striving that most people believe they are following indisputable rules for the way things are. Since the promise of the addictive system is that it is possible to have everything we want and need as long as we accept and conform to the system, we keep trusting the system to take care of us. Art that is totally the product of the way of thinking of this society is unlikely to reorient it in any way. Our only hope is to construct a very different sort of integrating mythology.

In September 1987, Dominique Mazeaud, who now lives in Santa Fe, began an art project she calls The Great Cleansing of the Rio Grande River. Once a month, ritually on the same day each month, armed with garbage bags donated by the city, she, and a few friends who sometimes accompany her, meet to clean pollution out of the river. Part of her work involves keeping a diary, of which the following are some extracts:

Nov. 19, 1987. My friend Margret drops me off at Delgado promptly at 9:00 a.m. Because of the snow I was not sure of the conditions I would find but did not doubt a second that I would put in my day. I find a stone warmed by the morning sun which makes a perfect site for my beginning prayer. . . . Yes, I see what I am doing as a way of praying:

Picking up a can
From the river
And then another
On and on
It's like a devotee
Doing countless rosaries.

Nov. 24. Visitors stop by my door and look at a group of objects laid down on a strip of fabric. "What is this?" they ask. "These are some of the treasures I have collected from the river." "You found this little girl's shoes?" "Yes," I reply, "even the two $5 bills. . . ."

119

I really enjoy talking about the river, as if she were my friend.

I am glad I am walking slowly . . . because it allows me to catch great "pictures." It's not that I can carve them out and put them in a frame when I get home, but it is that they are such strong images that they quickly fill the screen of my mind. They are called "soul-imprints" in my river vocabulary.

Dec. 2. Why in all religions is water such a sacred symbol? How much longer is it going to take us to see the trouble of our waters? How many more dead fish floating on the Rhine River . . . ? How many kinds of toxic waste dumpings? When are we going to turn our malady of separateness around? Most of the glass we find is broken, but even so, the two of us picked up 103 lbs. in the 14 hours of work we put in that day.

How many times did I wonder about the persons who hurl the beer bottles down the rocks: in the upper part of the river or, later on, from or under the bridges, trying to imagine what went into this action. Is it that man is inherently violent, is it that there is nothing else to do other than smashing bottles into the river? Is it pure and simple fun?

March 19.

> I can't get away from you river
> In the middle of the night
> I feel you on my back
> In my throat, in my heart. . . .

We decide to clean the dumping area and set out to work. This is a more delicate operation than picking up "a can and then another." It's soiled rabbit litters, crates filled with rotting fruit scattered all over, and more. Some of it is encrusted in the ice, some of it has been burnt. As soon as we start stirring, the offensive smell of the decaying fruit hits us and the ashes soil the water . . . what a mess, but we get to it "faces down," so to speak.

July 14. Today I realize that, in fact, it is the first time I am truly alone in the river. . . . I went to the block where, back in November, I not only saw the suf-

fering of the river but also the death of the river. Just as I could no longer walk on trashed riverbanks without doing something about it, I could no longer be there without transposing my witnessing into some form that people could share. That day I started my "riveries." . . .

July 20. Two more huge bags I could hardly carry to the cans. I don't count anymore . . . I don't announce my "art for the earth" in the papers either. I don't report my finds nor my time for the newsletter of *Santa Fe Beautiful*. All alone in the river, I pray and pick up, pick up and pray.

Who can I really talk to about what I see? I feel the pain quietly, knowing that I, too, must have been unconscious at one time. I have also noticed that I stopped collecting the so-called treasures of the river. It was OK at the beginning, but today I feel it was buying into the present system of art that's so much object-oriented. Is it because I am saying that what I am doing is art that I need to produce something?

Nov. 10. I call my river-journal my "riveries." . . . Is it too sweet a word for the feelings that my "river-musings" often bring up in me? Would "rageries" describe them better? But do I really rage? I have been talking a lot about feeling pain, sadness. Is rage my next step? Would rage affect the way of my work? Would it make me more of an activist than I am? Would it make me more open to the community about what it is that I am doing in the river?

In 1917 Marcel Duchamp exhibited a urinal and called it art, although at the time there wasn't any concept yet in place to explain such an act of transgression. Today Mazeaud's project is equally startling because it isn't based on a transgression of the aesthetic codes at all. It comes from another integrating myth entirely: compassion. Carlos Castaneda calls it the "path with a heart." We have so little experience with making art on this basis that we are not likely to feel at ease with it. In fact, we actively avoid it in our modes of detached abstract thinking. This is definitely not art in the fast lane, based on chronic hyperactivity and jockeying for positional importance. It is not just a variation on

the old system, but reflects a completely different, more "feminine" approach to the world.

What Mazeaud's project forces us to see is the power operating in our cognitive and institutional structures. "None of us is fully awake to how much the masculine pursuit of power, production, prestige and 'accomplishment' impoverishes us and drives the feminine values out of our lives," Robert Johnson writes in *We*. Within patriarchy, we are trained to respect only what is masterful, expensive and imposing. Mazeaud isn't competing in the patriarchal system at all, but stands true to her own feminine nature. By returning to the river every month on the same date to resume her task once again, she makes the ritual process into a redemptive act of healing. A writer-friend of mine sees Mazeaud's project as a variation on the ancient myth of Isis, who was queen of Egypt. The human debris she gathers are the dismembered parts of the murdered Osiris (garbage being a wonderful cipher for how we are dismembered by our technologies). Through her worry and care, Mazeaud resurrects Osiris's body, ensuring the renewed fertility of the vegetable kingdom in the crescent of the river. Caring nowadays, the Dalai Lama has often stated, is not a luxury. It is a matter of survival.

Another important aspect of Mazeaud's project involves the artist's interactions with others—passersby who wonder what she's up to. For Mazeaud herself, what has become increasingly important is her evolving relationship with the river, which has become her friend and confidante, and even her teacher. "It is through her that I understand how 'beingness' is the key to everything," Mazeaud states. "For the first time last month, my meditation directed me to go and be with the river and *not do* anything. The instructions were clear, 'Don't even take one garbage bag.' . . . It's no longer a systematic retrieving of everything in sight, it's a dialogue with the river. She as a living being has something to say. . . . I have landed in a new landscape where I discover the river is as true an artist as I am." Mazeaud feels that she has been on a quest since 1979, during which she has learned a great many things; the greatest gift, however, is what the river has taught her—to be silent, and to listen.

If the river project does not fit into the "meta-narrative" of art history, it must be said that even within the mainstream, the modernist idea of a progressive art history based on stylistic dominance has already broken down. Arthur Danto argues, in an essay entitled "Bad Aesthetic Times in the U.S.A.," that the whole philosophy of modern aesthetics is under pressure of redefinition. Traditional myths such as the masterpiece, the individual genius, the museum and the gallery are being deconstructed by feminists and postmodernists alike. Artists no longer worry about moving art history forward. It isn't only women, Danto claims, who have abandoned the tradition of "good aesthetics." Even males, he says, "seem to have lost the knack of continuing the great tradition. . . . Cézanne, Bonnard, Matisse, Picasso, Duchamp, and even Warhol and Lichtenstein have no true successors." Danto speculates that for many people, the collapse of the "grand narrative" of art history doesn't signify the end of art so much as the end of a particular narrative history: of artists responding, as they did within modernism, to previous art. What is happening, he claims, is that one set of imperatives is being lifted from the practice of art as it enters its posthistorical phase. So what does it mean, Danto wonders, to be an artist in the posthistorical period? How do we continue?

What is not yet clear within the patriarchal mainstream, however—and here I think I am reading the forces for change correctly—is that the cultural recovery of the feminine principle is the key to recovery from the institutional oppressiveness of patriarchy from which we are all suffering, and which, in the words of Jungian psychologist Marion Woodman, "is eating the heart out of this society." "How do men and women," Woodman asks, "trained in a patriarchal tradition—driven, goal-oriented perfectionists—find their way back into a relationship with their own lost hearts?" This feeling function—the reawakening of our capacity to be compassionate—is crucial to finding our way out of the evolutionary mess we're in. The emerging new myth in our time would seem to be the myth of empathy—the capacity to share what another is feeling, to live in the consciousness of our interconnectedness. This is the fundamental ecological vision.

Conscious femininity, manifesting itself as what

Woodman calls "an awareness of living in the world soul," should not be confused with political issues like the Equal Rights Amendment, or other feminist agendas. Nor are we talking here about female subject matter in art, or increasing museum exposure for women. Rather, we are talking about the reemergence of certain neglected archetypal aspects of the human psyche, enabling more feminine ways of being to be reinstated in the general psychological patterns of society.

As for what all of this implies for art, the injunction is, using Danto's summary description, "to begin a non-exploitative history in which art is something put to immediate human ends, rather than something destined for the brilliant collection, the dramatized auction room, the sanctuary of the museum, the graphic tomb of the expensive art book."

Exposing the inability of present institutional models to bring about transformation has been the chief value of the aggressive ground-clearing of deconstruction. Allan McCollum's *Plaster Surrogates,* for instance, are a shrewd commentary on what occurs when a guiding truth becomes bankrupt; they exemplify, perhaps better than any other deconstructive work, the paradigmatic inertia of aesthetic codes that have become just another petrified formula for an image-driven society of spectacle. With the *Surrogates,* we have come full circle, to the zero-sum point of Kurt Schwitters's statement at an early stage of the modernist project: "The picture is a self-contained work of art. It refers to nothing outside of itself. Nor can a consistent work of art refer to anything outside of itself without losing its ties to art."

By representing the art object in its modal existence as commodity and spectacle, McCollum is simply laying bare the function it fulfills in relation to the culture at large. When art, as Peter Halley puts it, "has been reconstituted according to the processes of bourgeois consciousness," the thing that everybody really talks about is how to get a show. This is the shadowy juncture where aesthetics melds with economics as the main metaphor for a single value system in which the artist, without any other social role to play, seeks to gain the attention of collectors, curators and critics. A crisis of purpose is at stake here, and as Baudrillard

124

succinctly puts it, "the boil is growing out of control." "We are no longer in a state of growth," he writes in "The Anorexic Ruins," "we are in a state of excess. We are living in a society of excrescence, meaning that which incessantly develops without being measurable against its own objectives." Through overproduction and excess, the system overextends itself, accumulates, sprawls, slides into hypertrophy, obliterates its own purposes, leaves behind its own goals and accelerates in a vacuum. McCollum captures it all brilliantly, in a single Gestalt: the intensification of the aesthetic process in a void. Production and then overproduction and exhaustion of creativity at the same time. Our whole culture's cooptation into the growth economy and the codes of consumption. The context of no-context. "They're not even paintings," McCollum says about the *Surrogates,* "only plaster objects which may, at a distance, resemble framed images." But every surrogate has been signed, dated and numbered, and no two are identical. We are in the presence of "original works."

"Enframing" is a way of seeing, inherited from the Renaissance, that produced the notion of the spectator who steps back and observes, who is the surveyor of the scene but outside of it, separate from what he sees. But if the frame is dissolved, the spectatorial orientation associated with the fixed gaze disappears, and we are in the presence of another vision entirely—one that Levin describes as enveloping and relational. Vision premised on empathy rather than on mastery is released from its reifying tendencies and is cognitively geared to the achievement of very different goals. Enframing is related to the domination of vision, which is the most reifying of all our perceptual modalities, as the paradigm for knowledge—a way of seeing, according to Levin, that implicates vision in the "will to power" that characterizes patriarchal consciousness—an objectifying that presses forward and masters. The "self" of this tradition is essentially Cartesian—that is, rational and separate. The Cartesian self is not really compatible with a world view attempting to recover its sense of wholeness and interdependence—its sense of the living continuum that cannot be cut up and divided because of the symbiotic interactions and interpenetrations of every-

thing within it. At this point, we really need to work out, in our ordinary understanding of art, its unconscious participation in what Levin terms the "collective historical pathology" of our vision—the observing, spectator consciousness, in which the subject exists independently of the objects around it. The new ethics of participation, it would seem, demands a radically different modality of engagement.

The Cartesian gaze (the disembodied eye) has been so integral to aesthetics, and to the world view of technological modernism—it conditions the character of our involvement with things so much—that it is hard to imagine it would ever be replaced. The bottom line is that McCollum's "fake" paintings pass more easily as "real" art than Mazeaud's project of picking up the garbage, because McCollum still retains a relationship, although a negative one, with the tradition of Cartesian aesthetics, which rests on the subject-object dualism. Thinking about how aesthetics is implicated in patriarchal modes of consciousness, I happened to pick up a copy of *Vogue* magazine, in which the critic Clement Greenberg was interviewed by Dodie Kazanjian on the pivotal role of Cubism in the development of modern art. "All major painting in our time," Greenberg states, "major painting, mind you—has assimilated Cubism, one way or another. . . . This is the record. I don't lay down the law, I only go by the record." He continues:

> Duchamp . . . never discerned what it was about. I think he saw the surface of it, that's all. . . . Mondrian . . . got it fairly early. . . . Giacometti before the war was liberated by Cubism. Lipchitz was a Cubist sculptor. I don't think Brancusi was. Then of course there was Julio González . . . and David Smith, who I think kept the burgeoning tradition of abstract sculpture going, better even than Picasso. Better than González. . . . Pollock assimilated Cubism by osmosis. He never made any bones about what he owed to Cubism. . . . All the Abstract Expressionist artists had contact with Cubism, [which was] a kind of foundation for them . . . there's an awareness, I maintain, of Cubism in painters like Newman and Rothko. Of course Gorky and de Kooning and Kline

and Motherwell and Gottlieb, they had their Cubism by heart, as it were: Clyfford Still is a different case. He knew Cubism, but his work came more, in its tortuous way, out of Miró's departure from Cubism. . . . [it goes on]

Much more is involved here than just aesthetic hairsplitting. Gender ideology is usually a little more subtle and indirect than this, but what an immaculate example to come to hand, just as I am writing this. It communicates perfectly how much modern aesthetics has been colored, structured and controlled by a kind of compulsive masculinity—and I don't just mean in the sense that, at least for Greenberg, art history seems to consist entirely of male walruses. The whole idea of stepping into a major league lineage based on competitive ranking, like the chronicles of baseball "greats,"—the topdog-underdog order of things—projects a masculine image. It represents an archetypal motif for a kind of individuality structured in the patriarchal myth of the judgmental Divine King. Under the Divine King's rule, whatever does not accord with this rigid system of order is discounted. More than anyone else, it was Greenberg who defined the concept of a progressive art history, dominated by, and answerable to, "laws" of stylistic dominance and succession—the kind of "style wars" that Danto suggests have now come to an end. It was Greenberg, above all, who promoted the "purity" of modern aesthetics—traditional, object-oriented, art for art's sake—over contextualized art. As the primary orchestrator of contemporary modernism, his influence on artistic practice has been profound. His criticism has been the philosophical grounding of modern art for over three decades, not so much because people believe his ideas or support his theories (mostly they are reacting negatively against them), but because it is the one philosophical framework we have. No one else, as Donald Kuspit points out in his 1979 monograph on Greenberg, has produced such a coherent position.

But as we become more conscious of the submerged mythology we are living out in this culture, and how it has shaped our thoughts, feelings and behaviors, we cannot help but notice how much modernism has evolved under

the influence of combative, masculinized values. Greenberg's evaluation of all those artists is not inaccurate—the development of modernism was quite ostentatiously identified with the patriarchal stance of a solitary, battling hero. This *is* the vision encoded in our culture. Its theories and models *are* based in images of dominance, and its root-metaphor of radical autonomy does sacrifice relational values to intellect and product. Modern aesthetics, certainly as Greenberg conceived it, has been a static, cognitive endeavor, proceeding according to its own "laws," without any reciprocal relationship to an observer, or for that matter, to life. It has led to a kind of art of fetishistic objects, that are severed from social relations and produced for a public of spectators or consumers. Our present models, which until recently have been focused on notions of autonomy and mastery, have been notably uncongenial to any aspect of the psyche that is receptive or connective, that emphasizes the importance of relationship and harmonious social interaction. This sense of deep affiliation, which breaks through the illusion of separateness and dualism, is the highest principle of the feminine.

According to the insights of both Woodman and Levin, we have to connect to the repressed feminine because the power that drives the patriarchy, the power behind our social addictions, has to be transformed. As Woodman says, there has to be a counterbalance to all that frenzy, ambition, competition and materialism. It needs to be said that both men and women become trapped in power drives; when women see themselves from the perspective of patriarchy, they can often be worse patriarchs than men.

I recently attended a symposium in Indianapolis that examined the role of women in the arts and the problems contemporary women encounter in defining themselves as artists. One of the speakers, a local artist named Ellie Siskind, told an amazing story (which I later asked her for permission to include here). Twenty years ago, after raising her children, Siskind decided to resume her earlier pursuit of art. She wrote to a famous woman artist, who was teaching in Baltimore at the time, to ask if she taught any summer workshops or classes that Siskind might travel to attend. The artist

was Grace Hartigan, an Abstract Expressionist painter, well trained in a cultural heritage that values only what one does, not what one is. Hartigan replied that even though she thought it was never too late to create, when she was Siskind's age (thirty-six), she had already been shown all over the world, with artists such as de Kooning, Pollock, Kline and Rothko. Her graduate students, she said, were all, appropriately, in their midtwenties, and she did no other teaching. Hartigan thought of Siskind's identification as "more in the realm of what you wish you had done instead of your reality—what you did." She wished her well, but added: "Years that are lost are irretrievable—that is the heartbreaking decision that has to be made."

Siskind assured the gasping audience that, although she had saved the letter for twenty years, waiting for the moment to reveal it, she had not allowed its potentially damaging content to discourage her from continuing to make art successfully. Life, in Hartigan's view, was clearly a finite quantity that one "used up" rather than a process of growth. By patriarchal standards, identity is created through accomplishment, fame and rank. Judged by these ego ideals, Siskind had not broken into the club. Her lack of achievement and acclaim at age thirty-six was a sign to Hartigan of personal inadequacy that quite simply put her out of the "race" of the hard drivers. Women artists of Hartigan's generation sought liberation through the emulation of men; they rarely challenged the basic script. In her comments to me, Siskind observed:

> One can understand that a woman coming out of the 1950s might not see other alternatives than that a woman artist must choose either art or family. However, this letter was written in 1975. *Heresies* was being published; the women artists' movement had reverberated as far as Indianapolis, and it is difficult to think that Grace was unaware of feminist politics, but rather that she was taking a position. . . . Thus I do not think it is unfair to use her own words to characterize patriarchal thinking.

129

It is crucial to understand that there is a serious difference between "feminist" issues and the cultural recovery of the feminine principle. Linda Schierse Leonard puts it well in *The Wounded Woman:* "When women hope to achieve the victories of men by being like them, the uniqueness of the feminine is subtly undervalued, for there is an underlying assumption that the masculine is more powerful." Imitating the masculine devalues the feminine by implicitly accepting the masculine as superior.

If theoretical-instrumental reason has operated for many centuries in the service of the *masculine,* can we encourage a radically different tendency? Levin asks in *The Opening of Vision.* "It may be time, psychologically speaking, for us to ground our vision in the principle of the *feminine* archetype. . . . The gaze of theoretical-instrumental reason needs to be reintegrated with a vision of wholeness, a vision of feeling, a vision of life." The imbalance between the masculine and the feminine must be corrected even in our ways of channeling perception and attention, goals and values. "In thinking through such possibilities," he adds, "we shall find that our visionary being is at stake. Our destiny may depend on our response to the historical challenge."

The reanimating and revitalizing of postmodern culture that I refer to in this book as the Reenchantment project, to distinguish it from the patriarchal structures of the Cartesian Enlightenment, will involve a reintegration of the culturally suppressed "anima" wisdom of the feminine, whose modes of connectedness have profound ramifications for the way we think about art, and for our previous aesthetic models based on masculinized notions of radical autonomy. It seems ever more obvious that the dichotomous patterns of patriarchy have given us separation and detachment and what Levin calls "rationality without heart." The consciousness that Descartes projects is a solitary one. The sense of everything being in opposition rather than in relation is the essence of the old point of view, whereas the world view that is now emerging demands that we enter into a union with what we perceive, so that we can see with the eyes of compassion. The success or failure of the Reenchantment

project will depend on our integration of these participative, empathic and relational modalities of engagement. They are nowhere better formulated than in Catherine Keller's definition of "empathic," in *From a Broken Web:* "Feeling the world into myself, feeling my way into the world, all these meanings unfurl from the idea of radical relatedness." If modernism developed around the notions of radical autonomy and art for art's sake, the politics of a connective aesthetics is very different.

CHAPTER 9
"MEANINGLESS WORK" OR AN "ETHIC OF CARE"?

Being an artist carries with it a great potential and a great obligation. . . . In a culture made up of images, sound, and stories created by artists who do not hold themselves accountable for that very culture, we have a set-up for destruction.

Suzanne Lacy

We have as yet no socially based art criticism which can address the inherent irresponsibility of the work of art.

Jeremy Gilbert-Rolfe

I'm questioning the cultural and societal changes in the role of the artist. . . . I'm afraid that if we don't address broader issues in art-making, we'll be left with an empty bag.

Keith Sonnier

There is a clear relationship between our picture of the world and how the cultural imperatives of modernism have been understood. Most of our definitions of art have acquired their full meaning in the course of a long historical process. We could, for instance, trace a certain "lineage"— beginning with Cubist collage and the "junk" aesthetic, that would include Kurt Schwitters's environmental *Merzbaue* constructions, continuing through Robert Rauschenberg's "combines," right up to the British sculptors Tony Cragg and Bill Woodrow—of artists who scavenge the beaches or city streets for discarded materials that might serve in their art. Like Mazeaud, these artists have "collected" the trash, but not because of any concern with pollution; they wanted to expand the boundaries of aesthetic expression. When Rauschenberg took his bed, together with its quilt and pillow, and painted on it in 1955, it seemed a little bit wild, because it implied that anything could be used to make art— Coke bottles, old newspapers, dirty socks, broken umbrellas, army parachutes, used tires, even a stuffed goat. Rauschenberg told the critic Jeanne Siegel, in 1966, "After you recognize that the canvas you're painting on is simply another rag, then it doesn't matter whether you use stuffed chickens or electric light bulbs or pure forms." Tony Cragg also uses found rubbish, discarded bits of colored plastic that he collects— the "celluloid wildlife" of thrown-away cups, combs, children's toys, flowers, whistles, bottle tops—arranging the fragments chromatically as if they were pieces of a mosaic to create images of human figures and other objects on the wall. *Policeman* (1988) is made entirely of blue plastic objects, while the embracing lovers in *Real Plastic Love* (1984) are composed of blue and pink plastic bits. Bill Woodrow slices up old refrigerators and air conditioners, and once he eviscerated an old armchair, to make his extraordinary sculptures. Even though these artists make their art out of real things, even out of trash, we don't have any problem with seeing what they do as art.

We could point further to another lineage—the conceptual and earth art of the 1970s, when artists like Walter de Maria and Richard Long traveled to remote places and

made their work directly in the landscape. Sometimes they did no more than walk a line in the desert, or rearrange some stones at the top of a mountain—situations for which, at the time, there was no artistic precedent. But I submit that a nagging unwillingness to accept Mazeaud's project as art still holds sway. What makes it so challenging to critical theory? It can't only be the absence of formal concerns or lack of a signature style, since many artists have strategically relinquished those. Certainly by now we are used to art breaking out of the institutional frames, demolishing our expectations or pushing our beliefs about its own definition to the limit— ever since Duchamp, we have been prepared to treat any object as a work of art. Why, then, does this particular project persist in escaping our usual categorial grasp? What makes using a bed for canvas, or walking a line in the desert, or exhibiting a manufactured urinal, more acceptable as art than hauling a withered sofa out of a dying river?

The difference lies, I believe, in the intentions of the artists, and in how they see the consequences of their work. Within the aesthetic framework, real-life actions or situations can sometimes be art, but only as long as they are not useful and serve no purpose. Within the context of modern aesthetics, creativity is at odds with utilitarian purpose. Rauschenberg's bed is not meant to be slept in. The urinal has been stripped of its normal function by being situated in an art exhibition—this is what makes it art. Last spring, I saw a show at the New Museum of Contemporary Art in New York, in which the Belgian artist Guillaume Bijl had installed an entire futon shop, but you couldn't sit on, or buy, the futons. This was art, so they were "Not for Use." In 1985, the same artist turned an exhibition space at the Stedelijk Museum into a showroom for Oriental carpets, which were spread out and stacked all over. What Duchamp did with a single found object, Bijl does with an entire environment: he turns it into a work of art by stripping it of its function and putting it into an art context. Other environments Bijl has appropriated and installed in various museums, galleries and art fairs are a gymnasium, a hairdressing salon, a laundromat, a gambling casino, a psychiatric ward and a

fitness center. The artist views them as prototypes of social institutions that reflect the values and beliefs of our time.

There is, in our managed capitalist culture, a lot of resistance to the idea of "useful" art—the aesthetic attitude must be disinterested and unconnected to other human purposes. "Art doesn't have a purpose," Chris Burden declared in 1974. "It's a free spot in society, where you can do anything." The distinctiveness of aesthetic experience has been that, in the name of unfettered creativity and abstract freedom, art was unaccountable—unequivocally divorced from the claims of morality and society. Avant-garde creativity in particular had an almost grandiose arbitrariness about it; Donald Kuspit quotes David Smith as stating that his "only motivation" for making sculpture was an arrogant independence to create. Our culture's most cherished idea remains the aggressive insistence on freedom for its own sake, freedom without praxis—the kind of freedom that makes picking up the garbage valid as art only if you want to "romance" the trash (that is, use it for an aesthetic effect), but not if you step beyond the value vacuum to try to clean up the river. In the name of aesthetic freedom, a meaningful action based on the perception of a real need is more likely to be viewed as "real" work than it is as art—because in the language of modern aesthetics, art has been defined as "meaningless work."

In 1960 the artist Walter de Maria published a brief essay, called "Meaningless Work," that is a minimanifesto for the notion of art as meaningless work:

> For instance putting wooden blocks from one box to another, then putting the blocks back to the original box, back and forth, back and forth and so on is a fine example of meaningless work. Or digging a hole, then covering it is another example. Filing letters in a filing cabinet could be considered meaningless work only if one were not a secretary, and if one scattered the file on the floor periodically so that one didn't get any feeling of accomplishment. Digging in the garden is not meaningless work. Weightlifting, though monotonous, is not meaningless work in its aesthetic sense because it will give you mus-

cles and you know it. . . . Meaningless work is poten-
tially the most . . . important art-action experience one
can undertake today.

In the early 1960s a refusal to capitulate to the
value placed on skilled labor and productivity in the existing
social arrangements of our society was a popular notion. It
was the period of Fluxus, an early form of light-hearted, neo-
Dadaist, ephemeral art in pursuit of the idea of the absurd
and instigated largely through the efforts of George Macu-
nias, a Lithuanian who studied art at Cooper Union, in New
York. The movement never quite managed to define itself,
but it clearly manifested a certain disaffection with the more
aesthetic, didactic, "high" art.

The point was to create work that was deliber-
ately antiheroic and antimonumental, subversive of tech-
nical virtuosity, without style, and focused on simple, even
trivial tasks. Macunias saw Fluxus as an antiart movement,
dissolving the distinction between art and ordinary life. George
Brecht, another Fluxus artist, created a series of "event scores,"
which were printed instructions on small file cards that he
kept in a box called "Water Yam." Mostly, they were point-
less exercises that were never performed, such as the "No
Smoking Event," for which the instructions were:

Arrange to observe a NO SMOKING sign

· Smoking
· No Smoking

Yoko Ono produced a work entitled *Apple* (1966), in which
an apple was placed on a table, and members of the audience
were invited to take a bite. John Cage introduced the notion
of music composed by chance methods. Yvonne Rainer cho-
reographed a dance for the Judson Dance Theater, called *Parts
of Some Sextets*, in which dancers walked back and forth
across the stage lugging mattresses. In *Three Seascapes* (1962),
she had a screaming fit with a winter coat and a length of
white gauze. Andy Warhol filmed Robert Indiana eating a

mushroom for forty-five minutes. Allan Kaprow was doing "Happenings"—rough, casual and partly improvisational events, which often included actions by the audience. Sometimes there was no audience, as with a work that was commissioned in 1965 by Florida State University in Sarasota; it consisted of smearing a car with jam and then taking it to the carwash, and was performed only once, without rehearsal and without spectators. Recently, I saw a reconstruction of another piece by Kaprow from the same vintage, in a New York gallery. Called *Soap,* it consisted of a bucket of water and a mop, leaning against the wall, with these instructions: "Wash with soap and water, and subsequently dry, a 1 and 1/2 foot strip running the entire length of the floor, down the center of the gallery." Pinned to the wall were Polaroid photos of people performing the "work," which, of course, was not intended to clean anything.

So how did we ever draw the necessary distinction between art and what Arthur Danto calls "mere real things" that has allowed us to accept all these quirky maneuvers as works of art? In a provocative essay called "The Real Experiment," Kaprow maintains that there have always been two traditions going on simultaneously within modernism: "artlike" art (in which art is separate from life and everything else) and "lifelike" art (in which art is connected to life and everything else). It has been artlike art, according to Kaprow, that has predominantly occupied the attention of artists and public, and that is seen as the most serious part of the mainstream Western art-historical tradition. This art engages in dialogue with other art, and is supported by galleries, museums and professional art journals, *all of whom,* he says, *need artists whose art is artlike.*

Issues about whether or not something is art have been part of the ongoing story of modernism all along. But the "other" tradition, the merging of art and life, has never really fitted into the framework of aesthetics, and was often deplored by more "serious" artists of, say, the Greenbergian persuasion. Willem de Kooning, for instance, once told John Cage that arbitrarily putting a frame around bread crumbs on a table cannot be considered an artistic act. (The com-

137

ment was probably aimed at Daniel Spoerri's table tops, on which were laminated the remains of meals eaten by artists.) Despite these alternatives to that more formal, institutionalized art history based on notions of quality and historical significance—the "style wars" that Danto declares have come to an end—they have never been focused in a proper perspective. According to Kaprow, no framework existed with enough authority to create a truly alternative context to the hegemony of stylistic aesthetics, with all of its patriarchal connotations.

"The philosophical sense of what was happening was unclear to most of us," Kaprow states, "and the impression left was of 'novelty' rather than of a shift to a radically different world view, in which reality was a 'seamless fabric' ":

> There were writings and manifestos, of course [by George Brecht, John Cage, Robert Filliou, Dick Higgins, Michael Kirby, Claes Oldenburg, myself and others], but they were neither cohesive nor always carried out in practice. It would have been too tall an order. Even if artists intuited what had to be done, the prospect of a clean break from everything in the high-art world was not only frightening but unclear in method. . . . We were so green then. We couldn't bypass the framing devices, perceptual clichés, and values of traditional Modern art. . . . We were always obliged to put on a *show*. All the traditional esthetic habits of detached spectatorship, the usual hour or so of attention after dinner . . . were brought to the new situation intact . . . but with one foot in straight art and one foot in life, it was self-canceling.

The question that seems up for the 1990s, and which the advent of posthistorical art raises, is whether the "clean break" that never quite happened in the 1960s is now either imminent or even possible. Obviously, one does not set out to construct a new framework out of the blue, or just for the sake of doing so. The need is being thrust on us with compelling force as a result of the ways that our cultural models have become increasingly complicit with the domi-

nator system and contaminated by the pathologies of capitalism. I think what Kaprow is saying is that even though many artists have tried for a long time to work outside the institutional "frames," in some sense they remained (and still remain) in thrall to the received ideology of aesthetics. Despite the fact that the formalist influence has ebbed, its myths, realities and styles continue, at a very deep level, to perpetuate the way we think about art. Writing about Tim Rollins and K.O.S. in the Swiss magazine *Parkett,* the critic Dan Cameron comments: "Artists working within museum-based culture are not expected to want to effect much social change, nor are those aspirations even deemed relevant to an assessment of art's cultural values." Highly successful artists, he adds, usually pursue a second-hand relationship to social issues by donating works of art to special causes.

What we clearly do not have, at this point, is any working framework for a socially or ecologically grounded art—an art that is accountable to the larger whole, in the sense of being contextually rooted in a living connection with a containing organic field. And I would submit that we *can't* have such a concept as long as we remain hooked on the myth of pure creativity and the inherent purposelessness of art for art's sake—which acquiesces willingly in the value vacuum that keeps art separate from any social, moral or practical use. We can't have such a concept as long as our idea of what constitutes "good art" follows the patriarchal ideal of an autonomous aesthetic culture that translates, finally, into the refusal to take on social tasks.

This was especially apparent at a panel discussion in which I participated during 1989 at the College Art Association's annual meeting, which took place in San Francisco. The subject was "The Moral Imperative in Art," and there seemed to be a consensus among the panelists (myself excluded) that, in itself, art had no moral imperative—there was only the individual conscience of the artist. "I don't believe there's any such thing as moral art," stated the first speaker, critic Amy Baker. "There are only moral artists. We judge the artist separately from the art work. We would be surprised by a panel discussion on the moral imperative of

plumbing." (Was she equating art with plumbing?) "For me," she concluded, "morality is a judgment that serves no aesthetic purpose."

Another speaker on the panel, artist John Baldessari, said he was getting quite paralyzed in front of the question of what the "right" art is that one should be doing. Art, he said, is doing what one does best, using all the strengths one has: *that* is moral purpose. It is perfectly true that moral purpose falls outside the scope of modern aesthetics just as surely as it falls outside the scope of scientific methodology— both are mute about responsibility, and artists today are not provided with any sense of the social or moral importance of their role. The Polish scientist Joseph Rotblat, who was part of the Los Alamos Manhattan Project, which invented the atom bomb during the 1940s, has described in the English magazine *Resurgence* how scientists with a social conscience were a minority in the scientific community. The majority, he states, were quite content to leave it to others to decide how their work would be used. It is also true that moral motivation is not what underlies activity that *is* considered appropriate in the art world, such as sending out slides and promoting one's work in various ways. Strategic, not moral, choice governs these actions. The problem is that whenever this consensually validated, self-interested motivation is actually overridden, as in some of the examples I have been discussing, by motivations that are morally rather than strategically oriented, then the work's credentials as art tend to be called into question. In 1969, the same year that he poured a truckload of asphalt down the side of a hill, Robert Smithson was prevented from dropping broken glass on an island in Vancouver by environmentalists fearful that it would harm the birdlife of that area. "The ecology thing," Smithson stated in his *Collected Writings*, "has a kind of religious ethical undertone to it. . . . There's no need to refer to nature any more. I'm totally concerned with making art." Michael Heizer, whose sculpture *Double Negative* in the Nevada desert consists of two enormous cuts in the desert floor that displaced 249,000 tons of earth, once said, "I don't care about landscape. I'm a sculptor. Real estate is dirt, and dirt is material."

Being an "earth" artist does not automatically imply ecological consciousness.

Much of our present practice is blind or counterproductive because it rests on assumptions that make us philosophical and ethical cripples. The dominant modes of thinking condition us to think of art as specialized objects, created not for moral or practical reasons, but to be contemplated and enjoyed, for the sake of formal pleasure. Autonomy, however, soon condemns art to social impotence. The question of whether or not art will ever change the world is not a relevant question anymore: the world is changing already, in inescapable ways. We can no longer deny the evidence at hand. The need to transform the egocentric vision that is encoded in our entire world view is the crucial task that lies ahead for our culture. The issue is whether art will rise to the occasion and make itself useful to all that is going on.

To become *useful* again: the very word indicates a complete reversal of that long process by which aesthetics developed an objectivity of its own, became formalized and divorced itself from basic moral and practical considerations. The very notion of "meaningless work" is a slap in the face of utilitarian logic. We imagine that to play a useful role would make art merely a tool, no longer a valuable end in itself. "In its time [the doctrine of art for art's sake] did indeed perform a liberating role," writes Hans Haacke, in his essay "Museum, Managers of Consciousness."

> Even today [he continues], in countries where artists are openly compelled to serve prescribed policies, it still has an emancipatory ring. The Gospel of art for art's sake isolates art and postulates its self-sufficiency, as if art had or followed rules which are impervious to the social environment. Adherents of the doctrine believe that art does not and should not reflect the squabbles of the day. Obviously they are mistaken in their assumption that products of consciousness can be created in isolation.

For a long time we have assumed that the truth art seeks to convey would be compromised by any pragmatic

end. As it has turned out, the very opposite is the case: in the name of radical autonomy, it is the pure and disinterested art work that can be most readily harnessed into the social process, and lends itself to easy cooptation by the economic apparatus. We could even say that the more the concept of aesthetics becomes emasculated (disenfranchised from any social role), the more it is open to just such ideological manipulation and repackaging—whereas art that is *not* autonomous, not cut off or "uncoupled" from life-world contexts, actually presents structural characteristics that are resistant to capitalist imperatives.

And we do have models for this kind of art. The idea that there is a moral and social dimension to artistic practice is the core of the German artist Joseph Beuys's concept of "social sculpture," which attempts to shift our understanding of art away from the creation of reified objects and the biases of self-interest, and to channel creativity onto the concrete social tasks that need doing—that is to say, toward the moral shaping of culture itself. And although Kaprow's thinking is along similar lines, it needs to be said that this action of "caring for the whole and taking it to heart" is more purposeful, and goes beyond the earlier efforts of "process" art to challenge the dominant paradigm by closing the gap between art and life.

Several times during 1986 and 1987, the Brazilian artist, musician and poet Bené Fonteles did a performance work in the main square of Cuiabá, the capital of the western Brazilian state of Mato Grosso on the border of Bolivia and the Amazon. He returned to the people of Cuiabá the garbage and litter they had left behind in the forest, creeks and waterfalls during their weekend picnics. Together with other artist friends, Fonteles is the founder of the Mato Grosso Ecological Society, whose primary goal is to transform the wilderness area just outside of Cuiabá into a nature preserve. As previous chapters have maintained, art that deals with life is hardly new, but what is at stake for artists like Dominique Mazeaud and Bené Fonteles is to deal with life in a reverential way, with a sense of purpose that lives in the larger picture of our need. "The world," writes Jungian psychoanalyst

James Hillman, "does not ask for belief. It asks for noticing, attention, appreciation, and care." What makes Mazeaud's work different from, say, Friends of the Earth organizing collection points for waste paper, according to the London artist James Marriott, is the fact that her action has a spiritual as well as a utilitarian function, and the combination is crucial. Raising a useful action to the level of the spiritual (thus making it resonant and catalytic) is precisely what is so difficult. Mazeaud, for instance, is perfectly aware that she can't clean up the river by herself, but since her main motive is spiritual, and not narrowly utilitarian, her activity is also symbolic—which is what keeps it in the realm of art. "Once, out of curiosity," she states, "I re-did a section in a very frequented part of a park, and there was as much garbage as the time before. So it's more the ritualistic aspect of doing it that's important."

Within the framework of art as it is currently understood and practiced, the pedigree of work that is oriented toward compassionate action is always somewhat suspect, not least because its potential for yielding an income is low, and it creates few opportunities for the prevailing business culture. Obviously, in a cultural climate where radical autonomy has been the built-in assumption of artistic practice for so long, to propose a shift in the artist's role from that of a self-directed, achievement-oriented professional to something like that of a cultural awakener or healer is to open oneself up to the accusation of mistaking art for a medical emergency team trying to save Western culture from itself. As Suzanne Lacy remarks, "I suppose that the process of making art is said to have a healing or transformative effect on the individual artist, but this notion that art can somehow 'heal' a culture . . . that's foreign to this particular time in our society. In fact, the prevalent artistic stance is one of distanced observation and passive reflection."

To reframe our models of art in terms that would truly integrate moral and compassionate action would be to break the bounds of the "disenchanted" culture we have been living out for so long. In cultural circumstances where freedom and autonomy have dissolved the social bond—our

relation with the other—the choice to set ourselves apart has political consequences of the utmost importance. It is not a minor choice. I have been suggesting that modern aesthetics belongs to the Cartesian mind-body dichotomy, whose bias toward separation has been conspicuous in the patriarchal, industrial age.

As scientists shatter atomistic and mechanistic world views with empirical evidence that nothing is self-sustaining or sovereign, perhaps the time has come, as Levin suggests in *The Opening of Vision,* to recognize the narcissism in modernity. Perhaps the heroic ego of modernity needs to be reconceptualized, within a total-systems context, as an interactive process based on the interconnectedness of self and world, rather than on the solitary monad. "In the wreckage of its aftermath," Levin states, "a world far humbler, far less grand and self-assured, begins to emerge." As artists learn to integrate their own needs and talents with the needs of others, the environment and the community, a new foundation for a non-self-conscious individualism may emerge—and we will have, not necessarily better art, perhaps, but better values, aims, beliefs. But the ego must pass through its death first, as Levin points out, before it can be reborn in this other vision of community and intersubjective coexistence; and the "ego" in question is not just the individual ego, it is the social and historical ego as well, whose thinking is still under the spell of narcissism as a model for the self's development.

As we begin to search for the blueprint that is hidden away in our own work, we shall need to decide whether or not it answers the call. And what is the call? To quote my friend Caroline Casey, it is that "nothing which is not socially or ecologically responsible make it out of this decade alive." It would seem that moving away from the competitive modes of institutionalized aesthetics is one way of not perpetuating the dominator system: forgoing its rites of production and consumption as a model for making art, its mythology of professionalism and its power archetype of success. Only then can we begin to evolve a new set of ground rules for the future. Recovery—the move from a value-free to a value-based culture—is the willingness to make this systems shift. As

144

Kaprow puts it: "Lifelike art in which nothing is separate is a training in letting go of the separate self. . . . It is even possible that some lifelike art could become a discipline of healing. . . . Something like this is already happening. If it develops more intentionally (and we don't know if it will), we may see the overall meaning of art change profoundly— from being an end to being a means, from holding out a promise of perfection in some other realm to demonstrating a way of living meaningfully in this one."

CHAPTER 10
THE DIALOGIC PERSPECTIVE
Dismantling Cartesianism

What strip mining is to nature the art market has become to culture.

Robert Hughes

Nothing exists outside the marketplace.

Barbara Kruger

It is time—indeed necessary—to restore the moral dimension of what we so coldly denote as "the economy," and more to the point, to ask what a truly moral economy is. . . . If we rely on self-interest and economic motives to evoke the popular response that will deal with these overarching problems, we will be relying on the very constellation of psychological factors that have so decisively contributed to their emergence.

Murray Bookchin

146

Recently I read somewhere that 127 dollars will bring one a year's subscription to the *New York City Art Gallery Price Watch,* a journal that informs readers of the prices being asked by New York galleries, whose work is selling and whose isn't, which artists are getting the best reviews and which works are likely to increase in value. Last spring I went to the tenth annual Chicago Art Fair, held at Navy Pier, which is certainly one of those places for testing whose credentials are in order by seeing whose achievements are being displayed. Since I began writing this book by posing the question of what it means to be a "successful" artist working in the world today, I decided to check out this professionally approved scenario for success.

Here was the reign of quantity, hugeness, excess. The art fair is a self-enclosed, self-reflexive totality in which art exists without any need of justification, and without the irksome questions of values or purpose. Any art there that is, let us say, socially or environmentally concerned, is inevitably sealed off and converted to the ends of economic individualism, whose goal has always been to maximize profit and to "conquer" new markets, never to serve social ends. With the marketplace as central shrine and symbol of our culture, only the buyer-seller relationship has reality; there is no engageable social milieu, no audience to speak of. It is all about individual artists, individual careers and individual marketable art works—the kind of "parts thinking" that values only objects while ignoring the context, or field, around them. This has become the socially conditioned form of interaction we now have with art. Every time we place art into the context of the marketplace, we give life to that idea as a relational phenomenon. It represents a cultural imperative in which success is measured by income, consumption and brand names; content is irrelevant because the market *is* the meaning, defining the purpose and determining the meaning of the work. The scene could easily cause anyone to conclude not only that things aren't getting better in the art world, but rather that they are getting worse. Perhaps we should think of it in terms of what cultural historian William Irwin Thompson calls the "sunset effect"—that is to say, the

147

intensification of a phenomenon that does not lead to its continuation but to its vanishing. When the pressures for transformation intensify, they can sometimes propel the system into bankruptcy unless the situation is reconceptualized and remapped.

Persons who grow up in any society are culturally "hypnotized" to perceive reality the way the culture experiences it. Acculturation, according to social scientist Willis Harman in his book *Global Mind Change,* works exactly like hypnosis. This trance of consensus programs much of our behavior. The challenge of the next few decades will be to awaken from this hypnosis; as Harman states, the real action today is *changing fundamental assumptions,* so that we can learn to transcend our culture. Once we become truly conscious of how we have been conditioned to follow a certain program, we can begin to surrender some of our culture's distorted images and role models for success. The possibility then arises for modifying the framework and not just being immersed in it.

We have been conditioned for a long time to accept the idea of art's self-sufficiency and to see the aesthetic as a special sphere removed from social use. We could call this the hyperindividualized and depoliticized view of art, whose "freedom," we now know, is essentially bound up with the premises of a commodity economy. When Herbert Marcuse argued, in his little book *The Aesthetic Dimension,* that by removing itself from social praxis and assuming a pure significance of its own, art could step outside the network of exchange relationships and values, he actually believed that autonomy would keep it from performing the ideological function of glorifying the existing system's conditions and goals. The truth slowly being recognized today is that we cannot look at art solely in aesthetic terms. We now know, thanks to deconstruction, that a work of art is *never* pure, never self-contained, never autonomous. Indirectly, a belief system is being reinforced. Underlying the ethos of radical autonomy, for instance, is the metaphor of the market. Aesthetic philosophies such as those of Greenberg or Marcuse only obtain if we ignore the whole question of context. A

museum wall or a gallery room is not a neutral zone, a disinterested container—a relationship is occurring that influences most strongly how the meaning will be received. The idea of the picture, the way it is hung, the gallery space itself are all an intensified form of coding, constituting what Brian O'Doherty, in his important group of essays collectively entitled *Inside the White Cube,* refers to as the "technology of aesthetics": a white, clean, artificial space that makes art exist in a kind of eternity of display, isolated from everything that would detract from its own evaluation of itself as art. The outside world must not come in. More than any single picture, according to O'Doherty, the gallery as "frame" may be the archetypal image of twentieth-century art. O'Doherty writes:

> During modernism, the gallery space was not perceived as much of a problem. . . . The artist was not aware he was accepting anything except a relationship with a dealer. . . . [But] the wall *is* our assumptions. It is imperative for every artist to know this content and what it does to his / her work. . . . For better or worse it is the single major convention through which art is passed. What keeps it stable is the lack of alternatives. *Genuine alternatives cannot come from this space.* [my italics]

There is no question but that the achievements of an aesthetic, decontextualized approach to art in the twentieth century have been profound, and it would be foolish to presume that everyone will want to abandon "pure" aesthetics in favor of a new, more participatory paradigm that integrates responsive dialogue and compassionate action. But it is also increasingly obvious that what was once a liberating notion for the artist—art for art's sake—has become a self-defeating limitation in the face of the new urgencies before us; as a guiding myth, it cannot suggest terms for an alternative, and possibly transformative, practice. Within the aesthetic mode, the artist has no social role or political function. The issue now is whether modernist aesthetics needs to be complemented by a new aesthetics of participation that is

149

less specialized, and that deals more adequately with issues of context; and whether *a new definition of art's cultural purpose* would open it (and ourselves) up to more creative interactions with others, and with the world.

Normally, in the aesthetic mode, our images for boundary are static: a wall or a frame doesn't allow for situationally flexible interfaces with the audience. Indeed, the whole function of the gallery, as has already been discussed, is to isolate the work by "framing" it so that nothing from the outside world will intrude. "Artlike art," Allan Kaprow states in "The Real Experiment," "sends its message on a one-way street, from the artist to us. . . . You can't 'talk back' to, and thus change, an artlike artwork, but 'conversation' is the very means of lifelike art, which is always changing." The monologic perspective, as we have seen, is individualistic, elitist and antisocial—the very antithesis of social or political practice. In a sense, the essence of modern aesthetics can be summed up in this single, primary feature of *rejecting dialogue and interaction*. "With the objects of modern pictures no intercourse is possible," Ortega y Gasset wrote in "The Dehumanization of Art." "By divesting them of their aspect of 'live' reality, the artist has blown up the bridges and burned the ships that could have taken us back to our daily world. . . . This new way of life which presupposes the annulment of spontaneous life is precisely what we call understanding and enjoyment of art."

Everybody seems to accept this, even though it is old physics. Now, nearly seventy-five years after the writing of Ortega's essay, perhaps we can dare to consider what the characteristics of a participatory artist using a participatory approach might be. In a relational, or total-field model, all pieces of the picture are included; integrity is not just the integrity of self, but its embeddedness in the larger whole. Whereas the struggle of modernism was to delineate self from other, in the emerging realm of quantum inseparability, the world becomes a place of interaction and connection, and things derive their being by mutual dependence. When everything is perceived as dynamically interconnected, art needs to collaborate with the environment and a new sense of rela-

150

tionship causes the old polarity between art and audience to disappear. The essence of nonduality is what Vietnamese Zen master Thich Nhat Hanh calls "realizing the nature of interbeing." The perception of ourselves as isolated individuals dominated by an economic ideal, meeting not in communal relationships but in competitive struggles for personal survival and success, conducting our business in art fairs, leaves us ill-prepared for realizing the nature of interbeing.

"The monologic view," writes Nancy Fraser in *Unruly Practices*, "is the Romantic individualist view in which . . . a solitary voice [is] crying out into the night against an utterly undifferentiated background." Certainly this sense of being isolated and alone with one's creations—that there's no one out there and one's work isn't receiving the attention it deserves—is a common experience for many artists in our culture, for whom the audience is external and accidental rather than essential and constitutive. "The only conceivable response to this voice," Fraser continues, "is uncomprehending rejection or identificatory imitation. There is no room for a reply that could qualify as a different voice. There is no room for interaction."

It seems clear that art oriented toward dynamic participation rather than toward passive, anonymous spectatorship will have to deal with living contexts; and that once an awareness of the ground, or setting, is actively cultivated, the audience is no longer separate. Then meaning is no longer in the observer, nor in the observed, but in the relationship between the two. Interaction is the key that moves art beyond the aesthetic mode: letting the audience intersect with, and even form part of, the process, recognizing that when observer and observed merge, the vision of static autonomy is undermined.

If this is true, what, then, can we say about painting? What future, if any, does it hold in the context of a new participatory paradigm? Is it a hopelessly Cartesian construction, a map that is urgently out-of-date, because it is inextricably intertwined with the conditions of individualism and consumerism? Or, to put it another way, how is the morally concerned artist who desires to function effectively

151

and responsibly as part of an integrated whole to do so, given the intense pressures of the art world for competitive achievement, salable objects and material success? "Most artists have political and social convictions," states Hans Haacke in an interview with Catherine Lord, "but these often do not transpire in their work. The more you become aware of this almost schizophrenic separation, which is normally not perceived as such, the more you have to deal with this problem."

Before I knew her, my teaching colleague from Santa Barbara, Ciel Bergman (also known as Cheryl Bowers), painted voids. Her paintings consisted of empty fields of ochre, which she thought of as deserts, arid places. At a certain point it occurred to her that they were images of spiritual deprivation, of the inability to manifest a fully creative response to being alive. After a visit she made to the Southwest, waterholes began to appear in these ochre fields. Eventually, glimpses of ocean and sky appeared.

Slowly, as awareness of our culture's self-destructive course began to dawn on her, Bergman realized that a change of attitude "so revolutionary and uncompromising that it may be beyond us" was being demanded. Questions began to form in her mind as to how the vicious circle of our destructive patterns could be broken. "In a time when science is not providing the answers we had hoped it would, what can art do? What can artists do?" she asked. "What is my role as an artist, and what does this have to do with painting?"

The very posing of these questions signified to Bergman her own radical shift, as an artist, away from the phenomenon of "psychological distancing" and into the paradigm of ultimate connectedness. She began to experience the need to move beyond painting as a one-way, passive medium, and to investigate possible situations in which artist and audience would be equally involved in investigating the problems of the world together. "Years ago," she states, "I could not have told you why, but now I can say I paint the ocean because I feel it is *sacred*. It is the source of all life on the planet, a vital organ of Gaia's being. J. E. Lovelock, author

of the Gaia hypothesis, has written: 'Indeed, no one knows what risks we run when we disturb this key area of the biosphere.' For years we have been dumping everything imaginable into the ocean. We don't have any idea of the risk we are taking. If she dies, we die."

Bergman's more recent paintings, collectively titled *Wild Sacred,* radiate hope even while they confront the darkness and her own grief at the wounding of the earth. Following upon an earlier series of watercolors on the theme of the rose, which included images of roses with death in their petals from radiation, she has moved more recently to the symbolically charged image of the iris, which exists not only as a flower, but also represents, in mythology, a figure symbolizing deep feminine wisdom—the goddess of the rainbow, the bridge between heaven and earth. Symbolizing the presence of the Black Madonna (the dark feminine), the iris heralds a reappearance of the *anima mundi*—the submerged soul of the world—looming like an avenging angel amid the debris of a wretched and degraded natural environment. For Bergman, it is a numinous message of life and hope, the move into integration, balance and the power of the feminine principle: the very opposite of apocalyptic vision.

When an invitation arrived in 1987 to create an installation of some sort at the Contemporary Arts Forum in Santa Barbara, Bergman decided to use the occasion to clean up the Santa Barbara beaches. She and her collaborator, sculptor Nancy Merrill, spent three hours a day for five weeks picking up all the nonbiodegradable plastic they could find, and then brought it into the gallery. Most of the plastic was hung from the ceiling, creating a contemporary *Merzbau* of sorts.

The feeling inside the room was that of a temple, with sounds of the ocean, whales and seagulls drifting through from an audiotape. On the south wall, Bergman painted a black mural, a rich compost of grief, in which there were seven openings onto the sea and sky. The trash objects on the floor were covered in flour, which created a haunting, post-nuclear-explosion atmosphere, and in the center of the room was a firepit of ashes, which functioned as a circular

prayer altar, in the manner of a Native American medicine wheel. Near the altar, fresh flowers were placed in vases and changed daily. Since the room was dimly lit, it took a while before people realized that what they were looking at was not art, but garbage.

Visitors to the gallery were invited to write down their fears for the world on one of the remaining walls and their hopes on the other. A collection of sticks that had been picked up from the beach were left in a pile, along with other natural materials and some rice paper, with a further invitation to the audience to make prayer sticks. By the end of the exhibition, both walls had been covered with writing, and nearly four hundred people had written a prayer, hope or thought and attached it to a stick, which they decorated and placed in a ring around the ashpit. Some people stayed for a long time, reports Bergman, and a few of the sticks were so beautiful that she found it difficult to part with them at the end. But since they had been intended as an offering, all were finally returned to the ocean in a special ceremony after the exhibition.

Instead of an opening, the artists held a "closing," in the form of a public debate about what to do with all the plastic, which now filled up six dumpsters. Some of the suggestions were: heap the plastic in front of grocery stores, asking that businesses and patrons begin to break the plastic habit; be brave and talk to people in the act of littering; support an annual beach clean-up day; send photos of the exhibition to board members of plastic manufacturing companies; tell stores you won't buy anything packaged in plastic; and take the exhibition elsewhere as a powerful tool to be used again. So far, Bergman has not done this, but like the projects of John Malpede, Tim Rollins and Suzanne Lacy discussed earlier, she has nevertheless produced a working model with *Sea Full of Clouds, What Can I Do?* that offers the possibility of repeated applications in other contexts, and has already had offers to clean up Chicago and Detroit.

In 1985, the U.S. alone produced over one trillion cubic inches of plastic that does not easily decompose. An autopsy on a twelve-pound sea turtle, who crawled onto

a beach in Honolulu and died, revealed three pounds of plastic in its intestines that included beads, a comb, a golf tee, a toy wheel, a piece of rope, a balloon, a plastic toothpaste cap, baggies and a plastic flower. Although most of the plastic in Bergman's installation came from ocean dumping, the impact of the whole experience on the local community was such that recycling for certain types of plastic garbage has now been instituted in Santa Barbara. (Currently in the U.S., only ten percent of trash is recycled; Western Europe recycles thirty percent, and Japan, fifty percent.)

"Art may not change anything," Bergman states, "but the ideas we have about ourselves we project into the world. . . . Negative images have a way of coming alive just as positive images have. If we project images of beauty, hope, healing, courage, survival, cooperation, interrelatedness, serenity, imagination and harmony, this will have a positive effect. Imagine what artists could do if they became committed to the long-term good of the planet. The possibilities are beyond imagination. If all artists would ever pull together for the survival of humankind, it would be a power such as the world has never known."

A Moving Point of Balance, the multisensory environmental work dedicated to healing and balancing that was completed in 1986 by Arizona artist Beth Ames Swartz and shown at the University of Arizona Museum of Art in Tucson and the Nickle Arts Museum in Calgary, Canada, strikes me as another work within the aesthetic mode that attempts to overcome the subject-object separation by increasing the audience's sense of involvement. Here, too, one enters a darkened space and hears gentle music, moving consecutively into seven different baths of colored light while contemplating seven large paintings of the seven chakras of the body. Each painting represents a different chakra, or energy center, that governs our physical and emotional well-being, in a system developed by Hinduism, and each chakra is symbolized by a different color: red for the first chakra, at the base of the spine, energizing issues of survival and involuntary response; orange for the second chakra, in the place of the reproductive organs, generating creativity; yellow for the

155

third chakra, at the solar plexus, the source of personal power; green for the fourth chakra in the place of the heart; blue for the fifth chakra at the throat, the place of communication and speech; indigo at the sixth chakra in the center of the forehead, the source of clairvoyant intuition; and violet at the crown of the head, the place of opening to the higher realms. The viewer is encouraged to pause at each meditation station, following a path in a kind of pilgrimage from one painting to the next. An accompanying text suggests what things to focus on in relation to one's own body while standing before each painting and absorbing the colored light related to that chakra.

Swartz feels that in our culture we don't understand the mysterious quality of the energy flow that connects mind, body and spirit. Through a special computer study done when the work was shown in San Diego and in Aspen, where the audience was invited to fill out response cards, Swartz found that people of all ages and varying ethnic groups claimed to have felt "cleansed, strengthened, balanced, energized and exhilarated" by their experience with *A Moving Point of Balance*. Many people sat, meditated, or even lay down in front of the paintings to receive healing. Although she has been a student of both Native American and Far Eastern healing practices, Swartz claims it was after her visit to the Rothko Chapel in Houston that she was inspired to create a public meditational environment. But there is another precedent for what Swartz has done. In certain parts of Egypt, healing temples were constructed to allow the sun's rays to enter so that they would break up into the seven colors of the spectrum. Archaeologists have found evidence that people were sent to particular rooms to absorb the color they needed. The assumption was that imbalances in the color harmony of the aura—the energy field surrounding the body—cause illness.

The paintings themselves relate more directly to the metaphysical tradition in early twentieth-century art, and remind one easily of the rhythmic simultaneity of Orphism. I am thinking, in particular, of František Kupka's series of works the *Disks of Newton* (1912), cosmic color wheels that

are a whirling matrix of dynamic movement, where everything is in perpetual energetic relationships. In Swartz's case, the addition of gold leaf, microglitter, crushed stones and crystals reputed to have healing properties creates a more encrusted surface, suggesting meteorites, stained glass windows or the jeweled icons of the Byzantine era.

For me, however, what makes these pictures not just a throwback to early twentieth-century versions of "the spiritual in art" is their participatory aspect, which represents a long overdue breaking down of the wall that has effectively separated artists from their audience. To make the transition from an exploitative and divisive paradigm to a more systemic, ecological vision, the old schismatic and confrontational energy of modernism must give way to a unifying, healing energy. (In the political arena we see this coming into play even as I write this—a willingness to give up old patterns of confrontation, the animus *against*—in the tearing down of the Berlin Wall and the shift into interaction and interrelation of East and West Germany. More currently, the Gulf crisis is an opportunity for all nations to acknowledge the manner in which everything is interdependent and affects everything else.) Obviously, we have not yet moved from the old dominator beliefs and ways of thinking to something else. Probably the biggest shift will be in these motivational or attitudinal changes. What we are mapping into place, I believe, is a kind of art that cannot be fully realized through a monological mode; it can only come into its own in dialogue, as open conversation, in which one is obliged to listen to other voices. *A Moving Point of Balance* was recently acquired by a California philanthropist, who intends to install it permanently in a new center for the creative arts to be established eventually in Sedona, Arizona, with the proposed mission of supporting interdisciplinary work "committed to global ecological harmony and the spiritual evolution of humankind." It will be the first study center for environmentally committed art.

A great deal of modern art was intended to be *against* the audience. But, as we have seen, there is another possibility. Art that realizes its purpose through *relation-*

157

ship—that collaborates consciously with the audience and is concerned with how we connect with others—can actually *create* a sense of community. The idea of collaborative dynamics is very important in dissolving boundary differences to create a more permeable membrane. Acting-on is one-way; interacting with is two-way. "Art cannot be a monologue," Albert Camus wrote in *Resistance, Rebellion and Death.* "Contrary to the current presumption, if there is any man who has no right to solitude it is the artist."

Through dialogue, self-contained individualism is transformed into flexible interfaces with the audience. One of the strengths of the work of Beverly Naidus, a New York artist now living in California, is that it succeeds in actually *realizing* this interrelationship; artist and audience form a relational dyad, so that the two parts can no longer be defined independently. Conversation is embedded in the process and becomes a practical imperative of the work.

An early installation by Naidus, entitled *Apply Within,* was her first audience-participation piece. A simulated employment agency, it was installed in the front window of Franklin Furnace, an alternative artist's space in New York. In the window were signs reading: JOBS, JOBS, JOBS—WE HAVE WHAT YOU WANT—PAID VACATIONS, FRINGE BENEFITS. People entered the storefront gallery, résumés in hand, thinking it was a real employment agency. As they sat down in chairs in the waiting room, an audiotape of voices began to recite clichés and stereotypes embodied in our attitudes to work in this society:

> Voice A: We're so glad you came to us. You made the right choice. We have the perfect job for you. . . .
>
> Voice B: We dreamt about doing great things.
>
> A: So you're tired of the same old routine. The same nine-to-five crap. Well, don't worry. We understand.
>
> B: We wanted to do something productive.
>
> A: You're looking for some excitement, some fun, some glamour, maybe even something meaningful?

158

B: We had such high expectations. . . .
A: You don't know what to do with your life? . . . You've come to the right place. We're here to help you.
B: We couldn't wait to get out of school and do something important.
A: You're looking for something creative perhaps? A job where you can use that special something only you have to offer.
B: We didn't want to be another cog in the machine.
A: None of our clients are ever disappointed. We place people almost anywhere.
B: We thought we had a right to be happy. . . .

According to Naidus, the experience of listening to the tape had an extraordinary effect on people. Many of them hugged her or shook her hand, and began to tell her about their dismal search for a decent job. They were thankful that someone understood their dilemma and could identify with their sense of isolation and humiliation. They seemed surprised to learn that this was "art," but didn't care. Only once, Naidus recounts, when she wasn't there, a woman, who came in looking for a job and was told that she was not in an employment agency but in an art gallery, became angry and left. Obviously, it was important for the artist to be there. "My work," Naidus states, "usually engages the audience in some sort of activity in relation to the piece. It addresses different social issues (fear of nuclear war or destruction of the environment, unemployment, consumerism, et cetera). My public is defined by both the site in which the piece is exhibited (museum, university gallery, community center, street or shopping mall) and by the assumption that these issues affect everyone living in our society."

I first became acquainted with Naidus's work in 1984, when she had an installation called *This Is Not a Test* included in "The End of the World" exhibition held at the New Museum of Contemporary Art in New York on the theme of nuclear war. Visions of cataclysmic ending are not new—they have haunted the human imagination for a long

time. But such visions are no longer symbolic or remote; in our own time, they have become a concrete and real possibility. The destructive capability of our present storehouse of weapons, Carl Sagan observed back in 1982, could create a World War II every second for the length of a lazy afternoon. One hopes that with the thawing of the Cold War, this threat is now being reduced. Naidus's installation was the one work in the entire exhibition that stood out for me above the others, communicating through its very shriveled means the desolation of what life might be like after a nuclear holocaust. Created from wood remnants, it consisted of a derelict shelter with a narrow, rumpled cot inside, on which a sequence of slide images of beautiful landscapes was continuously projected, like the memory of a lost paradise, alternating with flashes of white light. Stepping inside the shelter, you could hear the barely audible sound of dazed voices (from a six-minute tape loop) making comments like, "But I was busy working to a deadline," "We felt that everything was out of our control," "We didn't realize we had a choice."

This particular installation came to life for me because it seemed connected with a concrete intent; I had the distinct sense of someone making art, not only for the sake of making art, but because she wanted people to see something—not colors or shapes particularly, but something that normally we do not see. In *Waking Up in the Nuclear Age*, psychologist Chellis Glendinning discusses how, due to the secrecy surrounding its development, nuclear technology is invisible to us. "We cannot *see* radioactive materials being transported down our highways," she says. "We do not *know* where the waste dump sites are. We do not *see* the missiles aimed at our cities and silos. What's more, radiation is invisible. . . . If a cloud of plutonium from a test wafted by, we would not necessarily *know* it."

Outside Naidus's hut was a wooden mailbox, with a notice inviting the audience to write down any thoughts and feelings provoked by her piece. Notepads and pencils were supplied to solicit the audience's participation and response to such questions as, "What is your nuclear nightmare?" "What is your fantasy for the future?" A meeting

had been scheduled when the donated comments could be aired publicly and discussed. "The audience's ability to identify and connect with what is being said," Naidus comments, "is the key to the success of the piece. They can read each other's contributions and sense that there are many others who are experiencing the issue in similar ways." How does the threat of nuclear technology affect our sense of ourselves, our survival and our future as a species? The connection around feelings (of despair, confusion, hope and so on) is what has the possibility of empowering the audience and allowing them to leave the isolation of cynicism and hopelessness. The work provides a temporary community where people can "commune" with others about issues not freely discussed in daily life. Telling these stories breaks the silence, breaks the spell-binding business of pretending everything's normal, breaks the repression of what we know is happening to our world. It becomes a chain reaction as each person who opens up to her pain, fear and despair becomes a catalyst for other people to talk about their future, to be with their anxieties and to go beyond the psychic numbing that keeps us locked in denial. "It would be wonderful if people could see that art can perform such a function in the culture . . . if it could be seen as something that breaks down people's isolation," states Naidus. "My work is a conscious reaching out. Is there anybody out there who feels the way I do? Let's talk to each other, and that way we may have power to do something about it."

The heart of the transforming factor here is dialogue. Naidus began encouraging the audience to participate by writing down their responses after *This Is Not a Test* was first exhibited at the New York Coliseum during the Art Expo of 1981. At that time, a few people left unsolicited messages under the bed, which the artist discovered only when the piece was being dismantled. It made her understand what was needed: her work could get people to talk about their feelings as a mode of consciousness-raising; connecting through our feelings of despair is the first step toward social change. "And despite how uncool it was considered in New York City to let the audience participate in a piece this way," she com-

ments, "I was more convinced than ever to work that way. ... My students," she adds, "are all looking for something beyond the courses on how to produce slide portfolios and how to market your work. They're looking for role models for an art which talks about what's happening in the world rather than being obsessed with making innovative creative statements."

According to David Bohm, one of today's preeminent quantum physicists, when you listen to somebody else, what they say becomes part of you whether you like it or not. In an interview with John Briggs in *New Age Journal*, Bohm puts forward the startling view that lessons we learn from subatomic particles can be applied to help solve social problems. The electron is finely woven into its surroundings and cannot be disentangled from the context in which it exists—which includes the observer. What you have is a single interwoven field, an information field. Bohm proposes that by creating situations where people can learn to dialogue with each other, we might succeed in generating a kind of social "superconductivity," a higher state of social intelligence. "Just as superconductivity makes possible marvelous things such as trains that can move without friction," he states, "or circuits where electricity flows at incredible speed, so the intelligence that comes from dialogue may make it possible for something new to come into human relations. . . . I think that dialogue will liberate a more subtle kind of intelligence than that used in making tools. The intelligence that creates and uses tools is not able to organize society properly so as to take into account the consequences of these tools." Bohm believes we now need this higher social intelligence, born of exploring and talking together, or else we're not going to survive. Most of our life is social, he claims, and if we don't begin to manage things socially, if we don't find a way to be related to each other at a deep level, then individual intelligence or the achievements of science are not going to make much difference.

In art, as I have tried to argue, we have an aesthetic framework for those who believe the world is composed of discrete objects, and who are fascinated with the

individualized self, but we do not have a process-oriented framework for those for whom the world consists of dynamic interactions and interrelational processes. It is obvious that I am pointing to a historical transformation of the Cartesian and Kantian aesthetic traditions, based on autonomy and mastery, into artistic practices based instead on the interrelational, ecological and process character of the world, and a new sort of permeability with the audience. Where the dominator value system created distance and separation, the integrative trend of partnership creates and demands contact and nearness, both metaphorically and concretely. The integrative capacity described in these chapters may not be applicable to a great majority of people yet, but the many examples in this book suggest it is not unrealistic to imagine that people can be motivated to conceive of art in a way that radically breaks with these earlier traditions. Certainly the new world view, ushered in by twentieth-century physics, ecology and general systems theory, with its call for integrative and holistic modes of thinking, is no longer based on discrete objects; rather it presents a continuous flux of process and the dynamics of interpenetrating energy fields. And from a postpatriarchal, posthistorical perspective, our previous individualist, elitist and aestheticist assumptions do not seem compatible with this new archetypal direction. At this point it would seem to be the discourses and ideologies of the aesthetic project itself, and the Cartesian self that is assumed by the narratives of this tradition—not the art it has produced—that are in need of revision. The concept of reality that manifests itself in quantum theory is a real change in the structure of modern science and is being used to reframe our categories of thought in all spheres, away from atomistic, mechanistic models to ones that give living relationships priority. Fritjof Capra has been arguing for years that a new paradigm is arising in science and society, and that the old mechanistic and competitive world view is giving way to something much more organic, cooperative, ecological, feminine and spiritual. "I think it is characteristic of every shift of paradigm," he states in the newsletter of the Elmwood Institute, "that something is given up that was not even questioned before, not even recognized

as part of the framework. And in this century, it is the giving up of structure, moving to process, the giving up of foundations and moving to the network."

This insistence on the *relational* nature of reality is precisely what is missing in the Cartesian paradigm, and it would seem that what we are beginning to experience, at the leading edges of our culture, is the dismantling of Cartesianism—the paradigm of the bipolar subject and object. It is no mere academic exercise either, as Morris Berman makes very explicit in his ground-breaking book, *The Reenchantment of the World:*

> Regardless of its duration as a political entity, every civilization, like every person, is a message—makes a single statement to the rest of the world. Western industrial society will probably be remembered for the power, and the failure, of the Cartesian paradigm. . . . Cartesian dualism, and the science erected on its false premises, are by and large the cognitive expression of a profoundly biopsychic disturbance. Carried to their logical conclusion, they have finally come to represent the most unecological and self-destructive culture and personality type that the world has ever known.

At this point, the Reenchantment project reflects a more holistic outlook that is very much "in the air," but breaking the spell of dualism is no easy matter. "This notion that subject and object, self and other, man and environment, are ultimately identical, is the holistic world view," states Berman. Even though we are already changing the idiom of our culture away from the linear and the mechanistic and toward the ecological and the compassionate, dualistic ways of thinking continue to dominate all our discourses, myths and ideologies, so that it is not particularly easy to see the beginning of something that is being shaped by a truly different awareness.

"How we got tangled into the dogma of science as artists is a result of domination by the patriarchal, rationalist model," Ciel Bergman wrote to me in a recent letter.

"I have, for the 25 years I have been painting, felt continuously that I *must*, if to be seen and respected, repress much of the love and poetry I feel for life. This is wrong! We must not use the frame of science, we must reinvent what art is for our time." Although these ideas have started to move through our culture very quickly, the challenge remains for all of us to translate them into our own activities and practices.

Obviously, the kind of change I have been signaling here is so major that we will encounter much resistance to even recognizing it. For one thing, it calls for the formation of identities no longer restricted to the structure of subject and object—and the possibility of a new identity formation, which Levin describes as being grounded "in the communicative realization of our intersubjectivity." "The dualism in the subject-object structure is not an immutable transhistorical and transcendental reality," he writes in *The Listening Self*. "It is a product of our socialization in the modern world. Thus, it is not our fate. Quite the contrary."

The new ecological, non-Cartesian consciousness must be articulated very clearly, for it is both the model for personal transformation and the analytical framework for social criticism and change in the ecological age—the locus of energy and insight that will help us to break out of our present systemic addictions. Before we can successfully weave this new relational world view into our lives, however, through new thinking and new assumptions, we will need to recognize just how much our present mental habits, which are used to focusing on things rather than processes, obstruct our ability to understand and act from a perspective of relationship. (Even scientists have not yet caught up with the deeper implications of their own discovery that relationship is the fundamental unit of physics; they still think in terms of isolated problems with corresponding solutions.) One must be careful not to be caught in the Cartesianism one is rejecting. As Morris Berman puts it: "One must be quite clear about . . . accepting the consequences that such a rejection entails. More significantly, one must be willing to live those consequences; and in a Cartesian culture, that is not an easy task." Integrating the new myth into one's life disrupts one's total reality. As

another artist wrote in a letter, after hearing me lecture about Mazeaud's river project at a conference: "Many of us are trying to figure out . . . how to work 'outside' the institutional frame of capitalism and the old art world system and still make a living and share our work. On all fronts I see that dramatic change is necessary, and that it is happening, but not without pain. Your ideas challenged some of the people at the conference to the point of standing neck veins and skin blotches."

Discordant beliefs upset many people, but neck veins and skin blotches notwithstanding, I am still convinced that the aesthetic framework, based as it is on Cartesian dualism and the attitudes of nineteenth-century science, is no longer the ideal model for art, and has run its course as the ascendant vision for many artists, who are migrating toward another order of art-making. That many others so far have failed to consider alternatives to the dominant mode of aesthetics is a testament to the effectiveness of our training and our socialization. If we are asked about it, we unthinkingly repeat what we have learned about the prevailing definitions of art. Despite the pervasiveness of these prevailing definitions, nothing is more powerful than an idea whose time has come. A sense of all that is at stake here also suggests, at least to me, that although the ability to think systemically is likely to arise slowly, and in only a few places at first, the cultural framework for the future belongs to a new vision.

CHAPTER 11
THE REENCHANTMENT OF ART

Something escapes us; we escape ourselves in a process of no return, we have missed a certain point for turning back . . . and have entered a universe of . . . irreversible processes that nevertheless have no direction at all.

Jean Baudrillard

Each of us is now being drawn, in one way or another, toward a great vision. It is more than a vision. It is an emerging force. It is the next step in our evolutionary journey.

Gary Zukav

I believe that within a short space of time— perhaps a mere generation—we shall see the emergence of a new type of human being, and that many people now alive may be the first to accomplish this breakthrough.

Colin Wilson

167

The pursuit of certain kinds of problems characterizes a given paradigm. I am proposing that, in the ecological future, art will come to signify a very different set of behaviors and attitudes from its modernist aesthetic assumptions. Modernism was the art of the industrial age. The problems that fascinated modernists, such as style, originality and aesthetics, were without any question linked to a certain view of the world and concern about what was important, which I believe is now changing. Many people seem to have reached a critical threshold, at which the option of continuing on as they have before is no longer viable. How, then, does a culture redefine itself? The critic Arthur Danto refers to the end of art history as a time when art does not end, but continues in a new realm that is characterized by nonpatriarchal, non-Eurocentric ideals. A new narrative is being created, in which the old guidelines, based on the notion of masterpieces and the styles of the masters, are no longer useful. One could find devastation in the phrase "art history is dead," but as a student of mine pointed out, the repercussions are far from devastating. Although the end to art history is threatening to some, to others it is a step in the redefining of our values that will further assist the move into a new paradigm.

To speak of the end of a certain infrastructure of autonomous individualism—or what we have been calling Cartesian selfhood—is to threaten the historical and psychological foundations of modern aesthetic practice and modern art history, which have been based on an ideal of competitive self-determining personalities. But increasingly there is an emptiness at the core of this ego-centered desire for autonomy, the cost of which has been a diminished sense of community, a loss of social commitments and a truncated ability to care about others. "Our present idea of freedom," Wendell Berry writes in *The Hidden Wound*, "is only the freedom to do as we please: to sell ourselves for a high salary, a home in the suburbs, and idle weekends. But that is a freedom dependent upon affluence, which is in turn dependent upon the rapid consumption of exhaustible supplies. The other kind of freedom is the freedom to take care of ourselves and each other." It is the practice of this "other kind of freedom" that

I have tried to examine here, which encourages the artist to see beyond social passivity, culturally conditioned modes of distancing and the denial of responsibility, in order to act as a powerful force in transforming the paradigm of alienation to one of healing and contact. My approach all along has not been an argument within orthodox aesthetics but a critique of value-free aesthetics—of the ground on which it rests, its articles of faith and its commonly accepted assumptions.

Within modern culture, society has been characterized as a hostile rather than a resonant environment for the self-unfolding of the individual; especially within the avant-garde, the radical artist was always "against" society. I have tried to suggest that the politics of a contextual and connective aesthetics is very different—a departure from the confrontational, oppositional mind of modernism. A deep dualism between public and private existed within modernism, which severed any connections between them and colored our view of art as basically a "private" affair. Certainly the prestige of individualism is so high in our culture that even for an artist like Christo, whose environmental projects such as the *Running Fence* require the participation and cooperation of *thousands* of people, the feeling of being independent and separate still dominates the psyche. In a recent interview in *Flash Art,* Christo stated: "The work is irrational and perhaps irresponsible. Nobody needs it. The work is a huge individualistic gesture that is entirely decided by me. . . . One of the greatest contributions of modern art is the notion of individualism. . . . I think that the artist can do anything he wants to do. This is why I would never accept a commission. Independence is most important to me. The work of art is a scream of freedom." The entire structure of thinking and experience in our society has been shaped by this assumption of separateness as the absolute foundation on which we live our lives. In a time fraught with art politics, sexual censorship and fragile government support for the arts, Christo's "scream of freedom" continues to be the unwavering, ever-present moral imperative that is always brandished politically as well as philosophically in the great tradition of Western thought.

From the vantage point of individualism—the vision of a self in ultimate control, whose innermost impulse is to self-assertion—it is virtually impossible to imagine the relational pattern between individuals and society changing to a complementary partnership that is symmetrical and that forges mutually enhancing connections, or to imagine the roles of artist and audience changing to more equal kinds of relationship. Individual freedom and individual uniqueness were cultural ideals summed up and embodied in the motifs of Romanticism; today, however, we find that at the cutting edges of our society a different cultural imperative is being argued and fought. "Today," states ecofeminist writer Charlene Spretnak in an essay in *Reweaving the World*, "we work for ecopeace, ecojustice, ecoeconomics, ecopolitics, ecoeducation, ecophilosophy, ecotheology, and for the evolution of ecofeminism . . . to refuse to let the dominant culture pave them over any longer with a value system of denial, distancing, fear and ignorance."

At the 1989 Mountain Lake Symposium held in Virginia, one of the speakers, the artist Sidney Tillim, asked: "Do intentions matter? Does art, or do intentions, really matter if you can't make a living from them?" In a free society, he added, one has almost to improvise convictions. I should like to try to answer these questions through the description of a young artist whose work radically tests the meaningfulness of art beyond the disinterested, disembodied, free play of the mind.

I first met Bradley McCallum when he was in the undergraduate sculpture department at Virginia Commonwealth University in Richmond, where he was making large, rather distinctive objects in welded steel. Somewhere along the way, his consciousness changed, as did his basic commitments. He began thinking about how an audience would view and experience his work and realized that a lot of the experience was missing. He felt a need to engage the audience more directly and became interested in collaboration, feeling drawn at the same time to work with the homeless community in Richmond. Brad wanted to do this *as art*, that is, capitalizing on the same skills he used in making sculpture.

He was not searching for independence, autonomy or freedom so much as for the social need he sensed that art was meant to fulfill. His art soon became pragmatic, goal-directed, purposive and charged with ethical sensitivity—all things that run counter to the teachings of aesthetic autonomy. He began to care less for originality than for results.

In Richmond, his studio was in an old carriage house near some alleys where the homeless hang out and pass by with their carts. In time, Brad was able to make friends with some of them. His future art emerged from these relationships. Brad observed that, at least in Richmond, ordinary grocery carts do not roll well on the bumpy cobblestone streets. He was aware of the prototype designs for shopping carts, the *Homeless Vehicles,* pioneered by Krzysztof Wodiczko, which at this point still exist primarily in the realm of art, not having (yet) been manufactured or provided in any numbers to the homeless. Brad decided on a different path, since his fundamental concern was with how to translate helping the homeless into a living artistic practice, an actual *modus operandi* that would go beyond a merely symbolic potential.

He, too, started off by building a prototype cart, using a softer wire mesh than is found in commercial carts, and welding it entirely by hand to make a deeper, more pliant basket. Most of the materials he was able to obtain free, from scrap-metal companies and hospitals, whom he approached for donations of specially sized wheels, removed from broken wheelchairs and other disused medical equipment, that would be sturdy enough to make it over the cobblestones. Then he offered the prototype cart for a week to one of his homeless friends for use on a trial basis, inviting suggestions for its greater effectiveness from each potential user. This became the catalyst for further collaborations. One man, for instance, who had skin cancer, requested a little awning over his head that would shield the sun from his face while he pushed the cart around collecting cans. To be able to take in the different needs of each person, Brad had to develop a certain trust and fluidity; to be open to interpenetration and blending, he had to develop a more transparent and permeable ego structure that would be receptive to this intertwin-

171

ing of self and other. Then he would create another cart, incorporating the new features, and give it to the person. Before Brad left Richmond for graduate school in New Haven, he had constructed and given away a total of eleven carts. For him, the finished carts are sculptures, and for his senior thesis exhibition in downtown Richmond, he invited his homeless friends to bring their carts along for the opening if they wanted to. Some of them also agreed to participate in video interviews. A couple of years ago, Brad created a non-profit organization called Collaborative Urban Sculpture, with the intention of opening a mobile fabrication studio containing all the tools needed to fabricate carts and other temporary shelters, which would be able to operate in different communities, and where the homeless can learn fabrication skills and participate in building the carts.

During his first term at Yale in 1989, Brad introduced himself to Jackie, a middle-aged black woman who had been living in a small, abandoned city park, used temporarily to store materials for street repairs. Brad told Jackie that he was a sculptor and showed her photographs of the work he'd done with the homeless in Virginia. Initially, Jackie explained that she had no need for the mobile carts he'd made; later, in other conversations, she expressed a wish that the city would make park benches with awnings. This sparked an idea that they began to work on together. An aluminum structure with a backrest that jutted over at the top like a shelf was built and bolted to the park bench. Jackie was unhappy with certain features of the construction, but other homeless people liked it and said that they would happily use it in her place. They wondered why Brad felt the need to keep changing it, continuing to work with Jackie until both of them were satisfied with the result. Brad explained to them what he felt was important to collaboration—and the freedom that comes from being unattached to the outcome. "Simply put," he said, "if I were to ignore Jackie and leave the awning as it was, I would violate a trust that is essential to the collaboration: the potential for learning from one another is realized by honoring this trust and listening. With Jackie, it meant reworking the awning to satisfy both our

intentions." The essence of ecological thinking is not linear, but finds its identity in a continuous flow of mutually determined interactions: the self-in-relationship. In contrast with Richard Serra, who is not interested in the public's response to his work, having no stake in it and no loyalties, Brad's approach is more caring and compassionate. It is a break with dominator patterns of perception, thinking and feeling. Caring, here, is a quality of attention—a total commitment to looking and listening. The healing power of what he does rests not so much in the object exchanged, but in the path of mutuality and understanding that is created.

What finally emerged was far more functional, in Brad's view, and an even more powerful solution than the first attempt. The rigid back panel was removed, and a tarpaulin was attached to the remaining roof panel in such a way that it could be rolled up and down on pulleys like a Mozart curtain to create a tent around the bench that was adaptable to all weathers. Ten days after the tarpaulin was added, the New Haven Recreation and Parks Department removed the whole structure and moved Jackie's belongings to a parking lot across the street, their justification being that no one is allowed to make a permanent shelter in a city park. On one level, Brad was pleased that the structure had stayed up unmolested as long as it did; on another, he was worried that his work with Jackie had brought unnecessary attention to her place of refuge.

That same week, Brad was asked to participate in a first year students' show at the Yale University School of Art and Architecture. As a way of documenting his collaboration with Jackie, he got permission to do a performance on the night of the opening. Jackie had many plastic bags filled with clothes that she and Brad decided to wash and use in the installation, which turned out to be ten washloads at the laundromat. In the exhibition space at school, slides of the park-bench construction were projected, with a statement on the wall describing the nature of the collaboration and questioning the extent to which artists should involve themselves in the community. The performance took place in a room adjacent to the main gallery, where Brad strung up

a series of temporary wash lines and hung Jackie's clothes up to dry. During the opening, he stayed in the room, ironing and then folding the clothes into neat piles. The piece was over when he had placed all the clothes into plastic bags and returned them to Jackie (which was long after the opening had finished). The intention was to demonstrate through a commonplace ritual that his interaction with Jackie continues beyond the making of functional sculpture; but also to provide a way for the audience to relate to Jackie's homelessness in a very human aspect of her striving for identity— through collecting clothes, which she distributes to other homeless people.

The students at Yale were critical of Brad's work. They wondered, for instance, if by becoming involved in these people's lives, Brad might not be creating false hopes for them, and even subtly exploiting their plight for his own good. Some felt that if what he really wanted to do was to help the homeless, then he ought to put his energy toward working in soup kitchens, or other institutions already addressing these problems. Also, wouldn't politics be a more effective medium to work in than sculpture? And couldn't their problems be solved just as well by buying them tents and camping gear, if indeed temporary shelters were the answer?

My own students last summer in Boulder, Colorado, were more sympathetic. One of them, Jennifer Rochlin, commented thus: "Art that falls into the commodity route is considered art, but art that is for social change or for a social purpose is not accepted, because it seems to threaten the hold of patriarchal society. Art that is not 'useful' perpetuates the idea of commodities and wastefulness, which our society embodies. So what if we need to change our view of aesthetics to fit into a mode where process art can be accepted? Our minds need to correlate aesthetics with social good. The idea of cleaning a river and writing your thoughts about it is beautiful; helping the homeless is beautiful. These *are* the new aesthetics. Art as a process which helps people is far more aesthetically beautiful to me than a painting or a sculpture which is only pleasing to the eye."

Brad was able to retrieve the awning from the

city without any trouble. But he still sought a way for the awning to be used without its breaking the law or causing Jackie any more hardship, so he constructed a mobile bench for the awning, which might be placed, for instance, in front of an area shelter, for use at times when the shelters are closed, or full. Mostly, he is concerned that the work itself serve as a catalyst for dialogue and critical contemplation, and perhaps also as a bridge to link the homeless with sources of aid.

Why do I like this work so much? First of all, it does not aestheticize the homeless. Rather, it breaks the trance of economic thinking and legitimates another kind of motivation. There is nothing to buy, sell, display or promote. It offers our society a different image of itself that is not based on the conspicuous consumption of valuable goods or the inevitability of self-interest. The quality of the response is crucial—it moves away from alienation, and from the mode of the helpless, isolated individual who is submissive to things as they are, which tend to shape all our interactions. An intense involvement with things, with consumption and one's own standard of living, seems to go hand-in-hand with a lack of involvement in social problems and relationships. "The mechanical division between self and world," writes Wendell Berry, "involves an emotional dynamics that has disordered the heart of both the society as a whole and of every person in the society."

In shedding conventional notions of self and self-interest like an old skin or a confining shell, we engage more effectively with the forces and pathologies that imperil planetary survival, as the ecologist and Buddhist scholar Joanna Macy describes it in *World as Lover, World as Self*. For Macy, as for many others, the crisis that threatens our planet, whether in its military, ecological or social aspects, derives from a dysfunctional and pathogenic notion of the self. Awakening to our larger, ecological self will give us new powers, according to Macy, undreamed of in our squirrel cage of the separate ego. But, she adds, because these new powers are interactive in nature, they manifest themselves only to the extent that we recognize and act upon our interexistence.

Through the power of his caring, Bradley McCallum has extended his sense of self to also encompass the self of Jackie; it is a genuine shift in identity that extends the self beyond the narrow ego and into the larger whole.

The possibility of constellating a self beyond the egocentric one that has risen to power in the modern world and is maintained by our social consensus has also been compellingly raised by David Michael Levin in all of his books, each of which argues in turn for "practices of the self" that do not separate the self from society and withdraw it from social responsibility. Many people find it difficult to imagine a self that is not shaped by the concept of an isolated individual fending for herself in the marketplace. In our society, it is taken for granted that economic self-interest is a basic given of human nature. Survival-oriented behavior gives us a kind of rationale for why it is acceptable not to feel related or compassionate toward others, and leads us to falsely regard society and the environment as objects for manipulation and exploitation. These ideas are pumped into us from every direction. If a historically new kind of self—the ecological self—does truly emerge in our culture, it will challenge the assumption that human beings are basically selfish and motivated entirely by economics. Obviously, what is being suggested here involves a revolution in consciousness as far-reaching as the emergence of individualism itself was during the Renaissance.

To see our interdependence and interconnectedness is the feminine perspective that has been missing, not only in our scientific thinking and policy-making, but in our aesthetic philosophy as well. A recognition of kinship and solidarity between the individual and the world—a cultural context of empathy—cannot arise, however, until there has been an integration of masculine and feminine energies into a more creative partnership as the very ground of our whole culture; that synthesis is what can change the power and quality of human consciousness at this time. The next evolutionary stage in consciousness—a move from psychic defensiveness to psychic openness—requires a more integrated relationship between the masculine and feminine

components in the psyche, the model of inclusiveness and wholeness replacing the one-sided rule of the masculine as the dominant human consciousness. This is the inner basis for the ecological self, which is able to transcend the Cartesian self of the patriarchal tradition. As Levin puts it in *The Opening of Vision:* "Archetypes which for too long have been constitutive only of femininity must be seen and valued as essential for the fulfillment of masculinity . . . (and) be integrated into its network of practices and institutions, transforming them accordingly." In the post-Cartesian, post-patriarchal identity, the so-called feminine values of caring and compassion will play leading roles.

In discussing individualism as the hidden ideal of our culture, one of the founders of modern sociology, Georg Simmel, speculated more than eight decades ago that the free and self-sufficient individual might well emerge at some point in another sort of historical configuration. In *On Individuality and Social Forms,* Simmel stated:

> I would prefer to believe that the idea of free personality as such and the idea of unique personality as such are not the last words of individualism—that, rather, the unforeseeable work of mankind will produce ever more numerous and varied forms with which the human personality will affirm itself and prove the worth of its existence.

By redefining the self as relational rather than as self-contained, Levin argues that we could actually bring about a new stage in our social and cultural evolution. The restructuring of the Cartesian self, and its rebirth as an ecological self-plus-other or self-plus-environment, not only thoroughly transfigures our world view (and self-view) but, as I have been arguing myself, it is also the basis for the reenchantment of art.

To see beyond the individual's perspective is to engage with the world from a participating consciousness rather than an observing one. The mode of distanced, objective knowing, removed from moral and social responsibility,

has been the animating motif of both science and art in the modern world. As a form of thinking, it is now proving to be something of an evolutionary dead-end. Indeed, Morris Berman goes so far as to claim that the reenchantment of the world may necessitate the end of egocentric consciousness altogether, for the reason that it may not be viable for our continuation on this planet.

Once we have changed the mode of our thinking to the methodology of participation, we are not so detached. For the participating consciousness, things are no longer removed, separate, "out there." Objectivity strips away emotion, wants only the facts and is detached from feeling. Objectivity serves as a distancing device, offering the illusion of impregnable strength, certainty and control. Knowledge can then be used as an instrument of power and domination. If we strive for rather than give up on it, says Levin, there is at least a possibility that we may move beyond the prevailing historical conditions, beyond the socialized ego, and open up to our radical relatedness. Then, becoming uniquely ourselves need not be framed through the model of the separate, Cartesian ego.

Healing requires bringing forth precisely those capacities of understanding, trust, respect and help that have been suppressed—choosing to feel compassion instead of detachment. Care and compassion do not belong to the false "objectivism" of aestheticism, nor to the value-free art that is devoid of practical aims and goals. Care and compassion are the tools of the soul, but they are often ridiculed by our society, which has been weak in the empathic mode. Empathy welcomes back the full range of feminine values—feeling, relatedness and soul-consciousness—that have been virtually driven out of our culture by our patriarchal mentality. Gary Zukav puts it very well when he states, in *The Seat of the Soul,* that there is currently no place for spirituality, or the concerns of the heart, within science, politics, business or academia. Zukav doesn't mention art, but there is no particular hospitableness there either.

"If you're out, you're out—you simply don't count," the Neo-Expressionist artist Sandro Chia declared

recently in an interview with Lilly Wei in *Art in America*. "Anything that happens must happen within this system. . . . I work for a few months, then I go to a gallery and show the dealer my work. The work is accepted, the dealer makes a selection, then an installation. People come and say you're good or not so good, then they pay for these paintings and hang them on other walls. They give cocktail parties and we all go to restaurants and meet girls. I think this is the weirdest scene in the world."

Most of us work within a system of categories provided by society. Patriarchal structures are especially strong in the art world. Becoming aware of how much they enslave us is the first step toward breaking the cultural trance. So far, as Lester Milbrath points out in *Envisioning a Sustainable Society*, this awareness is still confined primarily to women, and now needs to spread to men. Many men will be receptive, he claims, especially if they perceive that a change in beliefs is essential for saving our ecosystem and society. We can be sure, however, that many other men will feel threatened by partnership ideas and values and will vigorously oppose the change. Sandro Chia's candid description of professional life in the art world is all too familiar, but it is a routine part of the trajectory of competition in our culture, where success is scoring, and artists distinguish themselves through selling or not selling. Other distinctions, such as moral or immoral, are foreign to the enterprise and are likely to be pushed aside. It is hardly surprising that more and more artists are recoiling from this debilitating ideology. Along with everyone else today, they are faced with a choice: whether to stick with the "old mind" conditioned by our culture, or to move into the very different consciousness of the ecological self.

How, then, can we shift our usual way of thinking so that we create more compassionate structures in our culture? How do we achieve the "world view of attachment" that James Hillman talks about, attachment to the world, continuity with the world? At this point we lack any practical personal blueprint for action, unless we are willing to act as architects and engineer a new conceptual framework for

our lives. The compassionate, ecological self will need to be cultivated with as much thoroughness as we have cultivated, in long years of abstract thinking, the mind geared to scientific and aesthetic objectivity: distant, cold, neutral, value-free. "When you are compassionate with yourself and others," writes Zukav, "your world becomes compassionate. You draw to yourself other souls of like frequency, and with them you create, through your intentions and your actions and your interactions, a compassionate world. . . . What you intend is what you become."

Even though dominator structures are still the most prevalent structures in our society, which of course includes the art world, and show great strength and staying power, the dominator model is not the only model. It is possible to have intimations of what it means to be an artist beyond dominator acculturation and the professional ideology of brisk sales and good reviews. In *Has Modernism Failed?*, I wrote that "generally speaking, the dynamics of professionalization do not dispose artists to accept their moral role; professionals are conditioned to avoid thinking about problems that do not bear directly on their work."

Since writing this nearly a decade ago, it seems as if the picture has been changing. The politics of reconceptualization has already begun, and the search for a new agenda for art has become a conscious search. Chicago artist Othello Anderson, for instance, who collaborates with Fern Shaffer in photographing her rituals, moved away some years ago from working in a Minimalist mode in order to paint panoramic images of the world's forests burning and the effects of deforestation from acid rain. He comments thus on his own transformation of consciousness: "Carbon and other pollutants are emitted into the air in such massive quantities that large areas of forest landscapes are dying from the effects of acid rain. Millions of tons of toxic waste are being poured into our lakes, rivers and oceans, contaminating drinking water and killing off aquatic life. Slash-and-burn forest clearing and forest fires are depleting the forests world wide. Recognizing this crisis, as an artist I can no longer consider making art that is void of moral consciousness, art that carries no

responsibility, art without spiritual content, art that places form above content, or art that ignores the state of the world in which it exists." "I have to say," Marcia Tucker, the director of the New Museum of Contemporary Art in New York, stated in a recent interview with Roslyn Bernstein in *Contemporanea*, "that I believe art cannot exist separate from social, political, and cultural concerns. I think that those who would like to put art in an ivory tower are working from an assumption about the world that is, to me, very unrealistic."

We are in transitional times, an undefined period between detachment from the old and attachment to the new. It is a good moment to attend to the delineation of goals, as more and more people now imagine that our present system can be replaced by something better: closeness, instead of distancing; the cultivation of ecocentric values; whole-systems thinking; a developed discipline of caring; an individualism that is not purely individual but is grounded in social relationships and also promotes community and the welfare of the whole; an expanded vision of art as a social practice and not just a disembodied eye. I have tried to show that none of these intentions is irrelevant to a value-based art, and that all of them are crucial to its reenchantment. The sacredness of both life and art does not have to mean something cosmic or otherworldly—it emerges quite naturally when we cultivate compassionate, responsive modes of relating to the world and to each other. Of course the exasperation over idealism keeps cropping up; but as the photographer Annie Gottlieb once put it, "the impossibly pure vision acts as some sort of magnet drawing reality in its direction."

All of this is not to say that the social change envisioned here will happen quickly. The status quo is deeply entrenched, and no new paradigm will suddenly eliminate the present order. Besides, given the differences among us, we are not likely to agree that an ecocentric, compassionate and participatory framework is a good thing for all art. "Aesthetic" art will continue to exist alongside that of the new paradigm, even after the latter has more fully emerged— but with certain limitations, perhaps, in its dominance and relevance. Cultural reenchantment, however, definitely entails

another sensibility. My students are often incredibly responsive to this sensibility when it is opened up for them. Dorie Klein, who lives in Denver, wrote recently: "I consummated my affair with the ecological paradigm last night. I am now committed to the relationship. It took a long time to realize and understand why my relationship with modernism had to end. I had been at odds with modernism's alienating attitude for a long time. . . . Since putting these feelings (about art) on a par with feelings of the heart and compassion, it became clear why I can't continue my relationship with modernism any more. I've lost a lot of respect. Modernism was primarily self-serving. I appreciate much that it had to offer, but its values were egocentric and different from those I aspire to. . . . My divorce from modernism will not occur overnight; it will take time to heal the wounds of separation. There will be things about it that I shall always remember with feelings of affection. However, once I became familiar with, and began to understand, the ecological paradigm, I knew I could never go back to modernism. The nurturing and healing process of the ecological paradigm is just what I need." Such insights are not gained without a painful struggle, as indicated by these comments of Kathy Ritchie's, another student: "Is it the responsibility of artists to find solutions? I think that I must finally come to the conclusion that, yes, it is their responsibility. I do not mean to say that it is solely their responsibility. . . . I struggle with this to some extent, because I believe there is still a place for other types of art in our modern world, but I guess I would have to say that art must take an increasingly responsible role in pointing to a new direction for our culture."

My sense is that the artists in this book who have moved beyond protest and oppositional mind to embrace reconciliation and positive social alternatives do not represent merely the response of isolated individuals to the dead-endedness of our present situation. They are not a movement in a vacuum. They are prototypes who embody the next historical and evolutionary stage of consciousness, in which the capacity to be compassionate will be central not only to our ideals of success, but also to the recovery of both a meaningful society and a meaningful art.

It is true that the value-based art they are trying to create still exists only at the margins of social change, but at some point, a critical threshold is reached when enough people change their self-images and beliefs to begin the realignment of an entire society. (It has been suggested that five to ten percent of a group of people need to change in order to create change in the whole.) And, as social ecologist Murray Bookchin points out in *The Modern Crisis,* it is precisely to the "periphery" and the "margins" that we must look, if we are to find the "cores" that will be central to society in the future, for it is here that they will be found to be emerging.

BIBLIOGRAPHY

Achterberg, Jeanne. *Imagery in Healing: Shamanism and Modern Medicine.* Boston and London, 1985.

Adorno, Theodor. *The Jargon of Authenticity.* Evanston, 1973.

Adorno, Theodor, and Max Horkheimer. *Dialectic of Enlightenment.* New York, 1927.

Appignanesi, Lisa, ed. *Postmodernism: ICA Documents.* London, 1989.

Argüelles, José. *The Transformative Vision: Reflections on the Nature and History of Human Expression.* Berkeley and London, 1975.

Baselitz, Georg. *Paintings 1960–1983.* Exhibition Catalogue, Whitechapel Art Gallery, London, 1983.

Baudrillard, Jean. *For a Critique of the Political Economy of the Sign.* St. Louis, 1981.

———. *Forget Foucault.* New York, 1987.

———. *In the Shadow of the Silent Majorities . . . or the End of the Social, and Other Essays.* New York, 1983.

———. *Simulations.* New York, 1983.

Beane, Wendell C., and William C. Doty, eds. *Myths, Rites, Symbols: A Mircea Eliade Reader.* New York and London, 1976.

Becker, Carol. *The Invisible Drama: Women and the Anxiety of Change.* New York, 1987.

Berman, Morris. *The Reenchantment of the World.* Ithaca and London, 1981.

Bernstein, Richard J., ed. *Habermas and Modernity.* Cambridge, Mass., 1985.

Berry, Thomas. *The Dream of the Earth.* San Francisco, 1988.

Berry, Wendell. *The Hidden Wound.* San Francisco, 1989.

———. *The Landscape of Harmony.* Hereford, England, 1987.

Bloom, Allan. *The Closing of the American Mind.* New York and London, 1988.

Bohm, David. *Wholeness and Implicate Order.* London, 1980.

Bookchin, Murray. *The Modern Crisis.* Philadelphia, 1986.

185

Cahoone, Lawrence E. *The Dilemma of Modernity: Philosophy, Culture and Anti-Culture*. New York, 1988.

Calvino, Italo. *Invisible Cities*. New York and London, 1974.

Campbell, Joseph. *The Inner Reaches of Outer Space: Metaphor as Myth and as Religion*. New York and Toronto, 1986.

Capra, Fritjof. *The Tao of Physics*. New York, 1977.

———. *The Turning Point*. New York, 1982.

———. *Uncommon Wisdom: Conversations with Remarkable People*. New York and London, 1988.

Carlson, Richard, and Benjamin Shield, eds. *Healers on Healing*. Los Angeles, 1989.

Castaneda, Carlos. *The Fire from Within*. London, 1985.

———. *The Power of Silence: Further Lessons of Don Juan*. New York, 1989.

Colegrave, Sukie. *Uniting Heaven and Earth*. Los Angeles, 1989.

Crane, Diana. *The Transformation of the Avant-Garde: The New York Art World 1940–85*. Chicago and London, 1987.

Danto, Arthur C. *The Philosophical Disenfranchisement of Art*. New York, 1986.

Debord, Guy. *Society of the Spectacle*. Detroit, 1982.

Deer, John (Fire) Lame, and Richard Erdoes. *Lame Deer: Seeker of Visions*. New York, 1976.

Devall, Bill. *Simple in Means, Rich in Ends: Practicing Deep Ecology*. Layton, Utah, 1988.

Devall, Bill, and George Sessions. *Deep Ecology: Living as if Nature Mattered*. Salt Lake City, 1985.

Diamond, Irene, and Gloria Fenam Orenstein, eds. *Reweaving the World: The Emergence of Ecofeminism*. San Francisco, 1990.

Doore, Gary, ed. *Shaman's Path: Healing, Personal Growth and Empowerment*. Boston and London, 1987.

Dossey, Larry. *Recovering the Soul: A Scientific and Spiritual Search*. New York, 1989.

———. *Space, Time and Medicine*. Boulder and London, 1982.

Duerr, Hans Peter. *Dreamtime: Concerning the Boundary Between Wilderness and Civilization*. New York and Oxford, 1985.

Eaton, Marcia Muelder. *Art and Nonart: Reflections on an Orange Crate and a Moose Call*. East Brunswick, N.J., 1983.

Eisler, Riane. *The Chalice and the Blade: Our History, Our Future*. San Francisco, 1987.

Elderfield, John. *Kurt Schwitters*. New York and London, 1985.

Eliade, Mircea. *The Sacred and the Profane: The Nature of Religion*. New York and London, 1959.

———. *Symbolism, the Sacred and the Arts*. New York, 1986.

Eppsteiner, Fred, ed. *The Path of Compassion: Writings on Socially Engaged Buddhism*. Berkeley, 1988.

Ereira, Alan. *The Heart of the World*. London, 1990.

Feinstein, David, and Stanley Krippner. *Personal Mythology: The Psychology of Your Evolving Self*. Los Angeles, 1988.

Foster, Hal, ed. *The Anti-Aesthetic: Essays on Post-Modern Culture*. Port Townsend, Wash., 1983.

———. *Recodings: Art, Spectacle, Cultural Politics*. Port Townsend, Wash., 1985.

———. *Vision and Visuality: Discussions on Contemporary Culture*. Seattle, Wash., 1988.

Frankovits, André. *Seduced and Abandoned: The Baudrillard Scene*. New York, 1984.

Fraser, Nancy. *Unruly Practices: Power, Discourse and Gender in Contemporary Social Theory*. Minneapolis, 1989.

Gardner, John W. *Self-Renewal: The Individual and the Innovative Society*. New York and London, 1981.

Gilligan, Carol. *In a Different Voice: Psychological Theory and Women's Development*. Cambridge, Mass., and London, 1982.

Glendinning, Chellis. *Waking Up in the Nuclear Age*. Philadelphia, 1987.

Griffin, David Ray. *Archetypal Process: Self and Divine in Whitehead, Jung, and Hillman*. Evanston, 1989.

———. *The Reenchantment of Science: Postmodern Proposals*. Albany, 1988.

———. *Sacred Interconnections: Postmodern Spirituality, Political Economy and Art*. Albany, 1990.

———. *Spirituality and Society: Postmodern Visions*. Albany, 1988.

Grof, Stanislav. *The Adventure of Self-Discovery*. Albany, 1987.

Grof, Stanislav, and Marjorie Livingston Valier, eds. *Human Survival and Consciousness Evolution*. Albany, 1988.

Grossinger, Richard. *Planet Medicine: From Stoneage Shamanism to Postindustrial Healing*. Boulder and London, 1982.

Harman, Willis. *Global Mind Change: The Promise of the Last Years of the Twentieth Century*. Indianapolis, 1988.

Harman, Willis, and Howard Rheingold. *Higher Creativity: Liberating the Unconscious for Breakthrough Insights*. Los Angeles, 1984.

Hawken, Paul, James Ogilvy, and Peter Schwartz. *Seven Tomorrows: Toward a Voluntary History*. New York and Toronto, 1982.

Heinze, Ruth-Inge, ed. *Proceedings of the Fourth International Conference on the Study of Shamanism and Alternate Modes of Healing*. Madison, 1988.

187

Henderson, Joseph L. *Cultural Attitudes in Psychological Perspective.* Toronto, 1984.

Hillman, James. *A Blue Fire: Selected Writings by James Hillman.* New York, 1989.

Horkheimer, Max. *Eclipse of Reason.* New York, 1987.

Horne, Donald. *The Public Culture: The Triumph of Industrialism.* London and Sydney, 1986.

Huyssen, Andreas. *After the Great Divide: Modernism, Mass Culture, Post-modernism.* Bloomington, Ind., 1986.

Israel, Joachim. *Alienation: From Marx to Modern Sociology, a Macrosocio-logical Analysis.* Boston, 1971.

———. *Collected Essays 1981–87.* Zurich, 1988.

Johnson, Robert A. *Ecstasy: Understanding the Psychology of Joy.* New York and San Francisco, 1987.

———. *Inner Work: Using Dreams and Active Imagination for Personal Growth.* New York, 1989.

———. *We: Understanding the Psychology of Romantic Love.* San Francisco, 1985.

Johnston, Charles M. *The Creative Imperative: A Four-Dimensional Theory of Human Growth and Planetary Evolution.* New York, 1986.

Jung, C. G. *The Spirit in Man, Art and Literature.* Princeton, 1966.

Kamper, Dietmar, and Christopher Wulf, eds. *Looking Back on the End of the World.* New York, 1989.

Keller, Catherine. *From a Broken Web: Separation, Sexism and Self.* Boston, 1986.

Keller, Evelyn Fox. *Reflections on Gender and Science.* New Haven and London, 1985.

Kohak, Erazim. *The Embers and the Stars: A Philosophical Inquiry into the Moral Sense of Nature.* Chicago, 1987.

Kohn, Alfie. *No Contest: The Case Against Competition.* Boston, 1986.

Kostelanetz, Richard, ed. *Esthetics Contemporary.* Buffalo, 1989.

Krippner, Stanley, and Alberto Villodo. *Healing States: A Journey to the World of Spiritual Healing and Shamanism.* New York, 1987.

Kunz, Dora, ed. *Spiritual Aspects of the Healing Arts.* Wheaton, Ill., 1985.

Kuspit, Donald B. *Clement Greenberg: Art Critic.* Madison, 1979.

———. *The Critic Is Artist: The Intentionality of Art.* Ann Arbor, 1984.

———. *The New Subjectivism: Art in the 1980's.* Ann Arbor and London, 1988.

LeShan, Lawrence. *From Newton to ESP: Parapsychology and the Challenge of Modern Science.* Northamptonshire, England, 1984.

Levin, David Michael. *The Body's Recollection of Being: Phenomenological Psychology and the Deconstruction of Nihilism.* Boston and London, 1985.

———. *The Listening Self: Personal Growth, Social Change and the Closure of Metaphysics.* New York and London, 1989.

———. *The Opening of Vision: Nihilism and the Postmodern Situation.* New York and London, 1988.

Lippard, Lucy. *Mixed Blessings: New Art in a Multicultural America.* New York, 1990.

Locke, Steven, and Douglas Colligan. *The Healer Within: The New Medicine of Mind and Body.* New York, 1986.

Lorenz, Konrad. *The Waning of Humaneness.* Boston and Toronto, 1983.

Loye, David. *The Sphinx and the Rainbow: Brain, Mind and Future Vision.* Boulder and London, 1983.

Luke, Timothy. *Screens of Power: Ideology, Domination and Resistance in Informational Society.* Chicago, 1989.

Lyotard, Jean-François. *Driftworks.* New York, 1984.

———. *The Postmodern Condition: A Report on Knowledge.* Minneapolis, 1984.

Macy, Joanna. *World as Lover, World as Self.* Berkeley, 1991.

Marcuse, Herbert. *The Aesthetic Dimension: Toward a Critique of Marxist Aesthetics.* Boston, 1978.

Maslow, Abraham H. *The Psychology of Science: A Reconnaissance.* Chicago, 1966.

McKibben, Bill. *The End of Nature.* New York, 1989.

Milbrath, Lester W. *Envisioning a Sustainable Society: Learning Our Way Out.* Albany, 1989.

Needleman, Jacob. *A Sense of the Cosmos: The Encounter of Modern Science and Ancient Truth.* New York, 1975.

Newman, Charles. *The Post-Modern Aura: The Acto of Fiction in an Age of Inflation.* Evanston, 1985.

Nicholson, Shirley. *Shamanism: An Expanded View of Reality.* London, 1987.

Noel, Daniel. *Approaching Earth: A Search for the Mythic Significance of the Space Age.* New York, 1986.

O'Doherty, Brian. *Inside the White Cube: The Ideology of the Gallery Space.* San Francisco, 1986.

Ortega y Gasset, José. "The Dehumanization of Art," in *A Modern Book of Esthetics.* Third edition, New York, 1960.

Pappenheim, Fritz. *The Alienation of Modern Man: An Interpretation Based on Marx and Tonnies.* New York and London, 1968.

Pearce, Joseph Chilton. *The Bond of Power: Meditation and Wholeness*. London and Henley, England, 1982.

———. *Exploring the Crack in the Cosmic Egg: Split Minds and Meta-Realities*. New York, 1975.

Peat, David F. *Synchronicity: The Bridge between Matter and Mind*. New York and Toronto, 1988.

Peck, M. Scott. *The Different Drum: Community-Making and Peace*. London, 1987; New York, 1988.

Perera, Sylvia Brinton. *Descent to the Goddess: A Way of Initiation for Women*. Toronto, 1981.

Progoff, Ira. *The Dynamics of Hope*. New York, 1985.

———. *The Symbolic and the Real*. London, 1977.

Rewald, John. *The History of Impressionism*. New York, 1973.

Roberts, Jane. *The Individual and the Nature of Mass Events*. Englewood Cliffs, N.J., 1981.

Robertson, Roland. *Meaning and Change: Explorations in the Cultural Sociology of Modern Societies*. New York, 1978.

Ross, Ruth. *Prospering Woman*. New York, 1985.

Rudhyar, Dane. *Beyond Individualism: The Psychology of Transformation*. Wheaton, Ill., and London, 1979.

———. *Culture, Crisis and Creativity*. Wheaton, Ill., 1977.

Schaef, Anne Wilson. *When Society Becomes an Addict*. New York and San Francisco, 1987.

Schafer, R. Murray. *The Tuning of the World: The Soundscape*. New York, 1977.

Seed, John, Joanna Macy, Pat Fleming, and Arne Naess. *Thinking Like a Mountain: Towards a Council of All Beings*. Philadelphia, 1988.

Shames, Lawrence. *The Hunger for More: Searching for Values in an Age of Greed*. New York, 1989.

Sheldrake, Rupert. *A New Science of Life: The Hypothesis of Formative Causation*. London, 1981.

Siegel, Jeanne. *Artwords: Discourse on the 60's and 70's*. Ann Arbor, 1985.

Simmel, Georg. *On Individuality and Social Forms*. Chicago and London, 1972.

Sinetar, Marsha. *Living Happily Ever After: Creating Trust, Luck and Joy*. New York, 1990.

———. *Ordinary People as Monks and Mystics: Lifestyles for Self-Discovery*. New York, 1986.

Skolimowski, Henryk. *Eco-Philosophy: Designing New Tactics for Living*. Boston and London, 1981.

———. *The Theatre of the Mind: Evolution in the Sensitive Cosmos*. Wheaton, Ill., and London, 1984.

Sonnfist, Alan, ed. *Art in the Land: A Critical Anthology of Environmental Art*. New York, 1983.

Spangler, David. *Emergence: The Rebirth of the Sacred*. New York, 1984.

———. *Manifestation: The Inner Art*. Redmond, Wash., 1988.

———. *Towards a Planetary Vision*. Forres, Scotland, 1977.

Starhawk. *Dreaming the Dark: Magic, Sex and Politics*. Boston, 1982.

Steiner, George. *Real Presences: Is There Anything in What We Say?* Chicago and London, 1989.

Sullivan, Barbara Stevens. *Psychotherapy Grounded in the Feminine Principle*. Wilmette, Ill., 1989.

Tart, Charles T. *Waking Up*. Boston, 1987.

Thompson, William Irwin, ed. *GAIA: A Way of Knowing*. Great Barrington, Mass., 1987.

Vaughan, Frances. *Awakening Intuition*. Garden City, N.Y., 1979.

———. *The Inward Arc: Healing and Wholeness in Psychotherapy and Spirituality*. Boston and London, 1986.

Vaughan, Frances, and Roger N. Walsh. *Beyond Ego: Transpersonal Dimensions in Psychology*. Great Barrington, Mass., 1987.

Wallis, Brian, ed. *Art After Modernism: Rethinking Representation*. New York, 1984.

Walsh, Roger. *Staying Alive: The Psychology of Human Survival*. London, 1984.

Weber, Max. *The Sociology of Religion*. Boston, 1964.

Weber, Renée. *Dialogues with Scientists and Sages: The Search for Unity*. New York and London, 1986.

Wheelis, Allen. *How People Change*. New York and London, 1973.

White, Stephen K. *The Recent Work of Jurgen Habermas: Reason, Justice and Modernity*. New York and Cambridge, England, 1988.

Whitmont, Edward C. *Return of the Goddess*. New York, 1988.

Williams, Donald Lee. *Border Crossings: A Psychological Perspective on Carlos Castaneda's "Path of Knowledge."* Toronto, 1981.

Wilson, Colin. *The New Existentialism*. London, 1980.

Woodman, Marion. *The Pregnant Virgin: A Process of Psychological Transformation*. Toronto, 1985.

———. *The Ravaged Bridegroom: Masculinity in Women*. Toronto, 1990.

Yankelovich, Daniel. *New Rules: Searching for Self-Fulfillment in a World Turned Upside Down*. New York, 1981.

Zukav, Gary. *The Seat of the Soul*. New York, 1989.